*The Prints of Edouard Manet*

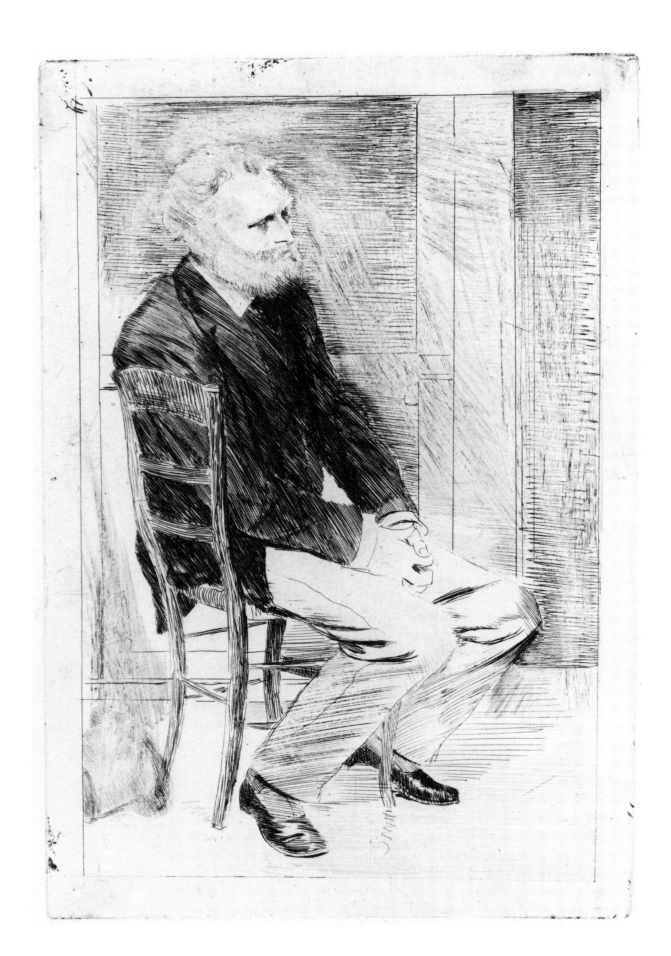

# The Prints of Edouard Manet

by

Jay McKean Fisher

*Organized and Circulated*

*by*

*the International Exhibitions Foundation*

*Washington, D.C.*

*1985–1986*

© 1985 by the International Exhibitions Foundation, Washington, D.C.
Library of Congress Catalogue Card No. 85-80175
ISBN 088397-083X

Cover: *Berthe Morisot (en noir)* (1872–1874). The George A. Lucas Collection of The Maryland Institute, College of Art, on indefinite loan to The Baltimore Museum of Art. Catalogue no. 60

Frontispiece: Edgar Degas, *Manet Assis*. The Baltimore Museum of Art.

Tailpiece: *Illustrated Cover for an Edition of Etchings (Cat and Portfolio)* (1861–1862). The George A. Lucas Collection of The Maryland Institute, College of Art, on indefinite loan to The Baltimore Museum of Art. Catalogue no. 21

Photo credit: All photographs of works from The George A. Lucas Collection courtesy Duane Suter, The Baltimore Museum of Art; photographs from the Indiana University Art Museum courtesy Michael Cavanagh and Kevin Montague.

This catalogue is underwritten in part by The Andrew W. Mellon Foundation.

Designed by Polly Sexton, Washington, D.C.
Produced for the International Exhibitions Foundation by Schneidereith & Sons, Baltimore, Maryland
Printed on 80 lb. Mohawk Superfine Text, Mohawk Paper Mills, Inc., Cohoes, New York
Composed in Palatino by Monotype Composition Company, Baltimore, Maryland

# Contents

## Lenders to the Exhibition

The Baltimore Museum of Art
Davison Art Center, Wesleyan University
Harvard University Art Museums
The New York Public Library
Boston Public Library
The Detroit Institute of Arts
The Maryland Institute, College of Art
The St. Louis Art Museum
Mr. and Mrs. Alan Schwartz

## Participating Museums

The Detroit Institute of Arts, Detroit, Michigan
University Art Museum, Berkeley, California
The St. Louis Art Museum, St. Louis, Missouri
Huntsville Museum of Art, Huntsville, Alabama
Art Gallery of Ontario, Toronto, Ontario, Canada

# Acknowledgments

During its 20th anniversary year, the International Exhibitions Foundation takes great pride in bringing to an American audience the first major exhibition of prints by Edouard Manet.

Throughout the organization of the exhibition we have been fortunate to have the cooperation of many friends and colleagues whose help proved invaluable. We are particularly indebted to the staff of The Baltimore Museum of Art, notably Jay McKean Fisher, curator of prints, drawings, and photographs, who selected the works and wrote the introduction and catalogue entries. His scholarly text has given us a catalogue that will add greatly to the limited literature on Manet prints.

We are extremely grateful to the institutions and collectors who have so kindly agreed to part with their works for an extended tour, especially The George A. Lucas Collection of The Maryland Institute, College of Art, which is on indefinite loan to The Baltimore Museum of Art, the Samuel P. Avery Collection of The New York Public Library, and the Rouart Collection of The Detroit Institute of Arts.

This publication could not have been produced without the assistance of our designer, Polly Sexton, and our printer, Thomas Phillips of Schneidereith & Sons, who collaborated to produce a fine catalogue. We would also like to acknowledge The Andrew W. Mellon Foundation for its partial support of this publication. Once again, I want to extend my heartfelt thanks to the staff of the International Exhibitions Foundation, particularly Taffy Swandby, Lynn Kahler Berg, B.J. Bradley, Deborah Shepherd, and Sarah Tanguy for their diligent attention to the numerous and complex details involved in organizing the tour and producing the catalogue.

ANNEMARIE H. POPE
*President*
*International Exhibitions*
*Foundation*

# Preface

The study of Manet's prints has produced no fewer than three catalogues raisonné, the first in 1906 and the latest in 1971, plus extensive scholarship in articles, books, and exhibition catalogues. During Manet's lifetime very little consideration was given to his prints by either critics or collectors, and until recently Manet's printmaking was known only in terms of widely available and totally unsympathetic posthumous printings of his etchings. His lithographs, while revered as precociously modern for their time, have too often been kept apart in the overall context of his graphic oeuvre. In 1983 the centenary retrospective of Manet's work gave viewers in New York the first opportunity to consider examples of the artist's printmaking within view of his paintings and drawings. The catalogue integrated the prints with paintings and drawings, both visually and through new analysis and documentation. It is therefore timely to isolate Manet's printmaking once again and to consider his print oeuvre as a whole in terms of recent analysis and research.

This exhibition is drawn from American collections, primarily The George A. Lucas Collection in Baltimore, together with selections from the Samuel P. Avery Collection at The New York Public Library, and objects formerly from the Rouart Collection, now in The Detroit Institute of Arts. These works represent the largest part of Manet's printmaking oeuvre, including his most important prints, exhibited in the finest lifetime impressions available. Manet's printmaking attitudes can only be understood through such examples, which are an aesthetic revelation for those viewers previously attuned to posthumous impressions. Certain images are exhibited either in more than one state to indicate Manet's working method or from variant printings to illustrate the finer points of print connoisseurship. The catalogue seeks to synthesize current research on Manet's prints from various, often inaccessible, references and to update current cataloguing knowledge. In addition to providing a catalogue of the most important prints from the Lucas holdings of Manet, this publication summarizes the rich print holdings of other American museums. The publication was conceived primarily in terms of extended catalogue entries with details concerning each object, along with a more general introductory essay.

In September 1983 on the occasion of the Manet centenary I organized an exhibition of Manet prints from the Lucas collection for The Baltimore Museum of Art. On viewing that exhibition, Mrs. John A. Pope, president of the International Exhibitions Foundation in Washington, D.C., suggested the possibility of a traveling exhibition on Manet prints, drawn primarily from the Baltimore collection, which would include some major loans of those images not otherwise represented and a catalogue. I was eager to comply with this proposal, and I am grateful to Mrs. Pope and her staff for their enthusiastic response to this project. The exhibition would not have been possible without the essential cooperation of The Baltimore Museum of Art, and I am grateful to Arnold L. Lehman, director, and Brenda Richardson, assistant director for art, not only for encouraging me to move forward with this project but for allowing me needed time away from museum responsibilities to prepare the exhibition and write the catalogue. In this regard I would also like to thank my colleague, Victor I. Carlson, formerly curator of prints and drawings at the Museum and now senior curator at the Los Angeles County Museum of Art. Our stimulating discussions about Manet's prints and his patient reading of the catalogue manuscript were immensely helpful. I would also like to thank Audrey Frantz for preparing the manuscript for editing; Viola Holmes for typing; Milton Mosher, Kendra Lovette, and Reba Fishman for preparing the Lucas prints for travel; Melanie Harwood, registrar, for loan arrangements; and Nancy Press and Duane Suter for photography assistance. At the International Exhibitions Foundation, I would like to thank editor Barbara Bradley for her skillful preparation of the manuscript, together with designer Polly Sexton. Lynn Berg handled all the loan arrangments while the project was

supervised by Taffy Swandby and coordinated by Deborah Shepherd and Sarah Tanguy.

I am especially indebted to a number of my French colleagues who provided invaluable assistance during and following a research trip to Paris, including Madeleine Barbin, Laure Beaumont, Claude Bouret, Mme. Grivel, and Francoise Woimant at the Bibliothèque Nationale. I received advice from other French colleagues, including Arsène Bonafous-Murat, Hubert Prouté, and Jean-Claude Romand. I would like to thank all my American colleagues who responded to inquiries concerning their Manet holdings, and specifically those who offered more extensive advice, including Martha Asher, Jacquelynn Baas, David Becker, Carolyn Bullard, David Cass, Malcolm Daniel, Douglas Druick, Richard Field, Adelheid Gealt, Joseph Holtzman, Jem Hom, Gail Kaplan, Robert Light, Suzanne McCullagh, Nesta Spink, Marilyn Symmes, Jeffrey Thompson, and Peter Zegers.

Special thanks are due the lenders, both institutional and private, for making these rare and frequently requested prints available for this extensive tour. I would particularly like to thank the following individuals for their patient responses to my numerous requests, including Ellen D'Oench of the Davison Art Center, Ellen Sharp and Kathleen Erwin in Detroit, Robert Rainwater and Tobin Sparling at The New York Public Library, and Judith Weiss in St. Louis. Our one private lender, Mr. and Mrs. Alan Schwartz, were especially generous in making their extraordinary lithograph, *The Races*, available for the exhibition. Finally among the lenders, I would like to thank Fred Lazarus IV, president of The Maryland Institute, College of Art, owner of The George A. Lucas Collection, which is on indefinite loan to The Baltimore Museum of Art, for the continuing cooperation and friendship that exist between our two institutions. I would also like to thank the staffs of the exhibiting museums, both for their interest in this project and for the careful presentation of the exhibition at its five venues.

The realization of this project would not have been possible without the extraordinary cooperation of Juliet Wilson Bareau, whose research on Manet's prints has immeasurably advanced our understanding of these objects. Her assistance to me went far beyond her excellent publications because she shared in an exemplary collegial relationship her most current thoughts and research in progress. Our frequent discussions, punctuated by her probing visual analysis and common sense approach to problem solving, were stimulating and provided guidance for the priorities of this publication. My own burgeoning interest in Manet's graphics was heightened by her intensely felt conviction of their importance.

JAY MCKEAN FISHER
*Curator*
*Prints, Drawings, and Photographs*
*The Baltimore Museum of Art*

*The Prints of Edouard Manet*

# Introduction

Edouard Manet (1832–1883) wrote very little about his art and almost nothing about his printmaking, so we cannot rely on his own words to shape our attitudes about the prints or to establish a context for their appreciation. The majority of Manet's prints interpret, some more faithfully than others, his painted designs. In making prints, he was clearly motivated by a desire to popularize his art, using the print as a means of visual communication. But determining Manet's motivation for making a print is difficult when he had no publishing opportunity. More than half of his over one hundred images were never published during his lifetime and are known in only a few impressions. If, as Michel Melot has suggested, Manet viewed the print primarily as an image of an image for wide distribution, were these unpublished prints then incomplete or failed visual statements of little real import in the overall scheme of Manet's total artistic output (New York 1983, p. 36)?

The recent exhibition of Manet's art at The Metropolitan Museum of Art in New York and its catalogue carried further what Léon Rosenthal accomplished in a 1925 study of Manet's prints—the integration of his printmaking with his painting. The Metropolitan's show demonstrated both visually and through documentation that prints were not made just in the service of reproduction—as a kind of visual reprise—but were in themselves artistic statements that, even when closely following the design of a painting, convey comparable creative choices, differently expressed. There has been a tendency in writing the history of 19th century printmaking to structure a dichotomy between original and reproductive printmaking. During the 1860s and 1870s, when Manet made most of his prints, printmaking still encompassed traditional modes, including the reproductive print. But for the next generation of "peintre-graveurs" (painter-printmakers) and their public, the print was assumed to be an accepted art form—its self-sufficient artistic potential fully realized. Melot noted that Manet's prints "stand between two worlds" (New York 1983, p. 36). And through the critical comments of such etching enthusiasts as Philippe Burty (see no. 15 and 16), together with Manet's apparent lack of commercial success, we can conclude that his public was limited to his most ardent admirers. But, as Henri Zerner points out in a review of the New York exhibition and catalogue, this concentration on the issue of reproductive versus original, and therefore on Manet's lack of identity, leads neither to an understanding of his printmaking nor to a context in which to appreciate his achievements (Zerner 1984, pp. 71–72). Many of Manet's most remarkable prints thereby become anomalies, whether they are original ideas based on personal experience or related to paintings. *Line in front of the Butcher Shop* (no. 53) records an actual event witnessed by the artist, while another extraordinary exposition of the medium's creative potential, the lithograph *The Races* (no. 56), can only be understood in the context of the paintings in which Manet first explored the form of this composition.

Manet's interest in making prints, intense in the period 1860–1863 but more sporadic until 1874 when he essentially abandoned direct printmaking, reflects his working methods and general artistic attitudes. In his preparation for paintings, the print was a constant source of inspiration and information. He found subjects in popular prints and often viewed the art of the past through printed images. Furthermore, when he approached his own printmaking he looked again at the prints by artists who had first provided a source for his painting, seeking stylistic and technical precedents in the language of printmaking. As an example, the design for Manet's painting *The Espada* (Rouart and Wildenstein vol. 1, 58) depends in part on Goya's prints, and when Manet made his etching, he returned to the Spanish master for insights into a compatible etching style and a technical approach that included aquatint. The composition of Manet's *Surprised Nymph* (Rouart and Wildenstein vol. 1, 39 and 40) looks to Rembrandt's oil. When the bather sits inside in Manet's etching *The Toilette* (no. 20), the rich chiaroscuro effects that

model the voluminous figure suggest Rembrandt's late etching-drypoints of bathers. *The Toilette*, like a number of prints (no. 1, 4, 35, 43, 49, and 56), has an important, mediating role in the evolution of the painted composition.

In 1862 Manet customarily would have left the actual work of producing a print of his popular painting *The Spanish Singer* (Rouart and Wildenstein vol. 1, 32) to a reproductive engraver like Charles Courtry, who in 1873 made a reproductive etching of the painting that allows an instructive comparison with Manet's own etching (see no. 11 and 12). Instead, Manet chose to draw his interpretation of the original directly on the copper plate, thereby reversing the composition. He began methodically, possibly using a photograph of the original, and then made an intermediate drawing from which he transcribed a basic design to the plate with a stylus and softened ground. But the reversal of his image is only the most obvious indication that Manet's interest in the print went beyond Courtry's reproductive goals. The engraver, whose approach really attempted to deny the character of an etching, sought a graphic substitute for the original; Manet, the artist-engraver, worked for an equivalent.

In this way Manet explored the potentials of printmaking in order to realize his exacting artistic standards, not just as self-conscious experimentation for its own sake, but as the inherently original expression of his probing artistic vision. Degas, who manipulated the processes of printmaking as have few other artists, himself owned one of the largest and most important collections of rare Manet prints. Manet's unconventional view of what etching and lithography would allow extended to new technologies such as the transfer relief print. And he used many of the new techniques developed during his lifetime, often at an experimental stage, for duplicating his drawings and paintings (see no. 63). Manet also knew what printmaking could not do, and his choice of subjects for his etchings reflected themes not only that could have popular appeal but also that were suitable for translation into a graphic language. Even though its inspiration might have been an engraving by Marcantonio Raimondi, *Luncheon on the Grass* (Rouart and Wildenstein vol. 1, 67) would clearly have been an impossible choice for a print. When it came to his later painting *Jeanne: Spring* (Rouart and Wildenstein vol. 1, 372), he felt that a reproduction without halftones would be inadequate. And after making that etching (no. 75) he remarked, "evidently etching is no longer my affair" (New York 1983, p. 487–488).

Manet was first attracted to printmaking by etching, a medium that was touted for its closeness to drawing, and he developed an etching style that sought graphic equivalents for ideas explored in painting. Gradually he moved from equivalency to the more immediate medium of lithography and finally to transfer processes where his drawings were directly translated into multiples. The decline in Manet's printmaking activity occurred when printmaking could no longer serve to develop his artistic goals, which does not lessen the impact of his accomplishments as seen within his total oeuvre.

*Printmaking Chronology*
Manet made most of his prints during two periods, 1860–1863 and 1865–1874. The first interval was a time of intense activity when he executed forty of his approximately 105 prints. His graphic output was more sporadic in the second period, which included a number of commissions and three projects for book illustrations. Manet produced most of his lithographs in this period as his etching production declined. A secure chronology for Manet's printmaking, especially for the first period, can only be suggested because a lack of documentation clouds the artist's stylistic progression. The very nature of Manet's working methods discourages a visually analytical approach since he constantly yet inconsistently relied on references to his earlier work, to sources in older art, and to themes that interested him throughout his career. His printmaking style was extremely flexible so as to reflect the nature of his model. In only a few cases are his prints actually dated. Nor can his graphic production be dated on the basis of his painted models (often dated), for he could have made the etching directly upon the completion of the painting or much later.

As a chronological beginning it would be helpful to know which print was Manet's first. The literature suggests several possibilities, none based on the same criteria. Most agree that his first print dates from 1860, although it now appears that his serious etching activity did not begin until 1861. Because of its reliance on sketches made during a trip to Italy in 1857 *Silentium* (no. 23) and the stylistically related *Infanta Marguerita* (no. 30) have been dated 1860. The latter can be related to a meeting reported by Loys Delteil between Degas and Manet when both were copying the supposed Velázquez picture, Degas working directly on a copper plate, which supposedly astounded Manet. Contrary to Delteil's dating of c. 1860, the

new catalogue raisonné of Degas prints from Boston (Reed and Shapiro 16) now dates that etching later, after 1862, thus further confusing the chronology of Manet's prints. Manet's portrait of Edgar Allan Poe (Harris 2) has been mentioned as the artist's first etching since it may have been intended for a volume on Poe being prepared by Charles Baudelaire in 1859–1860. But more likely it relates to Stéphane Mallarmé's writing a decade later. Marcel Guérin placed *The Travelers* (no. 7) first, presumably because of its tentative style. And the first version of Manet's etching of his father is actually dated 1860, as is the lithograph caricature of Emile Ollivier (Harris 1), which was published in *Diogenes* in April 1860.

Etienne Moreau-Nélaton quoted printmaker Alphonse Legros with regard to Manet's first version of *Boy with a Sword* (Harris 24): "I recall having made a few lines on the plate, just a few strokes, to show him how to do it" (Moreau-Nélaton 53). This plate, obviously early in Manet's oeuvre, shows more of Legros's style than Manet's. Certainly, if tentativeness in execution and uncertain working methods are to be taken as a standard, then *The Little Gypsies* (no. 1) must stand near the beginning, in spite of its thematic relationship to a later print and painting. It can, in fact, be described as an important part of the creative process that led to the final composition of a subsequently destroyed canvas. Etchings such as *Silentium* and *The Infanta Marguerita* are indications less of simplicity for lack of skill than conscious choice at visual reduction. Here, too, the unique impression of *The Travelers,* the only pure landscape in Manet's graphic oeuvre, shows a careful study of the prints of Daubigny and Haden. And in its localized application of aquatint in a well-realized panoramic landscape, it is far from the product of a novice etcher. In Manet's early prints, almost all based on a painted model, he gradually achieved fully integrated compositions, moving from the vignettelike character of his early prints such as *The Little Girl* (no. 3) or *The Urchin* (no. 4) toward prints such as *The Travelers,* an entire composition that approaches his goal of faithfulness to the original.

Because of its publication date, the caricature of Ollivier, as a lithograph an anomaly among Manet's earliest prints, is probably Manet's first graphic work, with several etchings following closely in late 1860 or 1861. The date 1860 inscribed on the first portrait etching of Manet's father may refer to the date of the original painting or to the drawing on which it was based because the closely related second version (no. 2) is dated 1861. Even before this portrait must come

the Legros-inspired *Boy with a Sword* and *The Little Gypsies* where Manet was unsure of his approach to the copper plate.

We do not know what encouraged Manet to begin printmaking, although the advantages of the technique were widely discussed by prominent critics of the day and a number of Manet's associates, such as Legros and Bracquemond, were making prints. From the first, the subjects of Manet's etchings with a very few exceptions were his painted compositions, so producing the prints was most likely motivated by a desire to disseminate his art to a wider public with a possible view toward financial reward. Such interpretive etching, while less admired in the late 1870s and 1880s, was an integral part of the etching revival as expounded by the critical writings and illustrated by the prints produced in this period. Early in 1861 Manet may have begun to conceive of a portfolio of his etchings or at least that several of his etchings might be published by Alfred Cadart. In spring 1862 Cadart exhibited some of Manet's prints for the first time (New York 1983, p. 507). Baudelaire's review of Cadart's activity and the new fashion for etching is probably the first public notice of Manet's printmaking (Baudelaire 1965, pp. 218–222). Later that year Cadart would establish the Société des Aquafortistes, of which Manet was a founding member. Manet's prints *The Little Girl* and *The Urchin,* originally etched together on the same plate, appear to be the earliest etchings planned for a portfolio that Cadart announced in September 1862. The first is an excerpt taken from Manet's large work *The Old Musician* (Rouart and Wildenstein vol. 1, 52), while the second, a thematic pendant, is based on another painting of 1860–1861. His most ambitious print of this early period was *The Little Cavaliers* (no. 6), a multifigured composition, for here Manet achieved what he had avoided in his vignette from *The Old Musician.* Years later he remained justifiably proud of this accomplishment and exhibited the print along with several others in the Salon des Refusés in 1863.

But Manet's official debut as a printmaker came with his first published print, *The Gypsies* (no. 15 and 16), included in the first folio of prints by members of the Société des Aquafortistes that was distributed in fall 1862. Before the separate portfolio of his etchings until completing this plate, Manet had approached etching with diligence, and some trial and error, as he became more conversant with a graphic language and found a working method that would insure a faithfulness to the basic design of his model. All the graphic techniques he would use throughout

his career appear in the early prints, including drypoint, aquatint, and a variety of etched lines and tonal procedures such as roulette. With his etching *The Absinthe Drinker* (no. 9) he achieved a demonstrable confidence in his etching style that clearly separates this plate from earlier works that had no consistent view of the graphic potentials of the etched line. Manet needed to find a method for transferring the design of the paintings to the copper plate, and he seems to have achieved this with his prints of Spanish themes, 1861–1862, including no. 11–19. Clearly using photographs, which he sometimes made himself, Manet could reduce the scale of the composition to the size of the copper plate. Then with an intermediate drawing, many of which still exist, he could transfer his design using a stylus and softened ground, although the prints were still most often in reverse orientation to the original painting. After the basic outlines of the design were on the plate, Manet worked toward an interpretation of the original—not an exact reproduction like many prints seen in art journals of the time. Manet studied the works of other printmakers, especially those who also served as models for his painting, such as Goya or Rembrandt.

In fall 1862 and later, sometime in 1863, two portfolios of Manet's prints were published: the first, Cadart's suite of eight etchings announced in the September folio for the Société des Aquafortistes, and the second, the artist's private publication of fourteen etchings, which was intended for distribution to his friends and associates. That portfolio contained plates from the Cadart edition with several new plates either not included or made after fall 1862. The tremendous care taken in the presentation of these proofs reflects Manet's personal concern for his printmaking, less well represented by the routine Cadart printings. Undoubtedly Bracquemond provided some technical assistance for this important project, including the printing and selection of paper. Manet combined prints that interpreted his major paintings as well as a few designs without recorded models, such as *The Candle Seller* (no. 10) or *Boy and Dog* (no. 5). Changes made to the title page for this private publication reflect Manet's indecision about its exact contents, and he may have altered the selection of the fourteen etchings in the course of the set's distribution over the next several years. Of the plates included, *At the Prado* (no. 28) was Manet's most direct acknowledgment to date of Goya's printmaking because, without a model in painting, it shows an alluring maja posing in the Prado, like similar scenes from Los Caprichos.

Three additional prints were published at this time including *Boy with a Sword* in an undetermined edition from 1863, and in the second Société folio, *Lola de Valence* (no. 25). Manet also published the first of two lithographic sheet music covers, a vignette of Lola for a serenade.

But a more important lithograph was his first truly ambitious use of the medium, *The Balloon* (no. 22) from 1862, near the time he was painting *Music in the Tuileries* (Rouart and Wildenstein vol. 1, 51). Cadart initiated this work as well, for he intended a portfolio of artist's lithographs that would encourage a revival of the medium while increasing the number of lithographs he published. What Manet produced undoubtedly disturbed the printer Lemercier, for its unconventional character stretched the medium's potential for artistic expression. Manet responded to the freedom it allowed in drawing, and like Delacroix before him, he realized he could highlight certain details by scratching away the crayon. A probable lack of commercial success led Cadart to abandon his project for a portfolio, and Manet did not return to working on the stone until 1868.

Manet made few if any etchings in late 1863 and 1864, but in 1865, perhaps encouraged by his adviser Bracquemond whose infectious enthusiasm is well documented, the artist returned to printmaking with the portrait *Felix Bracquemond* (no. 31), done in an experimental process developed by the sitter that could imitate the character of a pen line—the pen process etching. Through 1867 only a few prints were made each year, and they vary between careful translations of paintings including a number of portraits, such as *The Tragic Actor* (no. 33) or *The Philosopher* (no. 32), or a freer interpretation from 1868, *Boy Blowing Soap Bubbles* (no. 41), which could mark Henri Guerard's beginnings as a technical adviser. An alternative approach is seen in prints such as *The Rabbit* (no. 36), more a spontaneous caprice than a careful translation of this small still-life painting in the style of Chardin, or *Marine* (no. 35) where Manet created an original composition that is a pastiche of elements from various related paintings. Why these plates were executed is not known, perhaps again for a portfolio that may have included a wide range of subjects showing a flexible approach to printmaking. Cadart's worsening financial condition may have thwarted such a project.

The prints of this period that are based on paintings are more often in the same orientation as the original, and the precision of a print such as *The Philosopher* suggests that Manet may have evolved a new working

method that insured even greater faithfulness to the original, unfortunately with an accompanying lack of vitality. Almost no preparatory drawings are catalogued for these plates, so Manet most likely depended even more on photographs of the originals, reversed and reduced in scale, from which he might have made simple tracings. Unlike the contemporary, carefully finished *Philosopher, Dead Christ with Angels* (no. 37 and 38) of 1866–1867 is a lively and impressive interpretation of a major painting, and in its large scale and unconventional approach it is one of Manet's most ambitious and successful etchings. The artist's more famous painting, *Olympia* (Rouart and Wildenstein vol. 1, 69), was a model for his less successful etching, which is merely a transcription, lacking originality. The print was included in Zola's pamphlet for Manet's independent exhibition at the Avenue de l'Alma in 1867, in which a number of prints were hung together with paintings. Perhaps Manet intended to prepare a number of etchings after painted compositions for this occasion.

In 1866 Manet published a second lithographic music cover, *The Moorish Lament* (Harris 29), and that year an earlier plate, *The Spanish Singer*, was published in *L'Artiste*. Manet's Spanish subjects were especially popular. Also in 1867 Manet received a number of commissions including a demand for a lithograph poster and an illustration for Champfleury's *Les Chats*. In 1868 his etching *Exotic Flower* (no. 46), an almost direct quotation from Goya, was published in Burty's *Sonnets et eaux-fortes*. At this same time Manet reworked a number of his earlier plates with a heavy grain of aquatint (no. 47 and 48), achieving a dramatic effect very much unlike the original conception of the plates. Unlike commissions, these plates, like others from this period, were never published in Manet's lifetime.

There is a greater preponderance of etchings that represent original ideas for printmaking in this later period. In addition to Goya, reflected by Manet's greater use of aquatint, the influence of Japanese woodblocks by Hiroshige and especially Hokusai is readily apparent. Between 1869 and 1871, Manet made practically no etchings, except *Line in front of the Butcher Shop* from 1870–1871, which was his last etching until 1874 when he made his illustrations for Charles Cros's *Le fleuve* (no. 64a-h). The etching *Line in front of the Butcher Shop* is clearly one of Manet's most original conceptions for the copper plate. Strikingly modern, it is a schematic rendition of a desperate scene that he experienced during the Prussian siege of Paris, which ended in the bitter winter of 1871.

After the siege and the bloody events of the Commune of Paris, Manet completed little work, suffering from nervous exhaustion, as was diagnosed in the summer of 1872.

While his etching activity declined, the years 1868–1874 encompass his serious work in lithography, when he produced a number of objects that are among the greatest masterpieces of the medium. Near the time of his ingenious poster for Champfleury, *The Cats' Rendezvous* (no. 50), Manet made the censored and never published print *The Execution of Maximilian* (no. 49), a strong comment on a major political scandal during the Second Empire. In this image and in later lithographs such as *Civil War* (no. 55) and *The Barricade* (no. 54) from 1871, Manet articulated Daumier's view of lithography as a medium well suited for the distribution of provocative visual statements to a large public. For this purpose he created heroic compositions that exploited the artistic potentials of the medium. The broadly conceived lithograph *The Races*, impossible to date securely, was integral to Manet's evolving composition for a major painting of the races in the Bois de Boulogne. In 1874, the year of his last lithograph, he published one of the first color lithographs by an artist, *Polichinelle* (no. 61), where true to his real interests he used the talents of professional printers to achieve an innovative artistic statement intended for mass distribution as a veiled caricature of a known political figure. Besides *Polichinelle*, only two of his lithographs were ever published, *Civil War* and *The Urchin*.

Also in 1874 Manet began the first of three projects for book illustrations, *Le fleuve*, followed by his illustrations for *The Raven* (no. 65–71), published in 1875, and another collaboration with Mallarmé, *L'après-midi d'un faune* of 1875–1876 (no. 72). All three are now considered to be examples of modern book illustration because of the close collaboration between artist and writer, evidenced in the total integration of text and image. While *The Raven* plates are the most vivid illustrations, all these works serve more to complement, or evoke, visual images rather than to illustrate. As the last important etchings in his oeuvre, his plates for *Le fleuve* are among the most freely rendered and boldly conceived of his prints. His last etching *Jeanne: Spring* from 1882 was for Manet a failed attempt at the translation of a painting exhibited in the Salon that year. In the case of *Jeanne*, he was more intrigued by the experiments of Charles Cros, who made one of the first successful color photomechanical reproductions of Manet's painting as an illustrated cover

for Ernest Hoschedé's review of the 1882 Salon.

His etching *Jeanne: Spring* was the last of only a few prints dating from the final decade of his life, a period in which Manet showed little interest in direct printmaking such as etching and lithography and more intrigue with new technologies for reproduction such as "gillotage," a relief process that, like a transfer lithograph, begins as a direct transfer from an original drawing. This interest encompasses the 1875 illustrations for *The Raven* and two prints intended for periodicals, *At the Café* (no. 63) of 1874, and *In the Upper Gallery* (no. 73) of 1877, all traditionally identified as "autographies." In 1874 and 1876 Manet prepared blocks with drawings for wood engravings, including the plates for Mallarmé's *L'après-midi d'un faune* and the portrait *Nina de Callias* (Harris 76–78). In 1874 in addition to his etchings for *Le fleuve* he attempted an etched frontispiece for a book by Theodore de Banville, which was unsuccessful in two attempts. Between 1879 and 1881 Manet made an etching after a drawing of his sick wife (Harris 85 and Wilson 1978, 71), and his only pure drypoint, *The Smoker* (no. 74), done after 1879, is but a reprise of an 1866 etching (no. 40).

### Printmaking Techniques

Manet had a utilitarian view of the various techniques he worked with and in his etchings depended heavily on advisers such as printmakers Bracquemond and Guerard to bite the plates and print the proofs. Manet's prints are generally not characterized by complex combinations of techniques and are inherently nonexperimental. The specifics of his printmaking techniques are discussed in the individual catalogue entries for the exhibited impressions. But Manet did use a variety of processes, some at the time uncommon, and he did not allow any theoretical strictures about proper procedures and standard usage to limit the pursuit of his goals for printmaking. His expectations, whether in the service of an idea original to printmaking or in the search for a graphic equivalent to one of his paintings, demanded new approaches. In this way his printmaking was unconventional and stimulated the next generation of more experimental peintre-graveurs.

Manet used the same techniques in etchings from first to last, including etching, drypoint, aquatint, and various other bitten tones. The only differences result from how these techniques were applied, as the later prints show an inevitable increase in control and consistency. Manet's only real experiment with a new printmaking technique was the portrait *Felix*

*Bracquemond*, where in 1865 he used his adviser's pen process to reproduce the appearance of a drawing. Manet's etchings depend foremost on the pure etched line, and the very first states usually convey a nearly finished conception. States were a matter of refinement, not experimentation and variation. Those refinements usually included more exactly delineating a form, darkening a figure to flatten its shape against the neutral background, and shading backgrounds and making other such adjustments to the overall effect of the design. While a large number of Manet's prints used only etching, sometimes in concert with drypoint, Manet only made one pure drypoint, near the end of his career, *The Smoker*. Drypoint was used to add both rich black accents and detail. It is a quick procedure that avoids a return to the acid bath.

Manet's introduction of tonal areas in his etchings is certainly the least conventional aspect of his printmaking, and these effects appear first in his prints *The Travelers* from c. 1860 or *Boy and Dog* of 1861–1862, with the application of aquatint coincident with the use of roulette and other tonal processes in *The Urchin* and *The Little Cavaliers*. The use of tonal processes is to be expected for an artist interpreting the effects of his painting but was unusual among Manet's colleagues in the Société des Aquafortistes, who advocated pure etching. Even though Manet received the advice of Bracquemond for all these techniques, Bracquemond for the most part concentrated on the effects of pure etched line in his own prints. Maxime Lalanne in his treatise of 1866, a kind of technical manifesto for the Société, also advanced the cause of pure etching while describing alternative processes.

While in his etching *The Travelers* Manet used aquatint to darken selective areas with an even tone in order to suggest spatial recession and the varied texture of a landscape, generally he used aquatint to create a neutral background for a figure. This is especially true in the second period of his etching activity beginning in 1865, when in 1866–1868 with Bracquemond's help in biting the plates (and perhaps Guerard's as well), Manet had a professional apply aquatint grains to his plates to avoid the problems that appear in his early etchings. From the beginning, the major influence for Manet's use of aquatint had been Goya. The Frenchman's plates reveal an appreciation for the wide range of effects possible with aquatint, at times as subtle as one of Goya's Tauromachia prints (*The Espada*, no. 19) or as dramatic as one of Goya's Los Caprichos plates (*Dead Toreador*, no. 43, or *Exotic Flower*, no. 45). In his print *At the*

*Prado* (no. 28 and 47) he used aquatint of varying tone to create flat planes that recede in space, enhancing the effects he had first suggested with the etched line. Manet's keen interest in the effects of aquatint led him to rework a number of his earlier plates such as *The Absinthe Drinker* and *Boy with a Sword* (no. 48). These revisions with a heavy grain of aquatint introduced a dramatic mood to these plates, which is sometimes effective but obscures the subtleties and clarity of Manet's etched lines. Like most of his later plates, these versions were never published in the artist's lifetime.

Manet's use of other tonal processes such as the roulette, a tool much like a pastry wheel that can roughen the plate directly or through a ground in a regular or irregular pattern of dots, has generally not been noted in previous discussions of his printmaking. Use of the roulette allowed selective shading for more subtle tonal adjustments, as seen in *The Little Cavaliers*, *The Spanish Singer*, or *Marine*. In addition, other tonal processes were occasionally used that have normally been grouped under the generic term "aquatint" but are most likely not aquatints but bitten tones often hard to identify technically. These areas are characterized by random dots, widely spaced, almost like pockmarks in the plates, although clearly intentional (see no. 20). Rather than suggesting the flat tone of an aquatint, this technique creates a faint tone in areas otherwise bare of lines. These areas suggest the artist used some kind of lift ground, such as a salt ground or perhaps a sandpaper ground. Some tonal areas are closely related to aquatints and have a texture suggesting a soft ground or what Lalanne described as "mottled tints" seen in *Marine* and *The Rabbit*. In *The Espada* Manet used sulphur tint, brushing the corrosive directly on the plate to roughen its surface. In some instances acid may have been brushed on the plate through a softened ground imprinted with a texture. Such techniques were not uncommon because they were recorded by Lalanne and certainly known and practiced by Bracquemond and Guerard. A number of these tonal effects were used in the landscape etchings of Daubigny, an early influence for Manet.

In spite of the variety of printing approaches used for Manet's prints during his lifetime, he appears to have preferred a cleaner wiping for his plates, best seen in the proofs included in his c. 1863 private edition of fourteen etchings. These impressions, probably printed by Bracquemond, were inked cleanly to emphasize the clarity of Manet's line. A chine paper was chosen because it could pick up the finest line of ink. At the same time, stark black-and-white contrast was avoided by the choice of a chine with a luminous tone and the use of a bistre ink instead of black, resulting in a subtle tonal richness (see no. 11, 14, 15, and 17). In proofs of the later plates, most likely printed by Guerard, there is still a preference for the cleanly wiped impression over the heavily inked examples from Delâtre, characteristic of the Cadart editions. Even there Guerard chose papers with a slight off-white tint to avoid glaring contrasts. There was apparently very little experimentation with inking since the proofs show little variation. Exceptions are the two known proofs of the first state of *The Toilette*: one (Archives Paul Prouté, Paris), almost like a monoprint, exploits the chiaroscuro effects of the dark interior in a manner close to Delâtre's printings; and the other (Johnson collection, Chicago), printed on a prepared white paper, is cleanly wiped and concentrates instead on the linear structure of the design. While various kinds of paper were used in printing Manet's prints, the artist was not involved in a dramatic experimentation with effects of printing and papers, a practice that became more common with innovators such as Buhot, Goeneutte, Guerard, and Lepic in the late 1870s.

As a lithographer, again it was how Manet drew on the stone, not the techniques he used, that made his lithographs distinctly unconventional. After drawing his design, he expected the technicians to prepare and print the stone. Aside from his 1860 caricature of Ollivier, Manet's first serious attempt at lithography was *The Balloon* in 1862, and even at this early stage in his understanding of the medium, he adopted a drawing style that exploited the potentials of the medium, including a wide variety of strokes, from black to grey, and scraping off the crayon to add white highlights. *Civil War* of 1871–1873 is a print by a consummate lithographer in total control of the medium, using the crayon with confidence, drawing with its point, creating broad strokes with its side, and finally rubbing and scratching highlights by scoring the stone.

At the same time Cadart was publishing Manet's first etchings, the artist was also actively interested in the autographic reproduction of his drawings and as early as 1862 made drawings for gillotage reproduction, a rapidly developing technology that Manet followed closely. After 1874 when he produced his last crayon lithograph, Manet made several important gillotage prints, including *At the Café*, his illustrations for *The Raven*, and *In the Upper Gallery* of 1877. These prints, identified as autographies in Manet's oeuvre,

have been mistakenly linked to transfer lithography in previous publications, a fact that is discussed in detail in the individual catalogue entries. Manet's use of new printmaking technologies such as gillotage is consistent with his general approach to making prints, where he used all possibilities to attain a specific visual statement. He gradually moved away from the direct printmaking of etching and crayon lithography and, with the technical expertise of printers, relied more on reproductive media to make multiples of his original designs. Like his etching and lithography, Manet advanced the artistic potential of the newer printing technologies not through self-conscious experimentation but through his inherently unconventional expectations for whatever medium he used.

### State of Research

The bibliography for Manet's prints is extensive and includes no less than three catalogues raisonné and, with Juliet Wilson Bareau's recent publications and this catalogue, the beginnings of a fourth. The importance of Manet's printmaking oeuvre, both as an aspect of his creative output—and therefore as an indication of his artistic attitudes and working methods—and as a major body of work that had a serious impact on the history of printmaking in the 19th century, is now being explored anew. What is now required is a definitive volume, in a catalogue raisonné format, that will compile the information relating to Manet's prints from disparate sources and seek a better integration of his printmaking activity with his entire artistic output. Each print needs to be carefully studied and compared, following Bareau's recent research, in an attempt to discern what the visual evidence tells us that otherwise would be unconfirmed.

Not surprisingly, most of the faults in the past catalogues raisonné, including the most recent one by Jean Harris in 1970, have resulted from research based on too small a proportion of the existing impressions available, examined without a systematic comparison. With her catalogue for Ingelheim am Rhein in 1977, Bareau was the first to bring acute powers of visual observation, diligent study, and a common-sense approach to the task of solving the numerous questions left in the wake of previous catalogues for Manet's prints. Consequently, she was able to shed light on what were only unsubstantiated suggestions about Manet's printmaking attitudes and working methods. Our knowledge of Manet's prints, of their execution and distribution, was considerably advanced by her study of the objects as well as by

her archival research. The major retrospective exhibition held in New York, with its resulting catalogue, showed side by side for the first time the prints and drawings with the paintings. There Bareau's entries for the prints helped to define the consistent artistic attitudes that unify Manet's total oeuvre. Guided by careful X-ray examination of Manet's paintings, she has already discovered further links between prints and paintings (see Bareau 1984, and no. 4). A major exhibition planned this year at The National Gallery of London will look more closely at the working methods that unite prints with paintings.

There is no reason to assume that the tremendous volume of literature on Manet's art produced in the last decade, and most recently stimulated by his centenary, will now decline. Manet's sources will continue to be explored, just as his own lack of writing about his art will continue to encourage speculation on the meaning of his paintings and prints. For those prints not directly based on painted compositions, sources need to be investigated together with artistic influences from popular prints, Goya, or Japanese art. Dating for most of the prints is imprecise, especially for the intense period of productivity between the years 1860 and 1863. A secure chronology is difficult to establish, and even the date of Manet's first print is insecure. Manet exhibits neither a consistent stylistic development nor an orderly interest in subject matter, so the task, not an easy one, will have to be approached with a renewed examination of the prints themselves. Guérin was the first to arrange the prints chronologically, and Harris attempted to describe their stylistic progression, but many inconsistencies and much incorrect information invalidate their complete success.

In the context of a catalogue raisonné, Manet's printmaking techniques and his revisions from state to state must be systematically identified. This is important even though as a printmaker Manet depended on the technical efforts of others and was not experimental in his attitudes. Manet's goals for a given image were usually specific and ambitious, and his struggles with the medium need to be analyzed in terms of those expectations. The least studied and most difficult problems involve Manet's lithographs, although it is through these prints that his greatest contribution to original printmaking was made. Most questions involve the actual publication of these images, many drawn by Manet but not printed until after his death. As discussed in their individual catalogue entries, his autographies present the greatest technical questions. Careful research is required

on the technical aspects of transfer lithography and photomechanical processes recently introduced by Douglas Druick and Peter Zegers in their essay for the Boston catalogue raisonné of Degas's prints. In the process of such specific research, Manet's printmaking, often isolated from the work of his contemporaries, can be better related to the context of experimentation and new ideas for printmaking current in the 1870s.

*Manet Prints in American Collections*

Because of their relative rarity, the most significant lifetime impressions of Manet's prints are found in comparatively few collections. American museums have the largest collection of these prints. Although his lithographs are widely distributed, including rare before-the-letter impressions, the lifetime printings of his etchings are held in four major collections: The George A. Lucas Collection of The Maryland Institute, College of Art, on indefinite loan to The Baltimore Museum of Art; The Art Institute of Chicago; the Rouart Collection of The Detroit Institute of Arts; and the Samuel P. Avery Collection of The New York Public Library. In addition, important holdings of Manet prints are at the Museum of Fine Arts in Boston, The Metropolitan Museum of Art in New York, the National Gallery of Art in Washington, D.C., and the Davison Art Center of Wesleyan University in Middletown, Connecticut. Beyond these major collections, rare or unique impressions of Manet prints are scattered throughout American museums and private collections. Abroad, three institutions hold the major collections, including The British Museum in London; the Bibliothèque Nationale in Paris; and the Nationalmuseum in Stockholm. The Kunsthalle in Hamburg also holds important Manet graphics.

In the provenance listings for prints included in the 1983 New York Manet exhibition, Bareau compiled information about major Manet collectors in the 19th and 20th centuries. In summary, most Manet prints come from just a few sources, collections formed during or shortly after Manet's lifetime. Perhaps the first was that of his technical adviser Felix Bracquemond (1833–1914) whose collection became part of Philippe Burty's (1830–1890). Edgar Degas (1834–1917) acquired almost all of that collection when it was sold in 1890. In the second sale of Degas's collection in 1918, a Swedish collector named Schotte purchased the rarist of the Manet prints. Aside from a few impressions in American collections and elsewhere (including no. 24, 26, and 37 from the Rouart collection

in Detroit), many of the Manet prints from Degas's collection remain to be located. The Schotte holdings were confiscated by the Swedish government, and they remained in storage, uncatalogued, until their recent discovery in the Nationalmuseum in Stockholm. The contents of this important collection were published in the Ingelheim catalogue.

The second major collection belonged to Manet's other technical adviser Henri Guerard (1846–1897) whose association with Manet began in the 1870s. In addition to retaining proofs of prints when he assisted Manet, he also gathered proofs of earlier plates, either from Manet himself or from Manet's widow, Suzanne. In addition, he printed a number of proofs from the plates either before or shortly after Manet's death but probably before the posthumous editions. Because of his own collection and the access he had to the Manet estate through Suzanne Manet, Guerard is the major source for posthumous Manet prints, and American collections, like the Avery and Lucas holdings, derive essentially from Guerard. Guerard's inscriptions identifying states and providing other information on the rare and unique impressions purchased by Lucas and Avery testify to his important role as the major informant concerning Manet prints before the publication of Moreau-Nélaton's book in 1906. The final Manet collections mentioned by Bareau as important 19th century sources are those of Joseph Fioupou (1814–?) and Léon Leenhoff (1852–1927), Manet's son (stepson?). What these collections contained is not known, but Fioupou had formed an impressive collection of contemporary prints, buying precisely during the period of Manet's printmaking. One of the artist's sets of fourteen etchings was dedicated to him. The other major French collections were owned by the two cataloguers of Manet prints, Moreau-Nélaton and Guérin. Moreau-Nélaton's collection contained many of the rare proofs described in his catalogue and was given to the Bibliothèque Nationale in 1927. Guérin's collection was sold in 1921–1922 and is widely dispersed but included two impressions in the current exhibition (no. 3 and 31). Other major holdings in Paris are the Prouté archives, the collection of dealer Marcel Lecomte, and the Le Garrec family collections. Major collections now dispersed include the Gerstenberg collection (some sold, others missing since World War II), and the Henri Thomas collection sold at the Hôtel Drouot in 1952. An important collection of Manet prints (Franck collection?) was sold at Sotheby's in London, December 14, 1978.

Through Guerard and Susanne Manet the expatriate Baltimorean, George A. Lucas (1824–1909) was

in large part responsible for the largest and most important collection of Manet prints in America, the combined resource of the Lucas collection in Baltimore and the collection formed by Samuel Putnam Avery (1822–1904), now in The New York Public Library. Lucas, who trained at West Point as a civil engineer with a speciality in railroad construction, abandoned that career when he moved permanently to Paris in 1857 where he became an art agent and collector for a number of wealthy American collectors, including Avery, Frederick Corcoran, and William and Henry Walters. After 1884 he began to amass a major print collection for Avery and himself with Guerard's assistance and thus he had access to the Manet estate. In addition, Lucas relied on Louis Dumont, who published the second posthumous edition of Manet prints and who was also a dealer, on another dealer named Gosselin, and on numerous sales at the Hôtel Drouot in Paris. Lucas obtained great numbers of rare proofs and some unique impressions, the rarist of which went to Avery in New York, although Lucas retained a great number of important impressions for himself, especially of the earlier Manet prints. His presence in Paris when the lithographs were published in 1884 undoubtedly enabled him to acquire the rare before-the-letter proofs in his collection and Avery's, and he was also able to obtain one of the five known impressions of *The Balloon,* again probably with Guerard's help. Where Lucas was not able to find lifetime impressions he filled in the collection with Dumont impressions so that both the Lucas and Avery collections are virtually complete representations of the artist's work. The small but excellent collection of rare Manet prints at the Davison Art Center is also connected to Lucas because the prints were bound with a copy of Bazire's book that was purchased by Davison but at one time owned by Avery. This exhibition unites many of the impressions acquired through the Lucas-Avery-Guerard connection.

Guerard's personal collection remained essentially intact after his death, held by his family, and was catalogued in the 1978 Galerie Berès publication. This collection is currently on the market in the United States, but many of the most important proofs of Manet's etchings from the Guerard collection have recently been purchased by The Art Institute of Chicago. This important acquisition added to the Institute's already extensive collection of lifetime impressions creates one of the most important resources for the study of Manet's prints. While not including some of the greatest rarities in the Lucas and Avery collections, the Chicago collection does have a larger number of the finest impressions of most of Manet's more important prints. These works, of course, complement the largest collection of Manet's paintings in Chicago, several of which were the models for prints.

The final Manet collection of major importance was the Rouart collection. Henri Rouart (1833–1912) was a collector of art by his contemporaries, and a painter who was a close friend of Degas. Julie Manet (1879–1967), daughter of Berthe Morisot (1841–1895) and Eugene Manet (1833–1892)—Edouard's brother—married Rouart's son Ernest (1874–1942). Berthe Morisot had attempted to form an important collection of Manet's art, and her daughter's marriage joined the resources of both Morisot-Manet and Rouart families. The collection passed to Degas expert Denis Rouart and was eventually sold. The Detroit Institute of Arts was able to purchase the most important prints from this collection as a group in 1970, including the extremely rare first state of *Dead Christ with Angels* from Degas's collection and a number of other proofs, many of which are included in the current exhibition.

## Titles

Titles are given in English and French and either are the traditional titles established for Manet prints by the catalogues raisonné or have been revised to reflect current scholarship.

## Dates

Manet dated only a few of his prints, including two in this exhibition: the portrait *M. Manet,* 1861 (no. 2), and while the date is not visible in the exhibited third state, *Spanish Singer* (no. 11 and 12) is also dated 1861 in its second state. The earliest date to appear on a Manet print is 1860 on the first version of *M. Manet* (Harris 6). Because of their publication dates, definitive dates can also be attached to Manet's book illustrations, including *Le fleuve,* 1874 (no. 64 a-h), *Le corbeau,* 1875 (no. 65–71), and *L'après-midi d'un faune,* 1876 (no. 72). The remaining prints in the exhibition are dated according to current scholarship, and those dates appear in parentheses.

Because of a lack of documentation, many of Manet's prints can be dated only within a range of probable years. Research for this catalogue has suggested a revision of some of the dates for Manet's prints, and these changes are discussed in individual catalogue entries. In most cases, this catalogue relies on the dating that Juliet Wilson (now Bareau) put forth in three sets of catalogue entries, most recently the 1983 catalogue for the Manet retrospective at The Metropolitan Museum of Art, the 1978 catalogue for the Berès gallery, and the 1977 Ingelheim catalogue (see Bibliography for complete citations). Reflecting current scholarship, this catalogue suggests considerable changes in dating from the most recent catalogue raisonné by Jean C. Harris in 1970.

Determining the catalogue order for this exhibition required suggesting a chronology of Manet's printmaking activity. Early catalogues raisonné by Guérin and Moreau-Nélaton did not attempt a chronology, and only Harris has attempted to arrange Manet's print oeuvre in chronological order. This chronology was updated in the Ingelheim exhibition, but the catalogue for the Berès exhibition departed from a strict chronological order as did the Metropolitan exhibition which related prints to paintings. Rather than grouping by subject matter or medium, thus setting the lithographs apart, the prints in this catalogue are listed chronologically, reflecting both the current views of dating and an application of additional stylistic, technical, and conceptual criteria to arive at a possible order for Manet's print production. Because in many instances scholarship offers only a range of dates for a given object and because the periods of Manet's printmaking were relatively short with a profusion of images, an obvious order is not evident and had to be arbitrarily indicated with explanations in the catalogue entries for each object. A definitive chronology is further frustrated by the artist himself, for Manet was remarkably adaptable, altering his printmaking style for the requirements of the model, his painting. He also frequently returned to earlier paintings for the subjects of his prints.

Because the exhibition isolates Manet's prints from his other artistic production to understand better his approach to printmaking, the chronological order in some cases separates images traditionally linked by subject, such as *The Gypsies* (no. 1 and 15) or *At the Prado* (no. 24, 28, and 47). In two cases, states of the same image—*At the Prado* (no. 28 and 47) and *Boy with a Sword* (no. 17 and 48)—show Manet's technical progress. In both cases, the radical change in the plate from the addition of a heavy aquatint came only in later years when the artist's experiments with aquatint were guided by his technical adviser, Bracquemond. If it is known that the copper plate was reworked at a later time and if this date can be determined, that fact is also noted in addition to publication dates.

## Media

The media descriptions for each print are the result of a careful examination of each object, often with the use of high magnification, by the author with the technical advice of printmaker John Sparks of The Maryland Institute, College of Art. It is often impossible to identify securely certain processes and in some cases a question mark will follow what is meant to be a suggestion of medium. Certainly the most perplexing area of technical investigation for Manet's prints is the realm of tonal processes, usually identified in existing literature with the generic term "aquatint." Where aquatint is indicated with certainty, the term is still used. Often, however, areas of tone characterized by many tightly spaced black dots were made with a roulette or possibly with a variant etching ground, such as a salt ground, a sandpaper ground, or perhaps a soft ground; the direct application of other roughing agents to the plate, such as sulphur tints or spit bites, is also likely. Where identifying these areas securely is impossible, the term "bitten tone" is used to distinguish them from an aquatint tone. While the use of drypoint is not uncommon in Manet's prints, lightly etched lines can appear to have the rich burr of a drypoint line when they benefit from a wipe with the printer's rag drawing out the ink (retroussage). For this reason even a spent drypoint line can appear

rich with burr as if it were an early state. For an explanation of techniques used by Manet, see two widely available texts: Gabor Peterdi, *Printmaking Methods Old and New,* and Maxime Lalanne, *The Technique of Etching,* a text contemporary with Manet that is available in an English translation (see Bibliography for complete citations).

*Papers*

Paper type is indicated for all exhibited impressions. In addition to the standard English designations of "laid" paper and "wove" paper, the French terms "japon" (Japanese) and "chine" (Chinese) describe types of papers. These last two papers are not true oriental papers but instead are common paper types made in Europe to imitate oriental papers. Variations on japon are "japon imperiale," a heavier japon paper, and "japon simili," a smooth polished paper. The chine paper found on the finest impressions of Manet prints, on proofs, and for his special edition of fourteen etchings from c. 1863 is the type of paper normally adhered to wove paper in the "chine collé" process. This lightweight paper was commonly used on impressions of lithographs by Vuillard, Bonnard, and others toward the end of the century. Its thinness made it very responsive to the fine etched lines on Manet's plates. Faint laid lines can be seen on these chine papers. Lines are also visible on the japon paper, which is characterized by more apparent silky fibers. Watermarks, where decipherable, are also noted.

*States*

A change in state occurs when any modification is made to the plate by the artist or any other person. Changes can include an artistic revision, an accidental scratch, or an editor's change in a printed inscription. Here, changes are restricted to modifications by the artist. The identification of states for each exhibited impression follows the description of states in the three publications prepared by Bareau mentioned under "Dates." Unfortunately, the discovery of unknown proofs and careful new examinations by Bareau have made the previous catalogues raisonné wholly inadequate for identifying states of Manet prints. This arduous task can be effectively undertaken only with the use of all of the above publications in tandem. In a few cases, this catalogue may depart from the Bareau listing of states, and these cases are indicated with an asterisk. With the discovery and proper cataloguing of most of the major Manet print holdings in the last decade, scholars hope a new catalogue raisonné will be forthcoming that will provide a single, adequate reference for the detailed study of Manet's prints.

*Editions*

Where possible, the circumstances of the publication of a given print (when not a proof) are indicated after the state. These editions have been determined through the careful examination of paper types (see New York 1983 for a complete list of the editions of Manet's prints). Any of the prints included in the Cadart portfolios were also available as single impressions at least until the third portfolio of 1874. In a commercial catalogue from the Cadart firm from 1878, three Manet prints were listed: *The Gypsies, Boy with*

a Sword, and *Lola de Valence* (Bailly-Herzberg 1972, vol. 2, p. 144). The major editions of Manet's prints follow (see Harris 1970, pp. 17–19 for contents).

1862    First Cadart edition. Usually on laid papers standard for the Société des Aquafortistes publications in this period, with the Aquafortistes watermark or other watermarks found on Cadart publications, such as Hallines or Hudelist. It is difficult to distinguish prints in the actual edition of eight etchings from those prints bought separately from the Cadart establishment. The title for this portfolio, known in an intact copy in the Bibliothèque Nationale is "Huit gravures a l'eau-forte par Manet." It actually included nine images. These impressions are printed in a bistre ink, on paper with the Hallines watermark.

1863    A special edition of unknown purpose of the print *Boy with a Sword* (no. 17). A bon à tirer impression of the print is in the Avery collection of The New York Public Library.

c. 1863    An important edition of fourteen etchings was made by Manet for his friends and patrons (see no. 29 for a discussion of this edition). The contents of this edition, produced in a maximum of twenty-eight sets, but probably fewer and distributed over several years, apparently underwent revision from copy to copy. Impressions of exceptional quality from this set are printed on a chine paper that, judging from an intact set seen by Bareau at the dealer Paul Prouté (former Vindé collection), was mounted only at the upper corners to wove paper rather than entirely adhered in the normal chine collé process.

1874    Second Cadart edition. This edition included nine images, some different from the 1862 edition, printed on a japon paper.

1884    Memorial edition of six lithographs, printed by Lemercier on chine collé. It was previously thought that the size of this edition was one hundred prints for each image. Recent research by Bareau, however, has determined that the actual size of the edition was fifty (New York 1983, pp. 279–280).

1890    Memorial edition of twenty-three etchings arranged by Manet's widow. Printed on an imperial japon paper, no prints from this edition are included in this exhibition. Titled "Recueil de 24 planches . . .," the set included an ex libris by Bracquemond, *Manet et Manebit.* The set was printed by Gennevilliers.

1894    Dumont edition. This posthumous edition included the same twenty-three prints as the 1890 edition, plus seven more plates. As such, this set includes all thirty plates left in Manet's estate (Rouart and Wildenstein 1975, vol. 1, p. 27). The size of the edition was thirty impressions for each plate, printed in a brown ink on a blue-green laid paper with various watermarks. While of much

higher quality than the Strölin edition, overinking in the Dumont edition sometimes reduced the clarity of Manet's etched lines. A complete set of this edition is in The Metropolitan Museum of Art in New York.

1905    Strölin edition. This large edition of the same thirty prints that Dumont published numbered one hundred and was printed on a stiff laid paper often with the Van Gelder Zonen watermark. Printed in a bistre ink, Strölin impressions are also found on a stiff wove paper with a red number in the lower-right corner. Some of these impressions are printed in a reddish ink. Strölin took over Dumont's business, and canceled the plates with two small holes after his editions. Twenty-two plates are now in the Bibliothèque Nationale, two—the portrait *Charles Baudelaire* (Harris 21) and *Berthe Morisot* (no. 57)—were used for Duret's book of 1910, the other six have disappeared.

1906–    Porcabeuf edition. Three plates were published by
1910     Bracquemond's uncle, Porcabeuf: *The Toilette* (no. 20), *Boy Carrying a Tray* (Harris 28), and *At the Prado* (no. 47) are examples of this edition. The size of the edition was thirty, and the plates were printed on a heavy japon paper.

Modern  There are several modern editions of certain plates available, including an edition from the Bibliothèque Nationale of three canceled plates: *The Toilette, Lola de Valence* (no. 25) and *Line in front of the Butcher Shop* (no. 53). In addition, there are clearly modern impressions of undetermined origin on white wove paper of *Cat and Flowers* (no. 52).

## Proofs

When not noted as being from a specific edition of Manet's prints, an exhibited impression should be considered a proof, whether of an intermediate or definitive state. For the etchings, two distinct groups of proofs encompass most of the objects in the current exhibition. The first includes the plates made until about 1863, including those that were used either in the 1862 Cadart edition or in Manet's private edition of fourteen etchings, c. 1863. The proofs from these plates are too carefully printed to be actual working proofs, so they were most likely printed as special impressions that documented the stages of a plate. They were printed with great skill, probably by Bracquemond, on a chine paper with a bistre ink, the same procedure used for the exactly comparable impressions from the special edition of fourteen etchings in c. 1863.

The second group generally includes those plates that were never published by Manet during his lifetime. All these plates were among the thirty recorded in Manet's estate upon his death (Rouart and Wildenstein 1975, vol. 1, p. 27) that were eventually used for the various posthumous editions. But a significant number of proofs from these plates are better printed, usually on a tinted laid paper, and probably date from Manet's lifetime or in the period before the Dumont edition in 1894. Many can be

traced to Guerard, after Bracquemond, Manet's closest technical adviser, who supervised the posthumous edition of Manet's etchings for his widow and had access to the plates during Manet's lifetime. Guerard, who is known to have helped Manet in the biting of several plates after 1866, retained the plate for *Dead Christ with Angels*, now at The Art Institute of Chicago. Guerard was himself a master printmaker and a careful printer, which explains the quality of these exceptional proofs, far better than those from the posthumous editions. In addition to the proofs from Guerard's collection catalogued in 1978 by Galerie Berès, other proofs can be found in both the Lucas and Avery collections, which were formed with Guerard's assistance. Several proofs are on a paper with the M.B.M. watermark, recently identified by Roy Perkinson in Boston as from the firm Morel, Bercioux, and Masure after 1879. Some of these proofs are on earlier paper, such as that used by the Société des Aquafortistes, but Guerard probably would have had access to such paper for his own prints. Several proofs like the Guerard proofs are inscribed by Lucas as modern proofs from Dumont, so it is possible that Dumont, also a print dealer, sold single impressions from these plates apart from his edition that could have been printed by Guerard.

## Measurements

Measurements are given in millimeters and then inches, height before width. Where possible, measurements for sheet, plate (stone), and image size are given. Slight discrepancies between measurements in this catalogue and those previously published can be attributed to contraction and expansion of the paper caused by atmospheric conditions. Where relevant, the size of the chine paper is given if adhered to a support sheet.

## Inscriptions

Cited as they appear on the works, inscriptions include those in the plate or stone, those handwritten on the paper, and those in type. Where identifiable, collectors' marks are indicated. Marks from the current owners or inventory designations and accessions numbers, however, are not cited. When identified as to authorship or of special interest in content, hand inscriptions by individuals other than Manet are cited. For inscription location, u.l. is upper left, l.l. is lower left, c. is center, l.r. is lower right, and u.r. is upper right.

## Signatures

Manet signed his prints in three different ways during his career. A few prints in the 1860–1861 period are signed "éd. M.," such as *Boy and Dog* (no. 5), the illustrated cover (no. 21), and the first version of the portrait of Manet's father (Harris 6). This early signature was replaced by "éd. Manet" until about 1864, after which the signature "Manet" is used. One variation that appears on several prints is "M" on *Silentium* (no. 23), *The Toilette* (no. 20), and *At the Prado* (first version, no. 24), all in the 1862–1863 period.

## Abbreviations

Until a new catalogue raisonné is prepared that can function as a single reference for the study of Manet prints, six major references must be used. Therefore, the catalogue

numbers of individual prints in these references are cited. The abbreviations for these references follow (see Bibliography for complete citations):

N.Y.    New York 1983, The Metropolitan Museum of Art exhibition catalogue
B.      Wilson 1978, Galerie Huguette Berès exhibition catalogue
I.      Wilson 1977, Ingelheim am Rhein exhibition catalogue
R.W.    Rouart and Wildenstein 1975, catalogue raisonné
H.      Harris 1970, catalogue raisonné
G.      Guérin 1944, catalogue raisonné
M.N.    Moreau-Nélaton 1906, catalogue raisonné

*Catalogue of the Exhibition*

1

*The Little Gypsies*   (1861)
Les petits gitanos

Etching, drypoint, in bistre ink
On stiff laid paper, double floral watermark
Only state
Sheet: 240 x 154 mm (9⁷⁄₁₆ x 6¹⁄₁₆ in)
Plate: 195 x 138 mm (7¹¹⁄₁₆ x 5⁷⁄₁₆ in)
Inscriptions: Signed in pen, l.r. margin, "Les petits Gitanos"
I. 16, H. 17, G. 20, M.N. 61

*Davison Art Center, Wesleyan University, Middletown, Connecticut*
*1949.D1–1(11)*

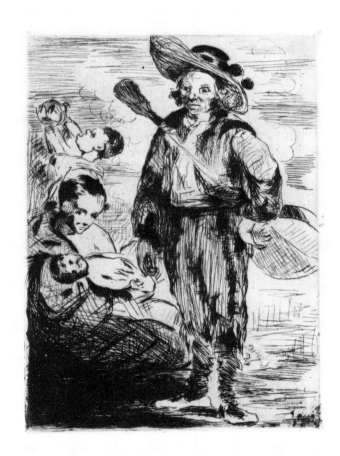

1 *The Little Gypsies*

Manet's first etching cannot be documented. A number of possibilities have been suggested, however, including *Silentium,* (no. 23), because it is based on a Fra Angelico fresco that Manet copied in 1857 during a stay in Italy, or *The Travelers* (no. 7), because of both its apparent lack of sophistication and its relation to early landscape paintings of the 1859–1860 period. But it was not uncommon for Manet to look to his earlier works for the new subjects of his prints, and these two prints are comparatively refined in technique as opposed to images such as *The Little Gypsies,* which in this exhibition must stand near the beginning of Manet's printmaking career. This rare print is usually placed later in Manet's oeuvre because of its compositional relationship to the etching *The Gypsies* (no. 15 and 16), which is dated 1862 through its relationship to a destroyed canvas. But these variants of the same composition should be chronologically separate because a comparison of the two images provides an instructive illustration of Manet's development as a printmaker. *The Little Gypsies* is not only an important step in Manet's formulation of the composition, it is also an indication of his initial involvement with printmaking before he understood the graphic potentials of the medium.

In addition to the exhibited impression, only two others have been located: one in the Avery collection of The New York Public Library and the other in the Bibliothèque Nationale in Paris. The Wesleyan impression also once belonged to Avery. The print represents Manet's earlier idea for his painting *The Gypsies,* which served as the model for the later etching and was then cut into pieces after exhibition at the Avenue de l'Alma in 1867. The painting is known in three fragments (R.W. vol. 1, 42, 43, and 44), one of which, *The Boy Drinking Water,* is now in The Art Institute of Chicago. Sometime between

1870 and 1874 Manet made an etching after this fragment (H. 43). There is no known painting or drawing that served as a model for *The Little Gypsies,* although it would be highly unusual for Manet not to have based his etching on another work.

This etching was drawn with a tentative hand, and much of the awkwardness, especially in the figure of the boy drinking water, can best be explained by the fact that Manet was trying to work in reverse from a model so

that the print would have the same orientation as the original design. Almost all Manet's later etchings are the reverse of the original. In this print, Manet has not yet evolved the graphic language that allowed him confidently to delineate forms or integrate compositional elements into a unified image. Figures, costumes, and background detail are only roughed in, without regard to differentiation of their material qualities. While it is true that Manet exhibited great variety in his approach to drawing on the plate depending on the character of the original (see no. 27), his technique here reveals no sense of confident purpose.

The Bibliothèque Nationale impression of *The Little Gypsies* was squared by the artist for transfer, suggesting that this print may have played an important role, like that of a preparatory drawing, as an intermediary between the two painted compositions, one lost and the other in fragments (see Hanson 1970). In the final composition, documented by the later etching, the central figure of the gypsy looks like a heroic figure modeled in the studio rather than the stocky, bedraggled figure in *The Little Gypsies*, which was probably studied from life. This is precisely the appeal of this work, for the scribbled and quickly drawn lines of the drypoint and etching needle give it the spontaneity of a sketch, less studied and purposeful than the later etching. For critics like Baudelaire and Burty this quality in etching was the attraction, and the danger, of the medium. This small work, richly printed in a bistre ink, is a testament to Manet's creative process and an indication of his early interest in the medium. It is one of several prints in Manet's oeuvre that gives us a more intimate view of his artistic thought.

## 2

*M. Manet*  1861
M. Manet père

Etching
On laid paper, fleur de lis watermark (Hallines)
First state of two
Sheet: 268 x 204 mm (10½ x 8 1/16 in)
Plate: 187 x 156 mm (7⅜ x 6⅛ in)
Inscriptions: Signed in plate, u.l., "éd. Manet 61"
B. 25, I. 6, H. 7, G. 10, M.N. 51

*The Detroit Institute of Arts, Founders Society Purchase General Endowment Fund 70.575*

This rare etching is Manet's second version of a portrait of his father. Both prints are modeled after the figure of his father from the double portrait of his parents dated 1860 (R.W. vol. 1, 30). The second plate is clearly based on the first in reversed orientation and therefore the same direction as the oil. A drawing of approximately the same dimensions (R.W. vol. 2, 345) was the intermediary between the painting and the first version and also served as an added reference for the new plate. There is only one other known impression of the first state of this etching (Nationalmuseum, Stockholm) and only a single impression is known of the second state (The Art Institute of Chicago, former Guerard collection). With the addition of etched lines, this state comes closer to the chiaroscuro effects of the drawing. The first version, dated 1860 and signed with the early signature form "é. M.," is Manet's earliest dated print, although it is unlikely the print actually dates from 1860. The date probably corresponds to the date inscribed on the drawing and the date of the painting; the two plates were done near the same time in 1861. The first version is known in only two impressions (Nationalmuseum, Stockholm, and Bibliothèque Nationale, Paris). It was probably abandoned in favor of a new plate because of the awkward application of etching over drypoint lines. The second version is more carefully drawn, in pure etching. It is possible that Manet was also dissatisfied with the features and expression of the first version, where his father appears gaunt, without the gentle countenance and the fuller face seen in the drawing, which the exhibited second version sensitively captured.

Manet's father was sixty-three when these works were made. He died in 1862. Auguste Manet was a high official in the Ministry of Justice and subsequently a judge and court counselor. In spite of his dignified position in society, critics commented after seeing the double portrait in the Salon of 1861 that Manet had painted individuals who were too common and unassuming. The variation in mood between the painting, drawing, and etchings is much more than the change in effect from the transcription from one medium to another. Manet's father is stern and distant as his narrow eyes are focused downward in the double portrait. But in the drawing they are open wide, fixed in concentration, his brow is not so furrowed, and the expression is more sad than stern. The changes of the drawing are best carried through in the first state of the second version, which is broadly drawn in pure

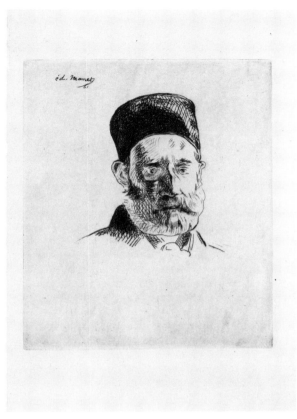

2 *M. Manet*

etching. In the second state Manet tried to match the shading of this chiaroscuro drawing with additional etching but was unsuccessful, obscuring the clarity of his initial drawing with the needle. In the first state, Manet followed the directional lighting of the drawing and painting, modeling the face with parallel and crosshatched lines. In this small portrait, Manet began to develop a more controlled approach to drawing on the copper plate, but he still retained the freely drawn attitude of an intimate sketch.

The broadly painted double portrait reflects the influence of portraits by Hals, but Rembrandt's works are also important models, especially for the chiaroscuro effects explored in the drawing and prints. Reff and Harris both point out the similarity between the portrait of Manet's father and certain Rembrandt etchings, especially *Bearded Man in a Furred Oriental Cap* (Hind 53), thought at one time to be a portrait of Rembrandt's father (Reff 1969, p. 42; Harris 1970). Rembrandt's example as a painter-etcher was paramount for most artists taking up etching at this time, although Manet's comprehension of his art was more profound than most.

## 3
*The Little Girl*   (1861–1862)
La petite fille

Etching, drypoint
On laid paper, indecipherable watermark
First state of two
Sheet: 236 x 141 mm (9⁵⁄₁₆ x 5⁹⁄₁₆ in)
Plate: 207 x 118 mm (8⅛ x 4⅝ in)
Inscriptions: Signed in plate, u.l. corner, "éd. Manet"; collector's stamp, l.l. margin, Lugt. 1872b supplement (Guerin)
B. 36, I. 14, H. 19, G. 25, M.N. 12

*The St. Louis Art Museum, Purchase Funds Given by Mrs. Mason Scudder 179.1980*

In 1862 Manet finished the large canvas of *The Old Musician* (R.W. vol. 1, 52) now in the National Gallery of Art in Washington, D.C. Reff convincingly demonstrates that Manet intended to make an etching after this painting, and for this purpose he prepared a drawing from which to transcribe his etching (R.W. vol. 2, 308; Reff 1982, p. 190). That etching was never executed, but Manet did make an etching of a single figure from the composition *The Little Girl*, exhibited here in a rare impression of the first state, formerly in the collection of Marcel Guérin. While for his etched portrait Manet had isolated the bust of his father from the double portrait of his parents, this etching represents the only example of such a practice using a large composition as a model. None of Manet's earliest prints reveal his eventual ability to reproduce effectively all the varied elements of an entire composition in an integrated whole—in short, they are not the reproductive prints Manet sought to produce of his paintings. The difficulty of making a print after *The Old Musician* was apparently daunting, although Manet would shortly complete two generally successful works, *The Little Cavaliers* (no. 6) and *The Travelers* (no. 7), both complex compositions.

In his etching *The Little Girl*, which is the mirror image of the painting, Manet isolated the figure on the sheet like the most suggestive of drawn sketches. There are certain awkward passages, the baby's head, for example, where Manet had difficulty suggesting the spatial relationship between the girl's profile and the slightly turned head of the baby. The artist instead scribbled over the indecisive area. Manet eliminated the girl's bare feet and tattered dress, the signs of her poverty, by cropping the composition above her legs. The figure thus floats on the sheet, and the revision also eliminated the details that related the figure to the context and meaning of the painting. Whistler has been suggested as a model for this cropping because in a print from his much admired French Set, the portrait of Annie Haden, c. 1857, he erased the figure's legs so she hovers on the sheet (Kennedy 10). The cropping, together with the transparent effect of the widely spaced, long, parallel lines, which are especially emphasized in the first state, also relate to Whistler's airy, graceful drypoints, such as *La Fumette* of 1859 (Kennedy 57). This figure is also alone on the page (Reff 1982, p. 186; Getscher 1977, pp. 120–122). In *The Little Girl* this isolation is qualified somewhat by indica-

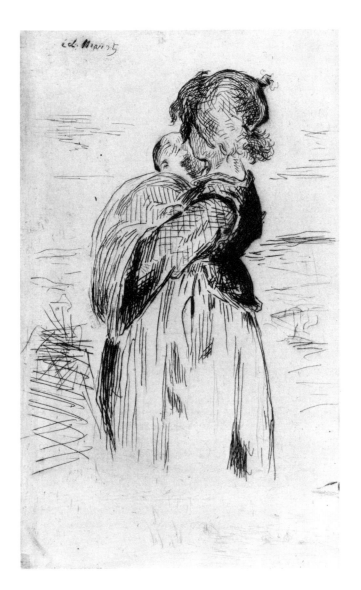

tions of a receding landscape to either side drawn in fine etched lines, which almost disappear in the final state. The fine burr that is barely visible in the first state also wears down in later impressions, although it, too, is obscured by additional etching. In the second state, Manet sought to solidify the figure by reinforcing contoured outlines. He added more shading to the girl's head and to her costume. He extended to the left and darkened both the front of her dress and the baby's blanket and gave the girl's waistcoat more body and shape to the right, carefully following the model in the painted composition. These changes were probably made to darken the figure, so that it would better balance its pendant, *The Urchin* (no. 4).

*The Urchin* and *The Little Girl* were drawn on a single copper plate, a fact recently determined by a close examination with measurements of the two copper plates, both in the Bibliothèque Nationale. In the first state of *The Little Girl*, a mark at the lower right edge corresponds to the location of the dog's head in the other print. For Cadart's 1862 edition of Manet's prints, the two images, taken from separated plates, were printed on the same sheet and counted as one plate, plate 8. They were subsequently published separately in later editions of the prints. Both prints depict popular types and were pendants, similarly conceived as isolated figures—vignettes—rather than as reproductions of painted compositions, like Manet's later prints.

**4**
*The Urchin (Boy with Dog)*   (1861–1862)
Le gamin

Etching, roulette, bitten tone
On japon paper
Second state of two, from the 1874 Cadart edition
Sheet: 454 x 402 mm (17⅞ x 15¹³⁄₁₆ in)
Plate: 207 x 148 mm (8⅛ x 5¾ in)
Inscriptions: Signed in plate, u.l. corner, "éd. Manet"
N.Y. 7, B. 38, I. 15, H. 31, G. 27, M.N. 11

*The Detroit Institute of Arts, Founders Society Purchase*
*General Endowment Fund 70.584*

Like *The Little Girl* (no. 3), its thematic pendant, *The Urchin*, represented a character type, a familiar pictorial convention of the time. Rather than being based on a detail from a larger composition, *The Urchin* reproduces an entire painting (R.W. vol. 1, 47), dated 1860–1861. This oil was also the model for a lithograph of 1872 (no. 62). The figure of the urchin boy would easily have been recognized for its reference to Spanish painting, particularly Murillo for the figure and thematic character, and Velázquez for the expressively realized face. Reff points out that Manet probably found his models in reproductive prints of specific works by these artists, such

4 *The Urchin (Boy with Dog)*

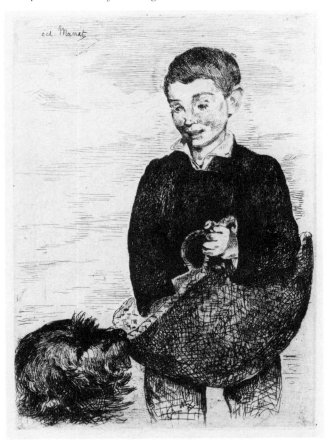

as those in Charles Blanc's *Histoire de Peintres* published in 1859 (Reff 1970, pp. 456–458). The painting and print alike illustrate Manet's penchant for literal borrowing from the art of the past, presented anew in a contemporary context, as a poor street urchin from the slums of Paris.

Manet most likely worked on these two prints in response to a request from Cadart, organizer of the Société des Aquafortistes, to produce a group of etchings for a portfolio. The practice of publishing groups of prints by a single artist was already well established, with graphics available by Daubigny, Huet, and Meryon, among others. In 1862 Cadart announced portfolios by Bonvin, Jongkind, Legros, and Millet. The early Manet prints, which come before these two plates, were each known in only a few proofs and were made without a specific project or assured audience in mind, but at this point Manet was choosing subjects for prints knowing he could broaden the recognition of his work. The model for two important prints, the painting *The Urchin* was a significant achievement for the artist. The etching appeared with *The Little Girl* in the 1862 edition and separately in the 1863 and 1874 editions of Manet's prints.

While the figure of the boy is more solidly modeled and the dog introduces a narrative element (the boy's expression does not fix on the dog), the print is similar to *The Little Girl* in the visual isolation of the figure. Again, the legs do not extend to the edge of the plate. But Manet had become more confident, as evidenced by his realization that certain types of lines have specific descriptive functions. The heavy coat contrasts with the more calligraphic rendering of the dog's fur. The influence of Whistler is less striking here since Manet's own style is more apparent. There are several differences between the original painting and the print that have suggested to some that Manet's transcription of the painting was more interpretive. The lithograph of 1872 is much closer in detail, especially regarding the boy's legs, which are very widely spaced in the etching and almost touch in the lithograph and painting as it appears today. In the etching Manet extended the composition farther at the bottom. Bareau presented new information redefining this situation in a lecture at the Manet symposium at The Metopolitan Museum of Art in New York in October 1983. X-ray study of the painting reveals that Manet had reworked certain details, including the boy's legs and the basket, and that the etching corresponds, without major variation, to the original appearance of the painting, excepting the cropped legs. This new technical analysis of Manet's paintings and the subsequent examination of his working methods provide important facts about his printmaking. His prints are faithful to the basic details of the original paintings, and because Manet reworked so many of his pictures at a later time, the prints are both elements of his creative process and important documents of compositions in progress.

5
*Boy and Dog* (1862)
L'enfant et le chien

Etching, aquatint
On thin laid paper
Third state of three, from the 1862 Cadart edition
Sheet: 241 x 155 mm (9½ x 6⅛ in)
Plate: 200 x 142 mm (7⅞ x 5⁹⁄₁₆ in)
Inscriptions: Signed in plate, l.l. corner, "éd. M."
N.Y. 9, B. 30, I. 25, H.11, G.17, M.N. 10

*Davison Art Center, Wesleyan University, Middletown, Connecticut*
*1949.D1-1(7)*

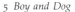

*5 Boy and Dog*

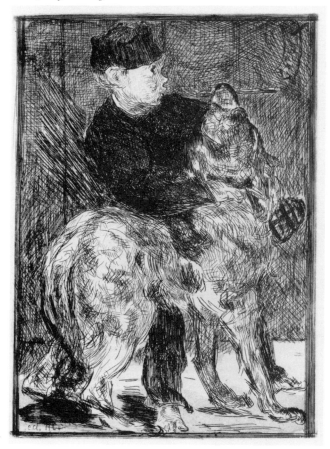

M anet made a second etching of a boy and dog, at about the same time, which was also intended for the forthcoming edition of his prints by Cadart. Not what was considered a popular type, this subject is much more personal and realistic, for here Manet shows his model and studio assistant, Alexandre, playfully holding a dog almost as large as he is. Alexandre worked for Manet from 1858 to 1859, and in 1859 the boy hung himself in Manet's studio. This event deeply disturbed Manet, and the print, done a few years later, is clearly an affectionate evocation. It is unusual in Manet's oeuvre, because no painted model has been found for this etching, although it might have been based on a very free pen-and-ink sketch, probably made from life but in reverse of the etching (R.W. vol. 2, 455). The print is signed "ed. M.," a form that appears on several of Manet's early prints from this time, including the illustrated cover (no. 21).

In its first state, before the addition of etched lines that refine and focus the image, *Boy and Dog* gives further evidence of Manet's technical inexperience with the medium. He has not developed a consistent graphic language where the type of etched line—whether hatching, parallel lines, or dashes—is purposely varied in response to variations in form. Manet's standards for reproducing his paintings were very high, and with each successive print he came closer to the consistency and control necessary for the task. In many of the later etchings he traced from drawings of the same size using a stylus, but clearly here Manet worked directly on the plate without benefit of a scaled model. Manet's experimentation enhanced the spontaneity of this etching; the etched lines of the second state are almost totally obscured by the background wash of aquatint because the aquatint ground was unevenly applied with a coarse grain, which formed splotchy areas. The exhibited impression of the third state, distinguished from the second by the border line, shows the fabric of crosshatched lines added to compensate for the unsuccessful aquatint. Manet very likely added this work at a slightly later time as it reveals more consistency in approach. He soon attempted aquatint again, this time more successfully, in his unique print *The Travelers* (no. 7).

While the additional work of the later states helped strengthen the impact and clarity of *Boy and Dog*, it largely diminished the fresh sketchlike intimacy that Manet retained from the drawing to the print in the first state. As such, the plate has more in common with the early Manet prints conceived before the Cadart project, which are more personal and intimate glimpses of the artist's concerns. This plate appeared in the 1862 edition as plate 7 and again in Manet's special edition for his friends, c. 1863, but it was omitted from Cadart's 1874 edition and was not published again in Manet's lifetime.

6
*The Little Cavaliers*   (1861–1862)
Les petits cavaliers

Etching, drypoint, roulette, bitten tone
On heavy laid paper
Fourth state of six* (fourth state dates from 1867?)
Sheet (irregular): 248 x 385 mm (9¾ x 15¹⁄₁₆ in)
Plate: sheet trimmed within plate mark
Image: 240 x 376 mm (9⁷⁄₁₆ x 14¹³⁄₁₆ in)
Inscriptions: In plate, l.l. margin, ''Cadart et Chevalier Editeurs
   R. Richelieu 66''; c., ''Imp. Delâtre Paris''; r., ''éd. Manet
   d'après Velasquez''; (lower edge inscriptions partially effaced)
N.Y. 37, B. 23, I. 10, H. 5, G. 8, M.N. 5

*Samuel P. Avery Collection, The New York Public Library
   Astor, Lenox and Tilden Foundations MN5*

When Manet chose not to make a print after his
painting *The Old Musician*, choosing instead to
concentrate on a single figure, *The Little Girl* (no. 3), he
postponed the challenge of etching a large, multifigured
composition. But the then-famous painting in the Louvre,
*The Little Cavaliers*, thought at that time to be a Veláz-
quez, offered an even more complicated figure arrange-
ment. Anxious to explore the stimulating problems of-
fered by the composition, especially important in view of
his 1862 painting *Music in the Tuileries* (R.W. vol. 1, 51),
Manet made a painted copy of the Louvre work (R.W.
vol. 1, 21) that, to carry the challenge to his printmaking,
then became the model for his etching. He was especially
diligent in this effort as he made the etching in the same
orientation as the painted copy and, in the course of six
states, gradually refined details and shading to achieve
his most carefully controlled print to date. *The Little Cava-
liers* is one of the few prints on which Manet commented;

he was tremendously pleased with it and many years
later considered it to be his finest print. His comments
are borne out by the image's exhibition and publication
history. It was included in all three lifetime editions of
Manet's prints and was exhibited in the print section of
the Salon des Refusés in 1863, in Manet's one-man exhi-
bition at the Avenue de l'Alma in 1867 together with the
painting, and finally in the Salon of 1869.

During 1861 and most of 1862 Manet was such a pro-
ductive printmaker, developing his conception of print-
making and etching technique successively with each
new work, that it is difficult to place a formative yet
accomplished etching like *The Little Cavaliers*. While the
first state could date from 1861, the revisions made to the
plate in the fifth state date from at least 1867 when Manet
wrote about some damage that had occurred to the plate.
The earlier states, which reveal a tentative beginning and
a gradual refinement, could well be reflective of work on
the plate during several months into 1862. The first state,
with an etching style characterized by more widely
spaced parallel lines, relates closely to the portrait of
Ambroise Adam (no. 8) or *The Absinthe Drinker* (no. 9),
but later states show as much consistency as the carefully
conceived *Candle Seller* (no. 10). Manet's early prints ex-
hibit a wide variety of etching lines, but in this print
Harris perceptively observes that ''energetic strokes are
carefully subordinated to areas'' (Harris 1970, p. 33).
Light creates the shading that delineates forms, eliminat-
ing the vagueness and indecision that would make this
effort a failure. The progression of Manet's printmaking
in this period can be summarized in the evolution of this
plate, a testament to the energy he put forth in this
creative pursuit.

At some time after the first two editions of Manet's
prints, the plate for *The Little Cavaliers* was damaged. A

6 *The Little Cavaliers*

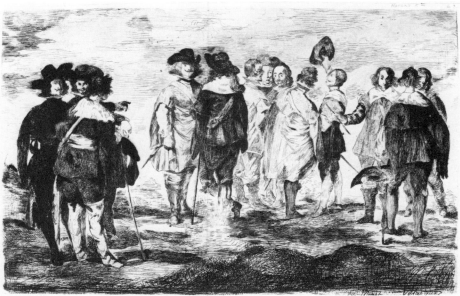

37

letter from Manet dated 1867 states that the plate had been damaged and could not be used for an edition for *L'Artiste*. *The Spanish Singer* (no. 11 and 12) was used instead. In order to repair the plate Manet reworked it with some burnishing and drypoint. The exhibited print is the single known impression of the fifth state, immediately following this reworking. In the fourth state, below the image Manet added an extensive inscription to the plate giving credit to his publishers, Cadart and Chevalier, to his printer, Delâtre, and to both artists, Manet and his model, Velázquez. The addition of these inscriptions indicates the important role of this print as a published image distributed as a single work not part of a portfolio edition. Manet's audience was clearly in his mind. In a Christie's, London, sale of December 1984, an impression of the print was offered that appears to be a new second state, before Bareau's second state, increasing the total to six states. (See advertisement, *Print Collector's Quarterly*, December 1984, p. 245; the print is now in the Johnson collection, Chicago.)

7
*The Travelers*   (c. 1860)
Les voyageurs

Etching, drypoint, aquatint
On chine paper
Only state
Sheet: 266 x 340 mm (10⁷⁄₁₆ x 13⅜ in)
Plate: 236 x 318 mm (9⁵⁄₁₆ x 12½ in)
Image: 226 x 302 mm (8⅞ x 11⅞ in)
Inscriptions: In pencil, lower margin, "Les Bohemiens en voyage. Eau forte de Manet, non catalogué dans Beraldi. H. Guerard trés rare."
I. 4, H. 4, G. 1, M.N. 70

This is the only known impression of this image, which together with *The Little Cavaliers* (no. 6) indicates a more ambitious involvement with printmaking. In both cases Manet sought to reproduce a large multifigured composition. In his catalogue of Manet prints, Guérin suggested *The Travelers* should be considered Manet's earliest print, and it has usually been dated 1860, primarily because of its relationships to landscape paintings and drawings of this date and earlier. The closest painting to this print is *La pêche* (R.W. vol. 1, 36) now in The Metropolitan Museum of Art in New York, a painting that recent research has shown might have been completed as late as 1863 but not earlier than 1861 (N.Y. 12). The Ingelheim catalogue finds similarities in the foliage treatment between the print and the 1862 painting *Music in the Tuileries*. But, the most compelling evidence for placing this print later in Manet's oeuvre, to 1861 at

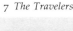
7 *The Travelers*

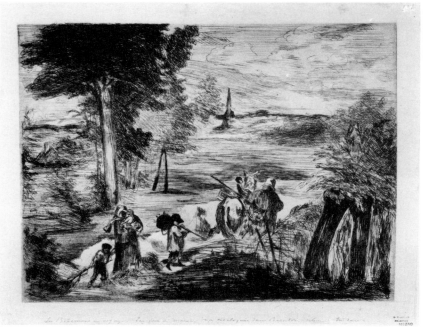

least, after he had made several etchings, is its technical accomplishment. Not only has Manet used aquatint more effectively in localized areas, but he also varied for a consistent purpose the types of lines he used.

Like the painting *La pêche*, the print shows an open landscape, a meandering stream or pond receding in the distance to the right, and, most important, the same distant spire that appears in several of these landscape studies. Manet's source was twofold: nature and the landscapes of Rubens and Annibale Carracci, known through reproductive engravings such as those by Bolswert after Rubens. Manet may also have studied other 17th century landscape prints such as those of Ruisdael or Rembrandt, but he was also probably familiar with the works of certain contemporaries, which were also inspired by the Dutch. Harris has suggested an 1844 etching by Daubigny, *Les petites cavaliers* (Delteil 49), as a potential source and also mentions Whistler and Haden prints of this period. The Haden suggestion is especially appealing, for like Whistler, Manet's fellow etchers were greatly impressed with Haden's etchings. One print that is very close to *The Travelers* is *Thames Fisherman* (Schneiderman 18), which was included in the Salon of 1859. Haden's reliance on drypoint may have encouraged Manet's more extensive use of the tool in this image, for drypoint is here integrated with etching rather than used alone as an easy way to sketch in a design for later reworking with the etching needle.

Far from a beginner's effort, *The Travelers* illustrates an ambitious attempt at a difficult and new assignment, and this print together with the late *Marine* (no. 35) are the only landscapes in Manet's oeuvre. Reflecting the same technical growth as *The Little Cavaliers*, Manet has begun to create a systematic graphic language. A more calligraphic line describes the foliage; strong vertical parallel lines accent figures and trees. Freer horizontal strokes suggest open areas; the aquatint, with a more regular ground and selectively applied like a wash, shades certain areas. This print clearly has an experimental character, like the first state of *Boy and Dog* (no. 5) although better controlled. It is almost as large as *The Little Cavaliers*, Manet's largest etching. But he abandoned the plate, with only one proof remaining as evidence of his creative growth.

## 8

### *Man with Dog on His Knees (Ambroise Adam)*   (c. 1861)
Homme au chapeau de paille, un chien sur les genoux

Etching
On chine paper
Only state
Sheet: 206 x 161 mm (8⅛ x 6⅜ in)
Plate: 138 x 104 mm (5⁷⁄₁₆ x 4⅛ in)
Inscriptions: In pencil, lower margin, "Pièce non Cataloguée par Béraldi, et supposée Manet père, très rare: Guerard"
I. 11, H. 10, G. 3, M.N. 68

*Samuel P. Avery Collection, The New York Public Library Astor, Lenox and Tilden Foundations MN68*

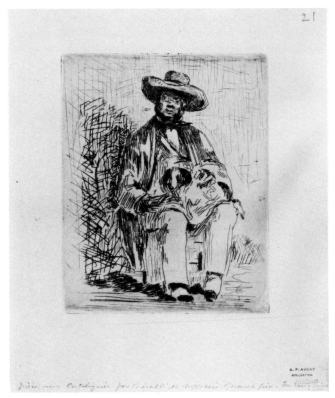

8 *Man with Dog on His Knees (Ambroise Adam)*

This portrait of Ambroise Adam is another personal exploration of printmaking without view toward publication and, like *The Travelers* (no. 7), known in only one impression. In a recent article, Bareau published for the first time a lost painting that served as the model for the print and thus definitively identified the subject of this etching, who was not previously known, as Manet's friend Adam (Bareau 1984, pp. 750–758). The painting, dated 1861, is signed "ed. M." in the manner of several of Manet's early prints from this period. Previously, the print had been titled only descriptively, and in an inscription written on this print Guerard suggested that it might be a portrait of Manet's father.

The etching copies the painting in reverse but eliminates the dense foliage that served as a garden backdrop for the oil portrait. Instead of using crosshatching, Manet used broadly spaced parallel lines similar to those of the figures in *The Travelers* and closely resembling the drawing style of *The Absinthe Drinker* (no. 9), especially the first state (see illustration, H. 16). This open approach, like that of *The Little Girl*, creates a sketchlike, almost transparent effect. The expansive brushwork dictated a less detailed and less linear conception for the print—one that would be in harmony with the broadly painted surfaces. The left background, where a chair was unsuccessfully drawn, is roughly scribbled over with heavy etched lines to suggest a shadow. The painting and etching alike are more personal works, of small scale, intended for the artist and his sitter. Like several early prints and the later print *The Rabbit* (no. 36), this is an experimental work. Certain passages are vague and unresolved. The dog in the figure's lap is difficult to distinguish, and Adam's features are poorly realized. Manet was probably not satisfied with the transcription of the oil, although its spontaneous quality makes it a very appealing image.

9

*The Absinthe Drinker*   (1861–1862)
*Le buveur d'absinthe*

Etching
On thin laid paper
Third state of five (second state dates 1867–1868 or 1874)
Sheet: 253 x 145 mm (9⅝ x 5¹¹⁄₁₆ in)
Plate: sheet trimmed within plate mark
Image: 246 x 145 mm (9⅝ x 5¹¹⁄₁₆ in)
Inscriptions: Signed in plate, u.r. corner, "éd. Manet"
B. 24, I. 12, H. 16, G. 9, M.N. 8

*Davison Art Center, Wesleyan University, Middletown, Connecticut 1949.D1-1(1)*

The painting *The Absinthe Drinker* (R.W. vol. 1, 19) was Manet's first major independent work, and when it was rejected at the Salon of 1859, Manet was certain his former master, Couture, had urged the refusal. Throughout Manet's career he looked back to earlier works for the subjects of new compositions, and in 1861–1862 the figure of the absinthe drinker was especially important to him. He used it in his large painting *The Old Musician* and about the same time made an etching of his original painting, in reverse. It was included in the second state as plate 5 in the 1862 Cadart edition, reissued for Manet's private c. 1863 edition, but not published again in his lifetime. Two small accidental scratches near the bottle are all that distinguish the exhibited impression from the second state included in the 1862 portfolio. Manet's probable intermediary between the painting and the print was a watercolor of about the same size as the print (R.W. vol. 2, 452). The etching shares with the Adam portrait drawing a technical approach, characterized by vertical parallel lines, especially apparent in the first state before further etched lines were added to the coat to darken it. But *The Absinthe Drinker* is more fully realized without the vague and unresolved passages of the other etching.

Manet's probable inspiration for this Parisian type was a Baudelaire poem, "Le vin des chiffoniers" from *Les fleurs du mal*. In her 1978 catalogue Bareau remarks on the striking resemblance between portraits of Baudelaire and the features of *The Absinthe Drinker*. This correspondence seems much clearer in the etching than in the original painting. Drawing on the plate with parallel vertical lines, Manet effectively varied the space and length of the lines to model form with shading. He studied the cloak carefully to reveal its folds and the substance underneath. It is the central focus of the composition and was the major area of reworking between the first and second states. On the right, Manet created a shadow with vertical and slashing horizontal lines, while on the left he suggested with rapid strokes and scribbles the illuminated texture of the wall. His work with the needle has become purposeful and consistent, and for that reason this print is among his most successful early etchings—an effective copy of the original painting with strong graphic power.

At a later date, c. 1867, Manet went back to several of his old plates; with the probable help of Bracquemond, he applied a heavy ground of aquatint to each, totally

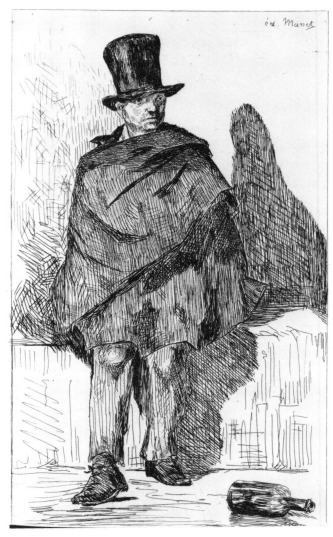

9 *The Absinthe Drinker*

transforming their effect. The three plates were *The Absinthe Drinker, Boy with a Sword* (no. 48), and *At the Prado* (no. 47). *The Absinthe Drinker* was the least successful attempt because the aquatint became so dark that most of the etched lines were hardly visible. Only the face was left with a dramatic touch of light, and the back wall was given a lighter tone using a finer grain of aquatint. The transformation was undoubtedly made with Goya's Los Caprichos prints in mind. The plates were not published in this state until 1906–1910 by Porcabeuf, a relative of Bracquemond.

## 10
### *The Candle Seller* (1861–1862)
La marchande de cièrges

Etching
On laid paper, crescent over crown watermark (Hallines)
First state of four
Sheet: 525 x 356 mm (20⅝ x 14 in)
Plate: 342 x 225 mm (13⁷⁄₁₆ x 8⅞ in)
Image: 308 x 198 mm (12⅛ x 7⅞ in)
Inscriptions: Signed in plate, l.r., ''éd Manet''
B. 31, I. 7, H. 8, G. 19, M.N. 56

*The Detroit Institute of Arts, Founders Society Purchase General Endowment Fund 70.578*

Because genre is one of the least common subjects in Manet's art, the unusually large etching *The Candle Seller* is unique in representing this aspect in the artist's printmaking oeuvre. Equally uncommon is the fact that no painting has been located that served as a model for this etching although there is a small pencil sketch of the composition, in reverse to the etching (R.W. vol. 2, 364)—a type of rapid pencil sketch customarily made from life rather than created in the studio. Manet's choice of this genre scene for a print subject was most likely influenced by Alphonse Legros, who, like Manet, was a founding member of the Société des Aquafortistes. According to Moreau-Nélaton, Legros, an experienced etcher, gave Manet his first instruction in etching. Legros was well known for his large etchings of church scenes, several of which are close compositionally to Manet's print. The large format, rectangular composition, and characteristically free drawing style of Manet's etching is not unlike Legros's distinctive manner. An etching from Whistler's popular French Set, *Le vielle aux Logues* (Kennedy 21), might also have influenced Manet, especially its contemplative mood.

Manet intended that his print *The Candle Seller* would be published, and although it was not included in the portfolio of 1862, its title appears on the listing for his own edition of fourteen etchings in c. 1863. Evidently Manet's decisions about the contents of that portfolio changed because the exhibited impression of its illustrated cover (no. 29) has the title *The Candle Seller* scratched out in pen with *At the Prado* (no. 28) substituted. Impressions from that edition are usually found on chine paper although the proofs of *The Candle Seller* are on a laid paper with the Hallines watermark. Very few proofs of the print have been located (only six of all states), which suggests that Manet did not wish to distribute the print widely, perhaps because of its uncharacteristic appearance and because it did not reproduce an important painting. Several years after the plate was begun, probably in 1866–1867, Manet added a heavy grain of aquatint to the plate just as he had with *Philip IV, Boy with a Sword*, and *The Absinthe Drinker*. This revision was similarly unsuccessful, for while it added a dramatic mood to the plate, it obscured the etched lines. An impression of this state on chine in the Bibliothèque Nationale may have been included in the portfolio of fourteen etchings that could have been distributed to Manet's associates as late as 1867.

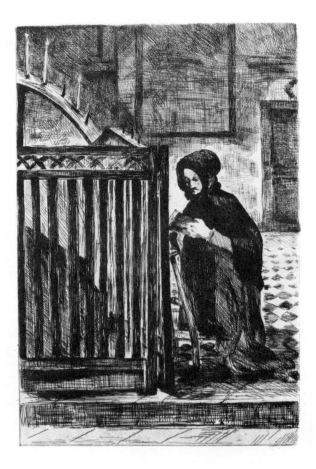

10 *The Candle Seller*

For *The Candle Seller*, Manet used a working method that became more standard in his subsequent prints intended for publication. Working from a scaled drawing, more detailed than the existing pencil sketch, he would transfer the outlines of the drawing to the copper plate by tracing the drawing with a stylus on the softened ground of a plate. Where the stylus impressed the paper, the ground would be picked up, baring it for the acid etch. Manet's use of this technique is confirmed both by an examination of his prints and by the existence of inscribed drawings. No such drawing now exists for *The Candle Seller*, although the etching shows indications that this method was used. Close examination of the etching reveals light, broken lines outlining forms. A more readable example would be the first state of *The Gypsies* (no. 15). With the composition and spatial relation of elements indicated on the plate, Manet was free to elaborate details and the nuances of shading as he carefully adjusted the relationship of tonal areas. This composition places the figure in what was for Manet an unusually deep and inhabitable space, although his treatment of the figure as a darkened silhouette in the foreground is more typical. This plate like others of this period shows real consistency in Manet's etching technique since the type of line he used on the plate was adjusted for a specific area and is related to other elements in the composition. Manet enhanced the evocative mood and tangible atmosphere of this plate in its second state by darkening structural elements of the composition, such as the frame in the background, and otherwise creating a denser atmosphere to enfold the figure, which is surrounded by a lighter area. As with *The Travelers* (no. 7), in this state Manet used a light grain of aquatint in the foreground, on the face of the step, and above to the left. He carried these same revisions further in 1866–1867 with the addition of a heavy aquatint ground that, while dramatic, obscured the clarity of the previous etched work.

**11**

*The Spanish Singer*  (1861–1862)

Le guitarrero

Etching, roulette, bitten tone
On chine paper
Third state of six
Sheet: 327 x 284 mm (12¹³⁄₁₆ x 11¹³⁄₁₆ in)
Plate: 299 x 243 mm (11¾ x 9⁹⁄₁₆ in)
Inscriptions: None
N.Y. 11, B. 29, I. 13, H. 12, G. 16, M.N. 4

*The George A. Lucas Collection of The Maryland Institute, College of Art, on indefinite loan to The Baltimore Museum of Art*
*B.M.A. L.33.53.5117*

**12**

*The Spanish Singer*  (1861–1862)

Le guitarrero

Etching, roulette, bitten tone
On laid paper, crescent over crown watermark
Fifth state of six, from the 1867 *L'Artiste* edition
Sheet: 348 x 270 mm (13¹¹⁄₁₆ x 10⅝ in)
Plate: 299 x 243 mm (11¾ x 9⁹⁄₁₆ in)
Inscriptions: Signed in plate, u.r., "éd Manet"; l.r., "Imp. Delâtre Paris"
N.Y. 11, B. 29, I. 13, H. 12, G. 16, M.N. 4

*The George A. Lucas Collection of The Maryland Institute, College of Art, on indefinite loan to The Baltimore Museum of Art*
*B.M.A. L.33.53.5114*

When it was exhibited in the Salon of 1861, Manet's painting *The Spanish Singer* (R.W. vol. 1, 32), now in The Metropolitan Museum of Art in New York, brought the artist his first major critical success. He had already begun to etch plates for the 1862 portfolio of his etchings, and the painting's acclaim would have created a demand for etched reproductions, a task Manet did not wish to leave to a professional reproductive etcher. Two impressions of different states—the third and the fifth, or last—were chosen for exhibition because they exemplify the difference in conception and result between Manet's print and that of a reproductive practitioner. Like his print *The Little Cavaliers* (no. 6), the existence of impressions from multiple states evidences the research and creativity of an original printmaker as Manet evolved a graphic equivalent for his painting. He did not try to overcome the printmaker's dilemma of a reversed image, concentrating instead on a consistent translation of the original, not a reproduction but an interpretative drawing on copper.

Manet worked from two intermediate drawings: one, a fully worked watercolor and the second, a tracing (R.W. vol. 2, 459 and 458), probably used for the direct transcription of the outlines of the composition to the copper surface, a method used for most of Manet's plates in this period (see no. 10). After establishing the basic outlines of the composition on the plate, Manet drew more freely, elaborating the effects of the painting based on both the watercolor and the original canvas. Between the two ex-

11 *The Spanish Singer*

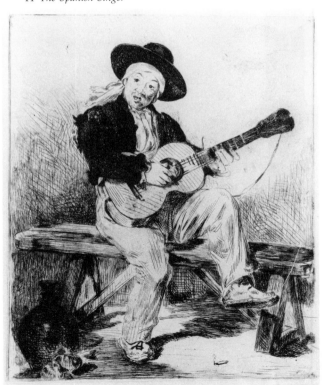

12 *The Spanish Singer*

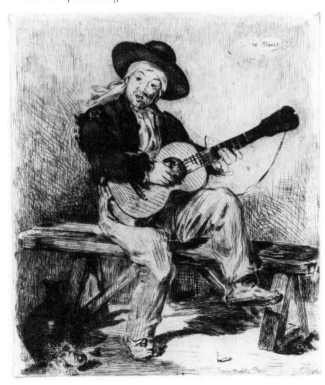

hibited states, the most noticeable difference is the darkening of the background to lessen the silhouette quality and to incorporate better the darkened shape of the figure in the shallow surrounding space. More subtle changes involve the adjustment of shading for individual areas of the composition so that all elements are fully integrated in a unified picture as carefully balanced as the original. But unlike a later reproductive etching by Courtry of the painting intended for Galerie Durand-Ruel's 1873 ''Recueil d'estampes gravees a l'eau-forte'' (see fig. 1), Manet did attempt to suppress the spontaneity of the etched line to imitate the smooth transitions of the brush. The darkened background to the left is energetically scribbled with slashing strokes similar to those of his portrait of Adam (no. 8). In the later state this area is surrounded by more regular parallel vertical lines. The handling of the jug in the left foreground, a still-life element and critical compositional accent, is another indication of the translations Manet had to make between his original and the etching. In the painting the jug's light rust color makes it a bright accent, while in the print Manet progressively darkened it so it balanced the dark cloak of the singer.

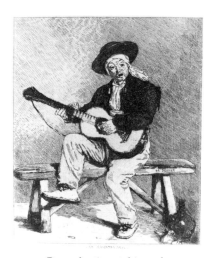

FIG. 1  Reproductive etching of Edouard Manet's *The Spanish Singer* by Charles Courtry, Archives The George A. Lucas Collection, The Maryland Institute, College of Art, on indefinite loan to The Baltimore Museum of Art

In the second state, along with the date and signature, Manet added a tone to the plate that has been clearly stopped out at the edges of the composition and is lighter in the bright area above the stem of the guitar. This is not an aquatint tone as it is made up of closely spaced black dots in a lighter field different from an aquatint's white spots in a darkened field. In the area of the cloak and above the figure's right shoulder, the tone looks like that of an irregular roulette—a similar technique was used for *The Urchin* (no. 4)—but the overall tone is more

evenly distributed, like that of a light salt or sandpaper ground. This bitten tone, for lack of a specific process, softens the stark linear impact of the etching and was subsequently exploited by the heavy inking of the Delâtre printing, exemplified by the exhibited impression of the fifth state. This impression was included in an 1867 issue of *L'Artiste* (identified by a horizontal fold), and we know from a Manet letter that it was the substitute for *The Little Cavaliers,* which could not be printed because of plate damage. The fourth and fifth states have the new Manet signature and the printing address of Delâtre. The proof of the third state is printed on a delicate chine, which is very responsive to the etched lines, picking up the ink very cleanly. For this reason, the plate was carefully inked, with skillful wiping to accent light areas and overall tone. By contrast, the print from *L'Artiste* is murky, and the crisp lines become feathery with the use of retroussage. As a question of print connoisseurship for lifetime impressions of Manet's prints, this comparison is the best possible illustration of the superiority of proofs on chine over the more standard editions where the heavy film of ink eliminates the subtleties of Manet's etching style. Most collectors have only known Manet etchings in these deadened impressions.

**13**
*Philip IV/King of Spain (after Velázquez)*   (1862)
Philippe IV/Roi d'Espagne

Etching, drypoint, in bistre ink
On chine paper
Second state of eight
Sheet: 380 x 257 mm (14¹⁵/₁₆ x 10⅛ in)
Plate: 353 x 238 mm (13⅞ x 9⅜ in)
Image: 316 x 199 mm (12½ x 7¹³/₁₆ in)
Inscriptions: None
N.Y. 36, B. 22, I. 18, H. 15, G. 7, M.N. 6

*The George A. Lucas Collection of The Maryland Institute, College of
Art, on indefinite loan to The Baltimore Museum of Art
B.M.A. L.33.53.5133*

**14**
*Philip IV/King of Spain (after Velázquez)*   (1862)
Philippe IV/Roi d'Espagne

Etching, drypoint, in bistre ink
On chine paper
Third state of eight
Sheet: 394 x 280 mm (15½ x 11 in)
Plate: 353 x 238 mm (13⅞ x 9⅜ in)
Image: 316 x 199 mm (12½ x 7¹³/₁₆ in)
Inscriptions: None
N.Y. 36, B. 22, I. 18, H. 15, G. 7, M.N. 6

*The George A. Lucas Collection of The Maryland Institute, College of
Art, on indefinite loan to The Baltimore Museum of Art
B.M.A. L.33.53.5134*

Manet's etching *Philip IV/King of Spain* acknowledges two important artistic influences in his work of this period: a continuing interest in Velázquez, especially his large scale single figure portraits, and a growing captivation with the prints of Goya. This etching is a copy in reverse of a work acquired by the Louvre in May 1862 that was then thought to be a Velázquez but was actually a copy. For the print Manet relied on an intermediate

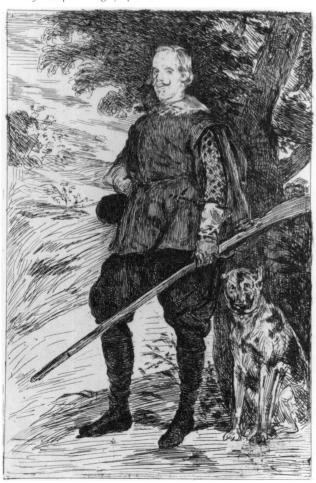

13 *Philip IV/King of Spain*

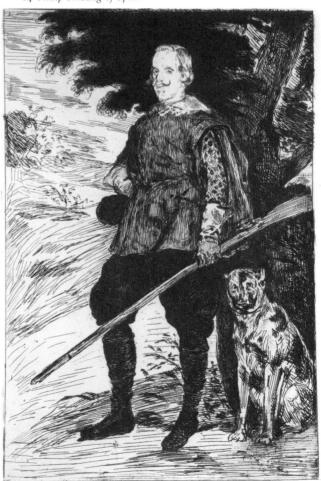

14 *Philip IV/King of Spain*

drawing (R.W. vol. 2, 68) from which he most likely traced the outlines of the composition using a stylus and softened ground. The plate was published in the 1862 Cadart edition and in his own edition of c. 1863 but was not included in the 1874 Cadart edition. The extensive inscriptions in the lower margin of the published sixth state, which give the title and credit printer, publisher, Velázquez, and artist, suggest that Manet probably intended an independent publication of this single plate in the tradition of reproductive printmaking, although the print was never published outside the two editions mentioned above. Like the prints *The Absinthe Drinker* (no. 9) and *The Candle Seller* (no. 10), the plate was given a heavy grain of aquatint in 1866–1867 perhaps in anticipation of a new edition of the prints that was never realized.

Unlike his print *The Little Cavaliers* (no. 6), Manet did not first make a painted copy of the canvas. His goal was to make a reproductive etching, but not only was it in reverse it was also much too interpretive to fall comfortably in the realm of traditional reproductive prints. An excellent example of that approach is Haussoullier's copy of the same painting published in the *Gazette des Beaux-Arts* in 1863 (see N. Y. 36, fig. a), which attempts to deny the free, linear character of the medium in favor of a more tonal, finely worked reproduction of the painting. While the study of such paintings incorrectly attributed to Velázquez influenced Manet's paintings of this period, another Spaniard's work, that of Goya, is even more relevant to the study of Manet's printmaking. Like his print *The Espada* (no. 19), *Philip IV* was one of the last prints Manet prepared for the edition of 1862, published in the early fall. For the painting *The Espada* Manet borrowed motifs from Goya prints, and both prints also show the technical and stylistic influence of Goya. There are striking compositional similarities between Goya's portrait print after Velázquez's *Infante Don Fernando* (T. Harris 11), especially in the last state of this print when Goya applied an aquatint grain, as Manet would eventually do for his print. Other stylistic characteristics that Manet seemed to acquire from a study of Goya's prints at the Bibliothèque Imperiale, where his visits had been recorded, include the use of broken contours in his rendering of the figure. Here, there is less outlining than for *The Gypsies* (no. 15 and 16) and instead, for example, the legs are drawn with a directional line defining volume in a manner very similar to Goya.

The proof impressions of the second state (the only recorded impression of which is illustrated in Guérin) and the third state are exhibited here together to convey the creative process revealed in the revisions Manet made to this plate. Unlike *The Spanish Singer* (no. 11 and 12) or the earlier *The Little Cavaliers* (no. 6), Manet did not require extensive state changes to achieve his goals in this plate. Between the first and second states he added some shading to darken the figure—a very common working method in all his prints that indicates his compositional approach to the figure in his paintings. The figure is brought closer to the picture plane, enhancing its two-dimensional quality. The artist also attempted to rectify the poorly drawn left paw of the dog, a process that continued to the fourth state. In the third exhibited state,

the shading is further darkened, especially the foliage above, with lightly etched lines and perhaps some drypoint. In this impression, modeling is greatly enhanced by the retroussage inking of the printer. The landscape, freely drawn in broad open strokes, is not revised in any way. The very interpretive rendering of the Velázquez landscape here is still effective in conveying spatial recession, in planes that rise to the high horizon line.

Both impressions in the exhibition are proofs before the edition of 1862, and each is extremely rare. Printed on chine in a bistre ink, they approximate the appearance of impressions from Manet's special edition of c. 1863. It was obviously determined through proofs such as these that this carefully wiped printing on chine achieved the optimum potential of Manet's plates. The Lucas collection in Baltimore is especially rich in these early proof impressions of plates from the 1862 edition, which were acquired through Guerard. Proofs like these were obviously not quickly pulled working proofs only for the artist's reference as he was preparing his plate. They are instead exquisitely printed demonstration pieces whose excellence became a model for the special edition Manet produced for his friends and associates. The printer of these skillfully realized proofs is unknown. Delâtre printed Cadart's editions, and in spite of his penchant for overinking impressions to enhance their visual impact, he could have executed these proofs with care and more guidance. More likely they were pulled by Bracquemond, who as a masterful etcher and probably the most skillful printmaker of Société artists, valued the impact of linear clarity.

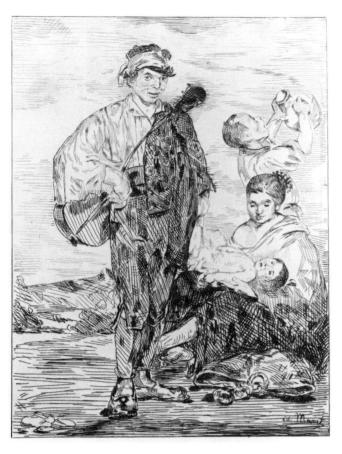

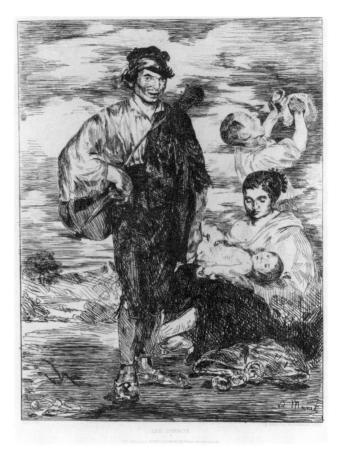

15
*The Gypsies*   (1862)
Les gitanos

Etching, in bistre ink
On laid paper, crescent over crown watermark (Hallines)
First state of six*
Sheet: 361 x 270 mm (14³⁄₁₆ x 10⁵⁄₈ in)
Plate: 319 x 238 mm (12⁹⁄₁₆ x 9⁵⁄₁₆ in)
Image: 284 x 205 mm (11³⁄₁₆ x 8⅛ in)
Inscriptions: Signed in plate, l.r., ''éd. Manet''
N.Y. 48, B. 32, I. 17, H. 18, G. 21, M.N. 2

*The George A. Lucas Collection of The Maryland Institute, College of
Art, on indefinite loan to The Baltimore Museum of Art
B.M.A. L.33.53.5127*

16
*The Gypsies*   (1862)
Les gitanos

Etching, bitten tone, in bistre ink
On laid paper
Third state of six, from the 1862 Cadart edition*
Sheet: 354 x 271 mm (13¹⁵⁄₁₆ x 10¹¹⁄₁₆ in)
Plate: 319 x 238 mm (12⁹⁄₁₆ x 9⁵⁄₁₆ in)
Image: 284 x 205 mm (11³⁄₁₆ x 8⅛ in)
Inscriptions: Signed in plate, l.r., ''éd. Manet''; in margin, l.l.,
    ''Manet sculpt.''; c., ''Les Gitanos./Paris, Publié par A.
    CADART & F. CHEVALIER, Editeurs, Rue Richelieu, 66.''; r.,
    ''Imp. Delâtre, Rue des Feuillantines, 4, Paris''
N.Y. 48, B. 32, I. 17, H. 18, G. 21, M.N. 2

*The George A. Lucas Collection of The Maryland Institute, College of
Art, on indefinite loan to The Baltimore Museum of Art
B.M.A. L.33.53.5123*

*T*he Gypsies was Manet's first published etching and as
such marks his official beginning as an etcher. This
print served as an appropriate announcement that he
was, by the time he made it, well practiced and consist-
ent in his working methods. The print was published in
September 1862 in Cadart's first folio for the Société des
Aquafortistes. The folio with prints by Bracquemond,
Corot, Daubigny, Haden, Jongkind, and Legros, among
others, was the group's first visual statement about the
primacy of etching as a means for contemporary artistic
expression. The folio provoked numerous reviews, and

Manet's print was well received, even by those critics who could not tolerate his painting. The painting that served as the model for this etching was cut into fragments by Manet after its exhibition at the Avenue de l'Alma in 1867 (R.W. vol. 1, 42–44). At that time both print and painting were exhibited together as they had been in 1862 at an exhibition at the Martinet Gallery. The etching is the only record of the full composition of this destroyed painting, which had evolved from an earlier version recorded in one of Manet's first etchings, *The Little Gypsies* (no. 1).

The staunchest advocate of the etching revival was the critic Philippe Burty. Yet he was surprisingly hesitant about Manet's etchings perhaps because the critic was overly concerned about the acceptance of etching by a public accustomed to the mechanical productions of professional engravers. In an 1863 review he wrote that Manet was one of a group of "excessive" etchers. Perhaps he had been thinking of *The Gypsies* when he cautioned the public about certain "brutal" etchings in the Société's first folio (New York 1983, pp. 143–144). Manet's print must have appeared very bold in comparison with the rest of the prints from Société artists. His large-scale figure posed in a very shallow space, broadly drawn with deeply etched, widely spaced lines, might well have caused hesitation in a believer in the artistic freedom of the medium. *The Gypsies* and *Philip IV* (no. 13 and 14) are similar in impact and almost the same size, suggesting a systematic approach to both. In each case he traced the outlines of the composition onto the copper plate using a scaled drawing. For *The Gypsies* no such drawing exists but indications of the transcription are clearly visible on the plate. For *The Espada* (no. 19) Manet used a photograph of his painting as the basis of his tracing.

A comparison of the two exhibited states—a rare impression of the first (one of two recorded impressions, the copy illustrated in Moreau-Nélaton, Guérin, and Harris) and the third—shows Manet's working method once the composition was outlined on the plate. The broken dashes of the tracing were followed with continuous etched lines outlining the figures and distant mountain. These distinct areas were then filled in with heavy lines, drawn with an almost mechanical regularity. The lighter, finer lines are the result of stopping out after a short time in the acid, while the darker lines were more deeply bitten. Unlike the prints *The Spanish Singer* or *The Little Cavaliers*, this plate did not evolve in a gradual progression of states. It is complete in the second state except for the revision of inscriptions. After the first state Manet added lines with more variety. The darker areas of the first state are shaded further with fine crosshatched lines in various directions to give the man's coat a surface texture. The sky is also darkened, a tree added to the left in a quick scribble, and some detail, perhaps blades of grass, begun in the left foreground but left unfinished. The composition is solidified and brought into balance, enhancing its two-dimensional impact.

In addition to the 1862 folio, *The Gypsies* was printed in Manet's c. 1863 edition of fourteen etchings and in the Cadart 1874 portfolio. Cadart also published the print in 1872, on chine collé paper, as part of his "Cent eaux-fortes par cent artistes." An additional state has been added to Bareau's total of five reflecting a variation in the inscription that resulted from Cadart's move to a new address. The inscription recorded for the print used in the first folio and the edition of eight etchings includes the names of Cadart and Chevalier, but after 1863, when Chevalier left the firm, the inscription was revised to reflect the new partnership between Cadart and Luquet. This change defines the new fourth state. The exhibited impression of the third state, carefully printed in the same bistre ink as the early proofs (exactly the same as a proof of the second state also in the Lucas collection), was probably issued in the 1862 portfolio of eight etchings, although it is difficult to distinguish this edition from single impressions available from Cadart.

17
*Boy with a Sword (Turned Left)* (version three)   (1862)
L'enfant à l'épée

Etching, roulette, bitten tone
On chine paper
Second state of four
Sheet: 361 x 270 mm (14⅜ x 10⅝ in)
Plate: 317 x 240 mm (12½ x 9⅜ in)
Image: 262 x 175 mm (10⅝/₁₆ x 6⅞ in)
Inscriptions: Signed in plate, l.l. corner, ''éd. Manet''
N.Y. 18, B. 27, I. 22, H. 26, G. 13, M.N. 52

*The George A. Lucas Collection of The Maryland Institute, College of*
*Art, on indefinite loan to The Baltimore Museum of Art*
*B.M.A. L.33.53.5150*

18
*Boy with a Sword (Turned Left)* (version three)   (1862)
L'enfant à l'épée

Etching, roulette, bitten tone
On heavy laid paper, partial fleur de lis watermark (Hudelist)
Third state of four, from c. 1863 edition of twenty-five
Sheet: 351 x 254 mm (13¹³/₁₆ x 10 in)
Plate: 317 x 232 mm (12½ x 9³/₁₆ in)
Image: 262 x 175 mm (10¹⁵/₁₆ x 6⅞ in)
Inscriptions: Signed in plate, l.l. corner, ''éd. Manet''
N.Y. 18, B. 27, I. 22, H. 26, G. 13, M.N. 52

*The George A. Lucas Collection of The Maryland Institute, College of*
*Art, on indefinite loan to The Baltimore Museum of Art*
*B.M.A. L.33.53.5149*

The third etched plate after Manet's 1861 painting *Boy with a Sword* (R.W. vol. 1, 37), now in The Metropolitan Museum of Art, shows the artist finding a resolution to a printmaking problem first broached in what may be his earliest etching. For this later work, in the course of several states, he applied the knowledge he had acquired from earlier projects to the challenge of realizing an etching that would capture the essence of this deceptively

17 *Boy with a Sword (Turned Left)*

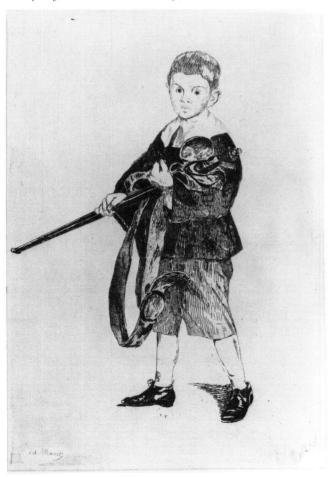

18 *Boy with a Sword (Turned Left)*

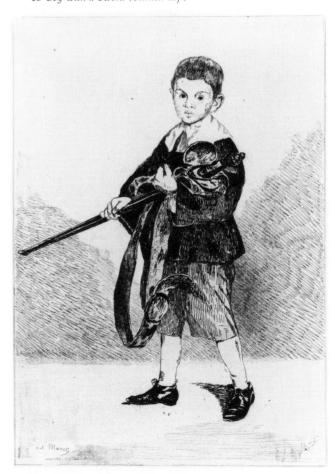

uncomplicated picture. His first version, known in only one impression (Nationalmuseum, Stockholm) was quite possibly his first etching, as Moreau-Nélaton cites a written statement from Manet's colleague in the Société, Legros: "I recall having made a few lines on the plate, just a few strokes, to show him how to do it; but the etching is actually by Manet" (New York 1983, p. 81). The drawing of this plate with its widely spaced parallel lines clearly shows the influence of Legros's hand. The second version, in an etching style closer to the earliest states of *The Spanish Singer* (no. 12 and 13) and known in only two impressions (British Museum, London, and The New York Public Library), was a more confident attempt, for Manet used a tracing from a photograph of the painting (R.W. vol. 2, 456). This version comes closer to solving the problem of situating the figure (Manet's model may have been his son Léon Leenhoff) in neutral surroundings of little depth. Manet considered this version a failure like the first, and he abandoned the plate.

With a view toward completing the project for the 1862 portfolio, Manet took a more systematic approach to the third version that is well illustrated by impressions of the two states selected for this exhibition. Following an approach consistent with other prints of this period, Manet resolved his problems with this composition by initially concentrating on the figure. He carefully darkened the figure with parallel lines, creating a flattened silhouette on the otherwise blank page. The dark areas of shading give the figure greater stature in the rectangular frame, closer to the effect of the painting than that of the earlier etched versions. In the second state, exhibited here, he added more shading to the figure, a shaded tone with the roulette to the sword's baldrick, and a very light, bitten tone to the lower section of the plate that he stopped out around the signature and at the level of the boy's chest. In the third state, Manet sketched in a neutral and nondistracting background using a regular squigglelike line. The shallow space here is also defined by a horizontal separation between the shaded wall and the blank floor. Manet again used the roulette to darken and localize shading in the background. The bon à tirer proof of this same third state in the Avery collection (designating an edition of twenty-five impressions), which is on the same laid paper with the Hallines watermark, is evidence of a special edition of the plate following the 1862 edition, which was published before Manet could finish this plate. The *Boy with a Sword* does appear on the title page for Manet's c. 1863 edition, although very few impressions of the third state on chine have been located. The print was not included in the 1874 Cadart edition, but it is listed in an 1878 commercial catalogue for the Cadart firm in addition to *The Gypsies* (no. 15 and 16) and *Lola de Valence* (no. 25).

When Manet reworked several of his early plates with a heavy ground of aquatint, probably in 1866–1867, he also reworked this plate (see no. 48). Finally, he attempted a similar effect in the fourth version of this plate, which is known in only one impression (Bibliothèque Nationale, Paris). This variation is difficult to date, but it was probably done about the same time as the third version. This plate is the only one of the four with the same orientation as the original.

**19**
*The Espada (Mlle. Victorine in the Costume of an "Espada")* (1862)
L'espada

Etching, aquatint, bitten tone (sulphur tint?)
On laid paper, Hudelist watermark
Third state of three, from the 1862 Cadart edition
Sheet: 524 x 357 mm (20⅝ x 14⅛ in)
Plate: 336 x 277 mm (13¼ x 10⅞ in)
Image: 306 x 238 mm (12¹⁄₁₆ x 9⁷⁄₁₆ in)
Inscriptions: Signed in plate, l.l. corner, "éd. Manet"
N.Y. 35, B. 42, I. 31, H. 35, G. 32, M.N. 7

*The Detroit Institute of Arts, Founders Society Purchase General Endowment Fund 70.585*

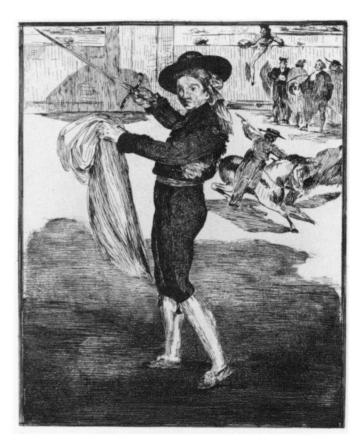

19 *The Espada (Mlle. Victorine in the Costume of an "Espada")*

*T*he Espada, also titled with the name of Manet's model, Victorine Meurent, was one of the last plates completed for the 1862 Cadart edition. The print is a faithful transcription of the oil, which is notable for what is now considered to be an intentional disparity in scale between the figures; the painting is now in the Metropolitan Museum of Art (R.W. vol. 1, 58). The only apparent variations between canvas and etching are the shape and length of the cape and the slight extension of the composition at the top to incorporate the end of the sword. Like *The Urchin*, the etching in fact represents the appearance

of the painting in 1862, as it corresponds to a watercolor that was reportedly made from a photograph of the painting. Most unusual for Manet prints is that the artist took pains to insure that the print was in the same orientation as the painting, requiring that he work in reverse. Painting and print alike illustrate the clear influence of Goya, for not only did Manet borrow motifs from his Tauromachia plates but the Spaniard's prints also suggested new techniques for Manet, especially the use of aquatint. Clearly *The Espada* was an important print for Manet because it reproduced a much-discussed painting; however, it was published only once after the initial portfolio of 1862, in Manet's private edition for friends and associates of c. 1863.

Manet worked on this plate in a way similar to that of *Boy with a Sword* (no. 17 and 18) and later *Lola de Valence* (no. 25). He drew on the plate with a stylus, following the outlines of a watercolor that he had traced from a photograph of the painting (R.W. vol. 2, 372). Victorine's hat was slightly repositioned, as the original outlines designated by light, dashlike lines indicate. The print was almost complete in the first state, and work for the second involved only adding more shading to the figure, which because of the consequent emphasis on contour appears more slender than that of the painting. At this stage Manet must have wanted to achieve an effect that approximated the fine aquatint tones of Goya's bullfight etchings. Thus he introduced a new technique that created a wash of tone, much like a watercolor, probably using a sulphur tint. As Lalanne's 1866 treatise on etching describes, this technique gently roughens the plate and is distinguished from aquatint by the lack of a grain. If Manet did not use a sulphur tint, then he may have applied acid directly to the plate in some way. This subtle wash of grey is visible near the edges of the etched foreground area. It is similar in effect to the luminous modulation of the fine aquatint grain in Goya's Tauromachia etchings. Like Goya, areas of shading in the foreground serve as a visual base for the figure and the distant picador. These areas, which seem to float on an otherwise blank sheet, were drawn with parallel horizontal lines that were in turn darkened with the sulphur tint and finally, in the third state, with a coarse aquatint grain. This last aquatint application creates a progression of shading from dark to light receding to the brightly lit background. Similar to Manet's etching *Philip IV* (no. 13 and 14), the background is drawn in the same broad, lively style and is untouched in the later states.

Unlike many of the earlier prints, the states of *The Espada* show little evidence of a struggle to find a graphic equivalent for the painting's qualities. But Manet's creativity and originality is well represented here, for he conceived and executed a variant work of art that translated the original into a different visual language. Bareau describes the change thus: "the emphasis on line and shape is clearly accentuated, creating a halfway stage between the pictorial and the purely graphic versions of the composition" (New York 1983, pp. 116–117).

**20**
*The Toilette* (1862)
La toilette

Etching, roulette, bitten tone
On japon paper
Second state of three, from the 1874 Cadart edition
Sheet (irregular): 456 x 404 mm (18 x 15⅞ in)
Plate: 285 x 224 mm (11¼ x 8⅞ in)
Image: 277 x 212 mm (10⅞ x 8⅜ in)
Inscriptions: Signed in plate, l.r. corner, ''M.''
N.Y. 25, B. 37, I. 8, H. 20, G. 26, M.N. 9

*The Detroit Institute of Arts, Founders Society Purchase General Endowment Fund 70.583*

Manet's etching *The Toilette* is unique among the artist's prints, for it conveys above all the figure's volume. The only other print in Manet's printmaking oeuvre that approaches a similar dense atmospheric background is the earlier etching *The Candle Seller* (no. 10), but there, as with most of Manet's prints, tone was manipulated to emphasize a contoured shape with more two-dimensional impact. The relationship of this etching, striking in its chiaroscuro effects, to Rembrandt's late etching-drypoints of bathers, especially the print *Woman Bathing Her Feet at a Brook* from 1658 (Hind 298), persuasively suggests a profound influence from the Dutch art-

20 *The Toilette*

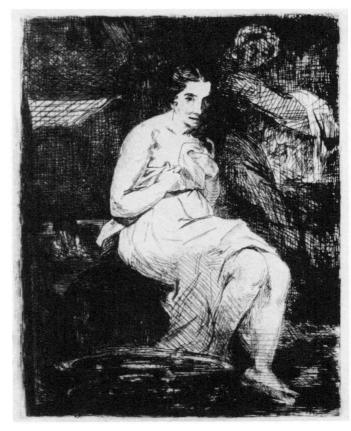

ist. Like Rembrandt, Manet used only a few lines to model the figure—strong lines to suggest contours and small areas of crosshatching. Brilliantly illuminated against an obscure dark background, the figure is mostly blank paper; the chiaroscuro effects are exploited further by the interpretive printing common in impressions of this image. The influence of Rembrandt was a major factor in Manet's paintings of this theme, and as he had with Goya, Manet also sought instruction from Rembrandt's prints in his attempts to realize the effects of his paintings on the copper plate.

There is no existing painted model for *The Toilette*, which represents instead a compositional variation of two canvases—the reworked oil *Surprised Nymph* from 1859–1861 (R.W. vol. 1, 40), where the figure of a satyr was removed after Manet's death, and a sketch with a nude and an attendant showing the larger composition *The Finding of Moses*, which Manet destroyed, retaining only the figure of the bather (R.W. vol. 1, 40). In the etching Manet chose an interior scene over the earlier outdoor bather compositions. There are four related drawings (R.W. vol. 2, 71, 361–363) in which Manet worked with the composition of the figure and a drawing scratched on a mica sheet (R.W. vol. 2, 358) transcribing the outlines (R.W. vol. 2, 363) for transfer to another sheet. An additional drawing shows evidence of the stylus (R.W. vol. 2, 360) that Manet used to transfer the figure to the copper plate. The etching itself, completed in time for the 1862 edition of Manet's prints by Cadart, was subsequently included in both of the other lifetime editions of the etchings.

There is a general disagreement about the placement of this work in Manet's printmaking chronology. Both Guérin and Harris date the print 1862, presumably because of its style and inclusion in the 1862 portfolio. Harris specifically dates the work in summer 1862, when she believes Manet returned to the theme ''the nymphs surprised,'' which includes the works mentioned above that are now dated earlier between 1859 and 1861 (N.Y. 19–24). This earlier dating of related works led to Bareau's 1861 dating of the etching, justified in her view by the print's less accomplished technique. While the relationship of the etched composition to the other works is relatively clear—coming last, directly preceded by the drawing now in the Courtauld Institute of Art from which it was traced—this connection does not mean that both had to be made in 1861. Harris is no doubt correct in placing the print later, immediately before the publication of the 1862 edition, because such an accomplished etching, reflecting a somewhat retrospective interest in the challenge of conveying three-dimensional form, which was boldly realized and confidently executed on the copper plate, cannot be understood when placed among Manet's more tentative experiments of 1861. The etching is signed with a variant signature ''M,'' which this writer believes was used by Manet late 1862–early 1863; it appears also on *Silentium* (no. 23) and *At the Prado* (no. 24).

In arriving at the second state of this etching, Manet added further shading throughout the background, leaving relatively untouched in bright illumination a small

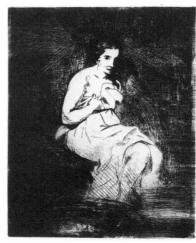

FIG. 2 *The Toilette*, Archives Paul Prouté, Paris

band to the left, the figure of the attendant, and of course the figure of the bather. In the second state Manet added a tonal shading with roulette along with some other type of bitten tone near the attendant and over the drapery and legs of the bather. The two known impressions of the first state (Archives Paul Prouté, Paris, and Johnson collection, Chicago) provide an early indication of the chiaroscuro effects Manet was to achieve with additional etching in the second state. The Johnson impression (see illustration, N.Y. 25) was cleanly wiped, creating strong contrasts between dark and light. The Prouté impression (see fig. 2) is covered with a rich film of ink—a veritable monoprint a decade before Lepic's and others' experiments with interpretive inking ushered in a more adventuresome period of etching activity. The plate is carefully wiped, leaving the figure clean to enhance its voluminous form, shrouded by an enfolding black background. This first-state printing, probably done by Delâtre, who was known for his manipulative printing, prefigures the direction of Manet's subsequent etching on the plate. In his printing of the impressions for the 1862 edition, Delâtre also left an amount of plate tone as seen in an impression of this edition in the Lucas collection. The exhibited impression, however, from the 1874 edition on japon and the only example from this edition in the exhibition, is much more cleanly wiped.

**21**

*Illustrated Cover for an Edition of Etchings (Cat and Portfolio)* (1861–1862)

Etching, accidental bitten tone
On tan wove paper
Only state
Sheet: 348 x 259 (13¹¹⁄₁₆ x 10³⁄₁₆ in)
Plate: 267 x 190 mm (10½ x 7½ in)
Inscriptions: Signed in plate, l.r. corner, "éd. M."; on portfolio, "eaux = fortes/par/Edouard Manet"; in pencil, l. margin, "Iʳᵉ titre pour la série de 8 eaux fortes de Manet très rare. non catal—Beraldi. H. Guerard"; u.r. corner, printed stamp of copper plate manufacturer
I. 33, H. 37, G. 28, M.N. 49

*The George A. Lucas Collection of The Maryland Institute, College of Art, on indefinite loan to The Baltimore Museum of Art*
*B.M.A. L.33.53.5113*

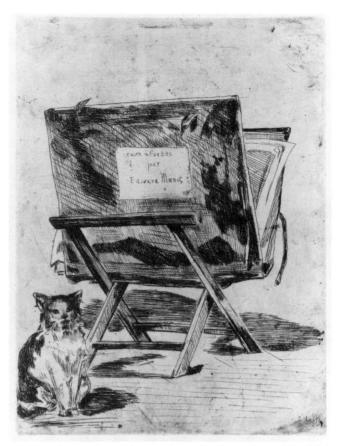

21 *Illustrated Cover for an Edition of Etchings (Cat and Portfolio)*

In the first Société folio of 1862, Cadart advertised several portfolios of etchings by artists such as Bonvin, Jongkind, and Millet, among others, including a set of eight prints by Manet. Portfolios like these were not uncommon before Cadart founded his business and the Société des Aquafortistes. Some of the artists who had previously published suites of their etchings included Chassériau, Daubigny, Huet, and Meryon. The artists customarily prepared an illustrated cover for the portfolios—a tradition that Cadart continued. The original etched designs of widely different compositions would be printed on a colored paper, often blue or blue green, used as a portfolio wrapper, and folded around the prints. Manet made two attempts to design a cover for his 1862 portfolio, but neither was ever used in favor of a plain, typographical cover. Impressions of the two prospective covers are extremely rare; each is known in only two or three impressions and in only one state. No drawings are known for either, thus both represent original ideas executed on the copper plate rather than designs interpreted from another medium.

The date for *Illustrated Cover for an Edition of Etchings (Cat and Portfolio)* is usually cited as 1862, based on the publication date of the portfolio in fall 1862 and its thematic relationship to the second version of the cover inscribed with the date "62" (H. 38). The two plates are so different conceptually that it is difficult to relate them stylistically. The second version is signed in the manner common to prints of this period, "é Manet," but the first plate, exhibited here, is signed simply "ed. M.," a form more usual in Manet's earlier prints, such as *Boy and Dog* (no. 5). It is not impossible that the first project for the cover was begun a year earlier than the second, in late 1861 or early 1862, when Manet first started to work on his prints for the portfolio. The only confirmation of the purposes of these two prints comes from inscriptions written on a proof of each by Manet's colleague Guerard at the request of George Lucas, who bought the prints either for Samuel Avery or for his own collection. Guerard wrote on the Lucas impression of *Cat and Portfolio* that it was the "1ʳᵉ titre." On the second print, which is the proof in the Avery collection at The New York Public

Library, he wrote "1ʳᵉ idée pour le couverture." It is entirely possible that Guerard used "titre" and "couverture" interchangeably, forgetting which print he marked as the first idea, but it is also possible that Manet had prepared both a title page and a cover. Doing so would have been unconventional for the Cadart publications, but it was a common procedure for illustrated books.

These two ideas for covers have generated a great deal of scholarly debate concerning Manet's thematic intentions. This is especially true of the second version, *Polichinelle Presents "Eaux-Fortes par Edouard Manet"* (see fig. 3), which because of its obvious symbolic content is frequently evoked in more wide-ranging discussions of the intellectual content of Manet's art. The *Cat and Portfolio* cover could simply be a variation on the traditional title page, with the cat being an element of genre, an inhabitant of the studio. Reff's view is more complex because he finds visual plays, such as the lettered title on the portfolio, that can be read as the actual portfolio label or as a superimposed title for the entire page. For Reff this visual play extends to the cat, which is visually related to the portfolio: "Thus the cat becomes not simply the artist's studio pet, a genre detail, but a sophisticated allusion to the artist himself, an echo of the portfolio containing his work and name, and in some indefinable sense an embodiment of his presence here, staring intently at the

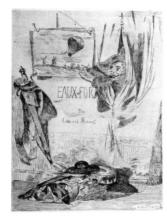

FIG. 3 *Polichinelle Presents*
*"Eaux-fortes par Edouard Manet,"*
The New York Public Library,
Samuel P. Avery Collection

spectator. Its direct descendant is the famous cat in
Olympia, a creature of similar significance" (Reff 1969,
p. 182). Fried sought to relate the two versions more
closely by suggesting that the cat was the traditional
companion of Polichinelle, the theatrical protagonist in
the involved narrative of the second plate, for he believes
that "the ultimate subject of Manet's etchings is not him-
self but essential aspects of his art" (Fried 1969, pp.
39–40).

**22a**
*The Balloon* (1862)
Le ballon

Crayon lithograph with scraping
On laid paper, S watermark
Only state
Sheet (irregular): 430 x 552 mm (16$^{15}$/$_{16}$ x 21¾ in)
Image: 400 x 510 mm (15¾ x 20⅛ in)
Inscriptions: Signed in stone (scratched white in black), l.r.
  corner, "éd. Manet"
N.Y. 44, I. 28, H. 23, G. 68, M.N. 76

*Samuel P. Avery Collection, The New York Public Library*
*Astor, Lenox and Tilden Foundations MN76*

**22b**
*The Balloon* 1862
Le ballon

Crayon lithograph with scraping
On laid oatmeal paper, light grayish-tan
Only state
Sheet: 487 x 621 mm (19$^3$/$_{16}$ x 24½ in)
Image: 400 x 510 mm (15¾ x 20⅛ in)
Inscriptions: Signed in stone (scratched white in black), l.r.
  corner, "éd. Manet"
N.Y. 44, I. 28, H. 23, G. 68, M.N. 76

*Fogg Art Museum, Harvard University, Museum Purchase*

In summer 1862, Cadart, anticipating the publication of
the first folio of etchings for the Société des Aquafor-
tistes, was also making plans for a portfolio of artists'
lithographs that would encourage a revival of that me-
dium as well. A year earlier Burty, whose articles on
contemporary printmaking provided a critical foundation
for Cadart's campaign for an etching renaissance, praised
the advantages of lithography in words he might also
have used for etchings: "the most spontaneous transcrip-
tion of an artist's ideas, . . . which should always render
these ideas with the force and purity of an original draw-
ing" (New York 1983, p. 133). Cadart provided five art-
ists—Bracquemond, Fantin-Latour, Legros, Manet, and
Ribot—with three stones each, with no strictures other
than Burty's edict of directness and spontaneity. In con-
sidering Fantin's contribution, Druick suggests that Ca-
dart may have actually had the concept of a multiple
drawing in mind because, at least for the proofs, he
chose a heavy laid paper with a great deal of surface
texture generally used for drawings, instead of the more
suitable smooth paper usually thought appropriate for
lithography (Druick and Hoog 1983, pp. 138–139).

Manet used only one of his stones in producing this,
his second, lithograph—the first was his caricature of
Ollivier in 1860 (H. 1). Cadart abandoned his publishing
project after seeing the initial results, so the Manet print
is extremely rare, known in only five proofs: two in the
current exhibition and one each in the Mellon collection
in Virginia, British Museum, and Bibliothèque Nationale.
In his catalogue of Fantin-Latour prints, Hediard provides
a likely explanation for Cadart's decision. Lemercier, who
printed all the artist's works, found Fantin's work "horri-

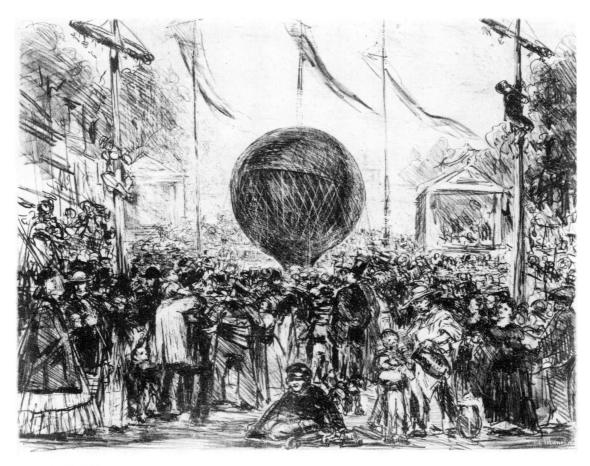

22b *The Balloon*

ble, insane, uncivilized, nothing like it has ever been seen before'' (New York 1983, p. 133). Surely Manet's energetic and broadly conceived piece would have provoked the same reaction in light of the more fastidious productions to which Lemercier and the public were then accustomed. Remembering Burty's hesitations about ''excessive'' etchers (see no. 15 and 16), Cadart, who was an indecisive businessman, did not feel encouraged to proceed. Later, however, he did publish lithographs by other less challenging artists.

With the exception of some lithographs by Delacroix and Doré, there are few artistic precedents for the large-scale exuberance of Manet's and Fantin-Latour's contributions, although for Manet, Goya's four lithographs of bullfights are an impelling source, both stylistically and thematically. Goya's prints show the same rapid execution with less important details, such as heads in a crowd, just scribbled in. Lightly drawn and strongly shaded areas alternate across the composition, while highlights are scratched through the crayon into the stone. In a recent article that thoroughly explores the subject of *The Balloon*, Druick and Zegers demonstrate that in his lithograph Manet sought to depict what Baudelaire saw in one of Goya's lithographs, a ''vast picture in miniature'' (Druick and Zegers 1983, pp. 44–45).

Through his accurate depiction of the festivities for the Fête de l'Emperor on August 15, 1862, Manet intended to comment more widely on the symbolic importance of the event—both a as self-glorification of the Second Empire and as an effective social diversion for a willing public, thereby obscuring the realities of the Empire's betrayal of republican values. The balloon is a symbol of the Empire's modernity, an indication of the glorious ascendency of the emperor, as opposed to the cripple in the foreground who is alone and unnoticed by the crowd and, by example, a symbol of the poor and disadvantaged left in the path of society's real progress in such a self-satisfied era. Mauner sees this opposition as a crucifixion scene, contrasting human misery with the spiritual ascension of the balloon between two crosses (Mauner 1975, p. 175). Whatever one's interpretation, the choice of lithography for satiric commentary was appropriate since Manet was well aware of the medium's traditional use by artists such as Daumier or Gavarni for social and political jibes. It was a medium for mass distribution.

The actual event took place on the Esplanade, in front of Les Invalides, near the Seine. It marked the annual celebration of Napoleon I's birthday, the only national patriotic holiday on the calendar. Popular prints, such as one from *Le Monde Illustré* (see illustration, New York

1983, p. 134), together with contemporary accounts discussed by Druick and Zegers, confirm the accuracy of Manet's depiction. The ascent of the balloon marked the climax of the festivities. Druick and Zegers, together with Kayser and Nicolaou of the Paris Air and Space Museum, demonstrate that Manet accurately drew the actual event, the effects of the wind, and the precise technique for launching a balloon (New York 1983, p. 135). But Manet moved the site of the balloon launch toward Les Invalides because it actually took place at the other end of the Esplanade. Essentially he created a composite of all the festival activities, including the booths for pantomimes on either side and the strolling acrobats. The crowd was undoubtedly drawn from sketches of the scene, with a wide range of individuals in the foregound, and broken, scumbled lines to define the anonymous mass of heads in the background. While Manet was working on this lithograph he had begun his painting *Music in the Tuileries*. Both lithograph and painting share a similar disjunction between carefully defined foreground details and a rapidly and vaguely executed background. Cadart, like Manet's critics, could not endorse this new style.

## 23
*Silentium*   (1862–1863)

Etching (unintentional oxidation)
On prepared wove paper, polished white
Second state of three
Sheet: 258 x 223 mm (10⅛ x 8¾ in)
Plate: trimmed at top x 156 mm (trimmed at top x 6⅛ in)
Image: 202 x 151 mm (7¹⁵/₁₆ in x 5¹⁵/₁₆ in)
Inscriptions: Signed in plate, l.l. corner, "M"; below c., "SILENTIUM"; in pencil, l. margin, "Le Silence par Manet. H.G." (Henri Guerard)
B. 19, I. 3, H. 3. G. 4, M.N. 22

*Samuel P. Avery Collection, The New York Public Library Astor, Lenox and Tilden Foundations MN 22*

In 1857, the year after he left Couture's studio, Manet went to Italy, where in Florence he made a number of drawings after frescoes in the cloister of the Annunziata (Leiris 1969, pp. 6–7) and after Fra Angelico in San Marco (R.W. vol. 2, 46–51). His etching *Silentium* is based on a lost drawing copied from the lunette fresco of St. Peter Martyr (Pope-Hennessey, *Fra Angelico,* London: Phaidon Press, 1952, p. 76) painted by Fra Angelico. The size of his other drawings after Fra Angelico from this time (288 x 212 mm), together with visual evidence on the print itself, suggests that, like his normal working method, this print began as an outline transcription from a drawing, incised with a stylus. The typical broken lines of this transfer method can be seen on the left side of the figure and on the outline of the figure's left forearm. *Silentium* was never published in Manet's lifetime, although it was included in all three posthumous editions of his prints. The first state represents his design as published; the second reflects the accidental oxidation of the plate; and the third can be identified by a reduction in the plate size. The exhibited impression is one of the few recorded proofs of the plate in its second state, acquired for Avery by Lucas from Guerard who owned several lifetime impressions (B. 19).

Because of its origin in Manet's Italian trip of 1857, the etching has traditionally been dated at 1860, which would make it one of Manet's earliest etchings. But in her 1978 catalogue Bareau suggests a later date, from 1862–1863. She thinks the etching exhibited a "style ferme et dépouillé." Her analysis is correct, for what some have seen as unskilled, technically uninformed etching, is actually a purposeful reductive approach to drawing on the plate. The effect is very similar to the minimal, outline style of Manet's Italian sketches. It is in fact Manet's confidence as an etcher at this point in his career that contributes to his technical and stylistic flexibility (see no. 27). The clarity and expressiveness of his line are not essentially different from *The Toilette* (no. 20), which shares with *At the Prado* the signature "M" used by Manet in 1862–1863. The exhibited proof is printed on a prepared paper with a polished white surface, similar to papers used for the proof of *The Toilette* formerly in the Guerard collection.

*Silentium* represents one of Manet's frequent reconsiderations of early work. Perhaps he prepared the etching for a new edition of his prints but abandoned the plate

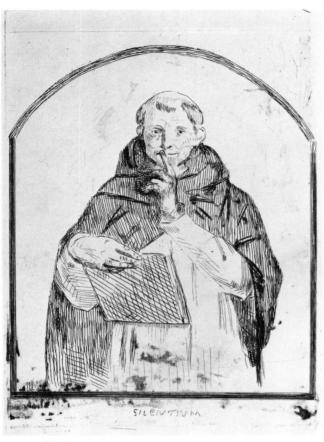

23 *Silentium*

viewer, impressing us with the seriousness of the message. Mauner suggests that Manet's etching *Silentium* conveys the artist's belief that it was necessary to conceal the themes of his paintings. Apparently, Manet never talked to his biographers about the philosophical aspects of his art, for as Mauner writes, "it was essential for the pictures to reveal themselves in the imaginative richness, subtlety and logic of their creation." But beyond this concern, Mauner and others suggest that Manet believed strongly in a code of silence that led him to choose elusive themes "meant to be revealed only to those who were predisposed to understand them." If Mauner is correct, then Manet intended this print, a return to an earlier moment in his career, to be a comment about his art for a public puzzled by his intentions (Mauner 1975, pp. 184–186).

after oxidation ruined its appearance. The only known impression of the first state, before oxidation, is on chine like the prints pulled for the edition of c. 1863 that were intended for his friends (see no. 29). The plate might also have been published separately because it shows a written title, in the same format as *At the Prado* (no. 24), which would have made it self-sufficient outside a portfolio of prints. The oxidation that mars the proof impressions of the second state is substantially reduced in the posthumous prints of the third state.

Manet reproduced the Fra Angelico of St. Peter Martyr in reverse, omitting the indication of his martyrdom, a wounded head, as well as the martyr's palm that he held in his left hand. The arched frame that Manet drew around his composition reflects the lunette form of the fresco. He drew these more elaborate borders around six of his prints from various periods, including *Boy and Dog, Boy with a Sword* (last state), *The Espada, Baudelaire* (H. 60), and the cover design *Hat and Guitar*, but the specific purpose is unclear. The features of St. Peter seem individualized although Duret's suggestion that Poe was Manet's subject does not appear to be correct. Following Fra Angelico, Manet left the saint in Dominican robes to make clear that he delivers St. Benedict's edict of monastic silence confirmed by the inscribed title below. The eyes are fixed in concentration as the figure looks at the

24
*At the Prado* (1863)
Au prado

Etching, aquatint, roulette, bitten tone
On chine paper
Second state of two
Sheet (irregular): 311 x 228 mm (12¼ x 9 in)
Plate: 181 x 119 mm (7⅛ x 4¹¹/₁₆ in)
Image: 168 x 115 mm (6⅝ x 4½ in)
Inscriptions: Signed in plate, l.l., "M"; c., below image, "au Prado"
B. 52, I. 36, H. 44, G. 45, M.N. 63

*The Detroit Institute of Arts, Founders Society Purchase General Endowment Fund 70.590*

Both Guérin and Harris dated the first version of *At the Prado* 1865, the year of Manet's trip to Spain during which he wrote to Fantin-Latour: "The Prado, a charming walk, is filled with pretty women, all with mantillas, which makes a very unusual picture" (Harris 1970, p. 128). As persuasive as the connection between this passage and the print may be, Bareau is correct in her view that the print must date earlier, in 1863, about the time Manet was working on his etching *Lola de Valence* (no. 25). Lola can be securely dated in 1863 because

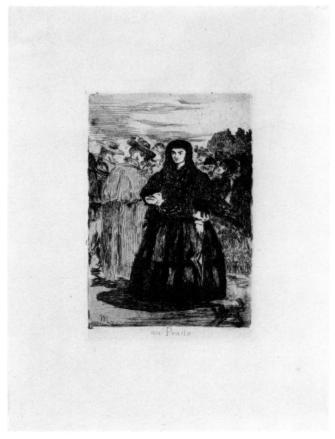

24  *At the Prado*

it was included in the second Société des Aquafortistes folio of September 1863. In the first state of *At the Prado*, known in only a single impression (The Art Institute of Chicago, former Guerard collection), the central figure of the woman wears a white mantilla and black dress, strikingly similar in costume and pose to Lola de Valence. The second state, included in this exhibition, is one of two known impressions; here the woman's features seem similar to those of Lola. Furthermore, the unique proof of the first state is printed on a paper used by the Société in the years 1862–1863 (watermark A-ANN [ONAY]), and the plate is signed with the "M" that appears on only two other Manet prints, *The Toilette* (no. 20) and *Silentium* (no. 23), both predating his Spanish voyage. Even without a trip to Spain, Manet could have known about Spanish customs through popular prints and, as Isaacson suggests, through Théophile Gautier's *Voyage en Espagne*, first published in 1843. In that work Gautier describes the Prado as a place of social rendezvous, similar to the gardens of the Tuileries (Isaacson 1969, 30).

Like his etching *Silentium*, Manet titled the image in script in the lower margin. There is no sure explanation for the practice, although Manet did sometimes include titles when a print was planned to be issued as a separate sheet. Manet may also have planned to publish a set of titled prints that would have included both *Silentium* and *At the Prado*. Interestingly, unlike most of Manet's early prints, neither of these works reproduce a known painting. Perhaps the titles distinguished these prints as compositions planned from the outset as prints rather than as copies of well-known paintings. We know that Manet was at this time preparing an edition of prints especially for this friends (see no. 29). On the watercolor study for the cover of this portfolio, where Manet also practiced the reverse writing of titles for prints to be included, the title "Au Prado" is clearly visible. When the actual cover was made, that title did not appear, but in the exhibited impression of the cover (no. 29) from the Avery collection, the title "le prado" was added in ink after the title "la m^de de cierges" had been crossed out. While we do not know what version of *At the Prado* Manet was referring to in these two notations, the existence of impressions of the first state of the second version, on chine (no. 28), seems to indicate that it was this version that was used in at least some of the portfolios Manet distributed to his friends. An impression on chine of this version was part of the complete group of Manet prints from the collection of Morel Vindé, which is the only recorded complete set of Manet's fourteen etchings (B. 53). The first version is known in only three proofs and was probably complete when Manet prepared the watercolor of the cover design, but he abandoned the plate, choosing instead to make a second plate. This plate, done somewhat later, was probably added as a substitution to the portfolio, which was initially distributed with *The Candle Seller*. It is likely that this portfolio was distributed over several years.

That this print represents an idea intended for printmaking only is given further credence by Manet's reliance on the prints of Goya, whose technical, thematic, and compositional influence on this etching is readily appar-

ent. Previous to this print, Goya's effect on Manet's painting and printmaking is best seen in *The Espada* (no. 19), but here Manet turns from the bullfights to a different set of Goya prints, Los Caprichos, especially plate 27, *Which of them is the More Overcome?* (T. Harris 1964, 62). Both plates are similar in size, and Manet uses an etching style of closely spaced parallel lines and light aquatint shading that approximates the character of Goya's print. Many of the changes made to the first version in the second state, known in only one other impression (Kunsthalle, Hamburg), substantiate Goya's influence, for the figure of the woman is now shaded so that she no longer wears a white mantilla. The outlined contours of her figure are thereby accentuated against the lighter background. Manet also sketched in a dog, like those of the Caprichos plates, a typically Goyaesque inclusion. A dark aquatint ground is added to the trees in the background while the figure of an abbot with his distinctive hat is added to the right.

25
*Lola de Valence*   (1863)

Etching, aquatint, roulette
On chine paper
Third state of eight
Sheet: 418 x 338 mm (16⁷⁄₁₆ x 13¼ in)
Plate: 260 x 183 mm (10¼ x 7³⁄₁₆ in)
Image: 234 x 159 mm (9³⁄₁₆ x 6¼ in)
Inscriptions: Signed in plate, l.l. corner, "éd. Manet"; collectors' marks verso, l.r., (Lugt 1378) H. J. Thomas; c., unidentifiable
N.Y. 52, B. 34, I. 29, H. 33, G. 23, M.N. 3

*The Detroit Institute of Arts, Founders Society Purchase General Endowment Fund 70.580*

Parisians of the 1860s were captivated by Spanish life and customs, which insured a tremendous response when the Royal Ballet of Madrid made an appearance at the Hippodrome theatre in August 1862. Manet persuaded the dance troupe to pose for him, and in addition to an oil of the group, he painted a full-length portrait of each of the two principal dancers in the company—the ballet master, Mariano Camprubi (see no. 27) and Lola Melea (R.W. vol. 1, 53). In 1863 Manet made etchings after both of these paintings. In the same orientation as

25 *Lola de Valence*

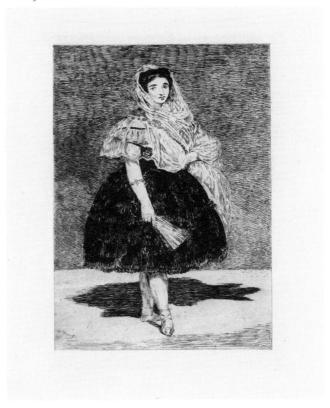

the original, *Lola de Valence* is one of his most carefully controlled derivations from a painting. He exhibited the print in the Salon des Refusés in spring 1863, and that fall Cadart published it in the second folio of etchings for the Société des Aquafortistes. It was subsequently included in Manet's own edition of his prints for his friends and later in Cadart's 1874 portfolio of Manet's etchings. For this reason it was, along with *The Gypsies* and *The Spanish Singer*, one of the most widely distributed prints during Manet's lifetime. Also in 1863, Manet made a lithograph from his painting of Lola that was used as a cover for a serenade inspired by her engaging character (no. 26).

Manet began this exact transcription of the oil with an intermediary drawing, traced from a photograph, through which he incised the design with a stylus over the softened ground of the plate (R.W. vol. 2, 369; see fig. 4). To insure the correct orientation of the etching when it was printed, he must have incised the verso of the drawing. The stylus actually cut the paper of the drawing, and it is possible to see these incisions, which vary slightly from the contours of the drawing. And these variations carry through to the etching. Other changes from the painting include Lola's costume, which is slightly more voluminous, and her position, with shoulders and head turned more toward the picture plane as she seems to confront the viewer more directly. The remaining differences between painting and etching, such as the background scenery to Lola's right in the painting that is not included in the etching, appear to denote changes made to the painting after the etching was made. X-ray analysis has confirmed the accuracy of Manet's etched copy, which is the best record of the original condition of the painting.

Like the etchings of *At the Prado*, the influence of Goya's Caprichos plates is apparent in Manet's technical approach to the etching of Lola. Again the progression of states shows Manet coming closer to the Goya model. In the first state individual lines have more integrity. The dress is a patchwork of light and dark areas corresponding to the vibrant colors of the painting, but gradually in the subsequent states this dress is more densely shaded, changing the emphasis from its surface to the contours of its shape. The background is also filled in around the figure with a continuous zig-zag scribble that achieves a neutral but lightly textured surface (see no. 24). In the third state, exhibited in a rare impression from the Rouart collection that was previously in Degas's collection, Manet sought to modulate the overall tone of the plate by adding a light grain of aquatint. This subtle tone would not have lasted through the printing of an edition, and in the fourth state a heavier grain was added. Perhaps the most impressive passage of Manet's etching, left unchanged from the first state onward, is Lola's transparent mantilla, a creamy white in the oil. For this passage, Manet drew on the plate with a fine needle in short parallel strokes, with a much softer touch than for the heavy lines of the skirt.

In the published sixth state, where a band at the bottom of the composition was removed, a quatrain by Baudelaire was added, written especially for the painting, where it originally appeared on a small card attached to

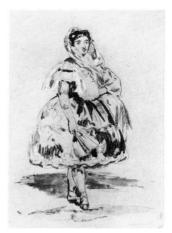

FIG. 4 *Lola de Valence*, Réunion des Musées Nationaux, Paris

the frame. For some, the clear erotic allusions of this poem were far more scandalous than the painting. The quatrain appears below, with a translation from the catalogue that accompanied the Manet retrospective in 1983, page 148:

Entre tant de beautés que partout on peut voir
Je comprends bien, amis, que le Désir balance;
Mais on voit scintiller dans Lola de Valence
Le charme inattendu d'un bijou rose et noir.

Among all the beauties that are to be seen
I understand, friends, Desire chooses with pain;
But one may see sparkling in Lola of Spain
The unforeseen charm of black-rose opaline.

26

*Lola de Valence*   (1863)

Crayon lithograph with scraping
On wove paper, folded as cover (music printed inside)
Only state
Sheet: 338 x 268 (13⅗₁₆ x 10⁹⁄₁₆ in)
Image: 245 x 215 (9⅝ x 8½ in)
Inscriptions: Signed in stone, l.l., ''éd. Manet''; in stone, above, ''LOLA DE VALENCE,'' below l. and r., ''Prix 3f, POÉSIE ET MUSIQUE/DE/ZACHARIE ASTRUC''; l.r., ''Imp. Lemercier, R. de Seine 57 Paris.''; above, l., ''Sérénade'' r., ''A Sa Majesté la Reine d' Espagne.''; below l.l. margin, ''Propriété de L'Auteur et pour tous Pays''; in pencil, l.l., ''très rare H.G.'' (Henri Guerard)
N.Y. 53, B. 73, I. 37, H. 32, G. 69, M.N. 77

*Samuel P. Avery Collection, The New York Public Library*
  *Astor, Lenox and Tilden Foundations*

Manet's third lithograph was this cover for a serenade to Lola de Valence, with words and music by Zacharie Astruc. It was published in March 1863 but probably drawn on the stone in the beginning of the year, not long after he finished the painting *Lola de Valence*. The lithograph shows the reversed figure of Lola, cropped at the hips, as a vignette. Like the etching, the lithograph was probably based on the same watercolor that was used to transfer the composition to the copper plate. But here the image was drawn directly on the

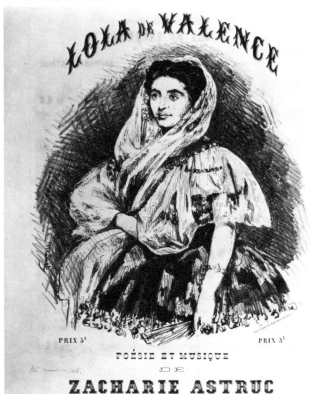

26 *Lola de Valence*

stone without an initial compositional guide because the image is enlarged and adjusted to the oval format. To accommodate this abbreviated shape, Manet raised Lola's fan so that it is contained within the lower edge of the composition. Following the details of the painting, only vaguely suggested in the watercolor, he emphasized the band of decoration on Lola's dress, which thus becomes the lower boundary of the composition. Even Manet's signature is held within the design, written vertically to the left.

Manet, obviously comfortable working on the stone, sketches the image with freedom, not encumbered by frequent reference to the model. He enjoyed the immediacy of the medium that allowed him to vary his graphic style from passage to passage. The fabric of the dress is drawn with heavy strokes in patches of light and dark, but the ornamentation is suggested in half circles drawn with the point of the crayon. It was no different than drawing on paper. But Manet understood the unique potential of the lithographic medium that allowed him to scratch highlights in already drawn areas. The fine scratches and scrapes are visible throughout the mantilla, like his careful work in the etching, which effectively suggests the transparent lightness of the garment. While Lola's facial features are more expressive than those in the etching, he has not given her the sly smirk of the painting.

The folded cover, which in the exhibited impression contains the music within, is extremely rare because of its use as sheet music. While it is conceivable that many copies are retained in music archives without consideration for the designers of covers, most of the copies apparently have been destroyed because the music was so popular. The serenade capitalizes on the widespread fascination with this Spanish dancer, and the almost equivalent fame of Manet's painting made this commission for a vignette of her figure from the painting most appropriate. Bareau summarizes the serenade's content:

> The poem evokes Lola's dancing of a seguidilla to the sound of a guitar, referring to the mortal folly inspired by her smiling eyes, the caress of her voice, and the mocking smile on her lips. It likens her to a crazed butterfly, as her feet graze and scrape the ground, her ''divine legs'' obscured from view in the shadows of her heavy parasol-like skirt. The poem concludes with a plea for another cigarette, the sound of another castanet, urging Lola to shake from her locks the jasmine flowers for which a hundred suitors will throw themselves to the ground. (New York 1983, p. 154)

## 27
*Don Mariano Camprubi (The Ballet Dancer)*   (1862–1863)
Le bailarin

Etching, in bistre ink
On laid paper, lion with sword watermark
Only state
Sheet: 366 x 257 mm (14⅜ x 10⅛ in)
Plate: 297 x 190 mm (11¹¹⁄₁₆ x 7½ in)
Image: 253 x 155 mm (10 x 6⅛ in)
Inscriptions: Signed in plate, l.l., "éd. Manet"; in lower margin,
   "don Mariano Camprubi/primer bailarin del teatro royal de
   Madrid"
B. 35, I. 30, H. 34, G. 24, M.N. 31

*The George A. Lucas Collection of The Maryland Institute, College of
Art, on indefinite loan to The Baltimore Museum of Art
B.M.A. L.33.53.5140*

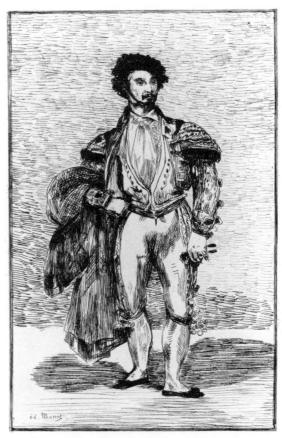

27 *Don Mariano Camprubi (The Ballet Dancer)*

T he principal male dancer in the Spanish ballet was
   Mariano Camprubi, who was older than the other
dancers and a choreographer. He had performed in Paris
as early as 1834, so the Parisian public knew him well.
(Reff 1982, 33). This etching from 1863 reproduces in
reverse Manet's oil of 1862 (R.W. vol. 1, 54), painted
about the same time as the canvas *Lola de Valence*, shortly
after the ballet company appeared in Paris in August
1862. Included in his special edition of fourteen etchings
distributed to his friends, the print was not again pub-
lished in his lifetime. The exhibited impression, on a
heavy laid paper, was designated by Lucas as a modern
impression from the Dumont edition. But this impression
is probably one of Guerard's proofs, which were usually
printed on a heavy, slightly tinted laid paper (see Leg-
end). The Dumont edition is more frequently found on a
blue-green paper, with dark brown ink. Manet inscribed
the title below, in incorrect Spanish. Bareau suggests that
this title may have been copied from a theatre announce-
ment.

   The broad, linear, and tonal style of this print is re-
markably different from other prints of this period, espe-
cially *Lola de Valence* (no. 25), which is one of Manet's
most controlled etchings where line is modulated to
translate graphically the effects of the painting. But here
the lack of an intermediary drawing, together with any
indication of a stylus transcription on the plate, suggests
that Manet may have worked directly on the plate from
his relatively small (18½ x 13 in) model. In addition to
variations in costume detail, the figure is much more
stocky in the etching. The etched lines, strongly bitten
and widely spaced with little variation in width, have not
been altered to reflect the brushwork in the painting. The
etching style is rapid and spontaneous. While using the
same zig-zag line for this background as he had for *Lola
de Valence*, the more open style and the lack of aquatint
tone create an insubstantial flickering backdrop for the
figure, rather than a neutral foil. Only one state is re-
corded for this plate, but unlike *The Philosopher* (no.
32)—which was obviously unfinished—it is clear that Ma-
net's conception of this print was fully realized without
the gradual addition of shading through several states
and intermediate proofs.

   The stylistic character of this plate was not an arbitrary
decision on Manet's part, but typically it was in response
to the character of the original painting. Unlike the large
painting of Lola (48½ x 36¼ in), the portrait of Mariano
Camprubi was a small and intimate canvas, painted with
the immediacy of a sketch, in intense colors of red, blue,
black, and white against a neutral background. In making
this etching, perhaps working directly on the plate from
the painted model, Manet was still captivated by the
vigorous style of the original, and he drew accordingly in
a manner entirely different from his contemporary etch-
ing *Lola de Valence*.

## 28
*At the Prado* (1863)
Au prado

Etching, aquatint
On chine paper
First state of two, from the c. 1863 edition of fourteen etchings
Sheet: 253 x 180 mm (9¹⁵⁄₁₆ x 7³⁄₁₆ in)
Plate: 222 x 155 mm (8¾ x 6⅛ in)
Inscriptions: None
B. 53, I. 40, H. 45, G. 46, M.N. 62

*The Detroit Institute of Arts, Founders Society Purchase
General Endowment Fund 70.591*

A second version of *At the Prado*, exhibited here in a rare impression of the first state, is more successful than the first in design and execution. In this second version, Manet carried Goya's influence even further and, in a somewhat larger format, created an image of dramatic graphic impact. This plate was eventually reworked in 1866 or 1867 in a much darker aquatint (see no. 47). The first state was included in at least some of the portfolios published for distribution to Manet's friends beginning in 1863. While the title "Au Prado" does not appear on the cover for this edition, it was included on the watercolor study and in pen, in place of "la m^de de cierges," on the impression of the cover included in this exhibition (no. 29).

As Bareau points out in her 1978 catalogue, from the first version to the second, Manet transformed a Spanish matron with umbrella into a maja with fan. Although Suzanne Leenhoff reportedly was the model for this print, the features here do not seem as individualized as in the first version. Like *Exotic Flower* (no. 45), for which Leenhoff also modeled, Manet seems to have idealized her features. Manet's study of plate 27 from Goya's Los Caprichos is even more apparent in the second version, for details such as the two dogs are a direct borrowing from Goya's plate. The background group is also simplified and the use of aquatint is more basic to the overall visual effect. The figure of the maja, larger in scale and close to the picture plane, becomes a silhouette, darkened against a second plane of intermediate grey tone achieved with a sparse aquatint grain that extends to the background trees. The maja is moved to the left of the composition, and the viewer is led through the right background, first to the man behind and to the left, then to the other young woman in the middle ground in a pose that echoes the foreground maja, and finally to the lightened hat of the man to the right. Behind him are trees that seem no more than cutout shapes against the sky.

In this print Manet also evolved a different type of etched line based on his study of Goya, which he used frequently in prints of this period and later. The strongly etched parallel lines visible on the mantilla and dress of the maja in the first version become a kind of continuous vertical zig-zag in the rendering of her dress in this version. This approach, first seen in the *Boy with a Sword* (no. 18), is more visible in the background of *Lola de Valence* (no. 25) or *The Ballet Dancer* (no. 27). While based on Goya's model, Manet's aim was different. Goya used

this continuous line to suggest tone, while Manet, much like Fragonard and before him Tiepolo, used this line to suggest a kind of shimmering, unstable surface, like moiré. The background figures are drawn with only a few widely spaced parallel lines because Manet relied almost entirely on the aquatint grain to shape the figures. Here aquatint covers the entire plate, dramatically stopped out in the sky and receding along the right from the immediate foreground. This print represents a major advancement toward the type of prints Manet would make in a later period of etching activity in 1866–1867. Both technically and compositionally, this plate is one of the most experimental in Manet's oeuvre, for his creativity was stimulated by an admiration for Goya. Through his example, Manet concentrated on issues of printmaking, rather than the search for graphic equivalents to ideas that began as paintings.

*28 At the Prado*

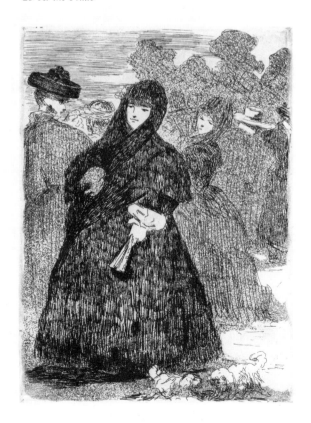

## 29

*Illustrated Cover for an Edition of Etchings (Hat and Guitar)*   1862–1863

Etching, aquatint, drypoint
On wove paper, folded as cover
First state of six, from the c. 1863 edition of fourteen etchings
Sheet: 450 x 316 mm (17¾ x 12⁷⁄₁₆ in)
Plate: 438 x 296 mm (17¼ x 11¹¹⁄₁₆ in)
Image: 332 x 225 mm (13¹⁄₁₆ x 8⁷⁄₈ in)
Inscriptions: In plate, c., "Eaux = fortes/par/Edouard Manet";
    below, in two columns,

| | |
|---|---|
| Philippe IV (Velasquez) | le guitarero |
| les petits Cavaliers (did) | Lola de Valence |
| ("id" and crossed out "d" | l'espada |
|     are in pen) | le bailarin |
| l'enfant à l'épée | Les gitanos |
| le buveur d'absinthe | la toilette |
| le gamin | la m^de de cierges |
| la petite fille | le gamin |
| l'enfant et le chien | (last two lines crossed out |
| |     in pen) |
| | le prado (in pen) |

in pen, u.r. margin, "à P.M [erasure] témoignage d'amitié/
    Edouard Manet"
N.Y. 47, B. 68, I. 35, H. 39, G. 62, M.N. 1

*Samuel P. Avery Collection, The New York Public Library
Astor, Lenox, and Tilden Foundations MN1*

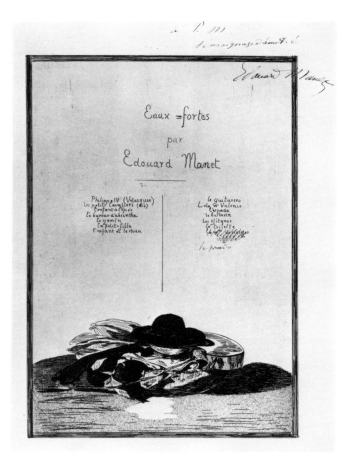

29 *Illustrated Cover for an Edition of Etchings (Hat and Guitar)*

Manet was not able to complete satisfactorily an illustrated cover for the 1862 Cadart edition of his eight etchings, in spite of two attempts (see no. 21). A typographical title page was substituted for the illustrated covers usually included with such projects. Through a diligent comparative study of Manet's prints, Bareau was able to determine that there had been a special edition of the artist's prints, fourteen in all, that Manet probably published himself for distribution to his friends. Bareau believes Manet distributed this special edition beginning in 1863 and continued throughout the next several years (New York 1983, pp. 139–141). The third design for a portfolio cover, *Hat and Guitar*, was intended for this edition but was subsequently used in a reduced version, without the written titles but with a new typographical title, for Cadart's 1874 edition of the prints. The central motif of the cover, above which Manet inscribed the title and list of contents for the portfolio, is the same as the reduced version (H. 38). It represents a basket of Spanish costumes and props worn by studio models in various paintings, including *The Espada* (no. 19) and *The Gypsies* (no. 15 and 16). For both cover designs, this still-life element was copied in reverse from a painting that hung above the door of Manet's studio (R.W. vol. 1, 60), where the costumes in a basket are placed against decorative wall molding that in the second version becomes a curtain. For this cover design, Manet transferred his design from an intermediary watercolor (R.W. vol. 2, 671) that included some of the titles written in reverse.

The watercolor design was transferred to the copper plate with a stylus, following Manet's normal procedure for etchings of this period. The hat, guitar, and basket of costumes were carefully drawn in a more precise, regu-

lar style than is evident in the second version of the cover. As in the painting and watercolor, this still-life motif is brightly lit with stark contrasts of light and dark. A sparse aquatint ground was also added in the foreground. Using his reverse writing in the watercolor as a guide, Manet wrote the titles of the portfolio's contents in the center of the page in two columns. Mistakes are evident, such as the letter reversal after "les petits Cavaliers," "di" instead of "id" (idem), or the double listing of "le gamin." In the exhibited impression, Manet corrected these mistakes in pen by scribbling out the errors.

Five impressions of the first state, used for the edition of 1863, have been recorded, all of which were dedicated to friends. The exhibited impression was dedicated "à P. M[erasure]." Bareau suggests that the name is either Paul Montluc—to whom the 1862 portfolio was dedicated—or Paul Maurice (New York 1983, p. 140). This impression is one of two (the other in The Art Institute of Chicago, former Guerard collection) on the full sheet, folded to contain the prints. The impression from the Bibliothèque Nationale, dedicated to Baudelaire, also contains an inscription "28 pieces EM," which Bareau takes as an indication of the edition size. It is conceivable, however, that this inscription indicates that Manet gave Baudelaire a double set of the fourteen etchings, perhaps on different paper, thus the total of twenty-eight. There are no com-

plete sets of the fourteen prints extant, although a set of the prints, which are all on chine from the former collection of Morel Vindé, was recently broken up and offered for sale (Catalogue "Watteau," 173. Paris: Paul Prouté S.A. 1984). Prints that have been identified as part of this edition are obvious from their careful presentation. On chine that was originally attached at the upper corners to a support sheet, the etchings are printed in a brown-black ink, carefully applied to record with clarity even the most delicate of Manet's etched lines. The overall tone of these beautifully printed impressions is warm, and they are certainly the finest impressions of Manet's etchings. Comparatively few of these impressions have been recorded, and this fact, together with the discovery of only five covers, strongly suggests that Manet never produced twenty-eight of these portfolios.

Apparently Manet was unsure of the contents for this portfolio as there are variations between the titles in the watercolor and the etched cover. On the exhibited impression, Manet scribbled out the title "la m^de de cierges" (no. 10) and substituted instead "le prado" (see no. 24 and 28). This is not the case with either the portfolio's cover dedicated to Baudelaire, or that in The Art Institute of Chicago from the Guerard collection, which perhaps included *The Candle Seller*. The contents more likely varied somewhat from person to person. It is not possible to determine how long Manet distributed this portfolio, but it was probably over several years. Because it included prints completed in late 1862 or early 1863, including *At the Prado* (no. 28) and *The Ballet Dancer* (no. 27), the edition likely dates from 1863. Proofs and watercolors appear on paper used for the Société des Aquafortistes in 1862–1863.

30
## *The Infanta Marguerita*   (1862–1864)
Infante Marguerite

Etching, drypoint, in bistre ink
On heavy laid paper
Only state
Sheet: 286 x 241 mm (11¼ x 9½ in)
Plate: 230 x 189 mm (9 x 7⅜ in)
Image: 161 x 146 mm (6⁵⁄₁₆ x 5¹³⁄₁₆ in)
Inscriptions: None
B. 21, I. 19, H. 14, G. 6, M.N. 14

*The George A. Lucas Collection of The Maryland Institute, College of Art, on indefinite loan to The Baltimore Museum of Art*
*B.M.A. L.33.53.5135*

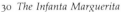

Manet's etching *The Infanta Marguerita*, after a painting in the Louvre by Velázquez (Lopez-Rey 398), is like *Silentium* (no. 23) extremely difficult to place in Manet's printmaking oeuvre. Guerin dated the print 1860, as one of the earliest prints in Manet's career, while Harris dates it 1861, relating it to other early prints that evidence Manet's initial interest in Goya's etching style. The subject, a Velázquez painting, relates the print to Manet's early studies of Velázquez in the Louvre, rather than to his later study in Spain. The print was published only once in Manet's lifetime, in the 1874 Cadart edition. The print might reproduce an oil copy of the Velázquez, which Tabarant remembered but which has never been located. It might also have been based on a wash drawing, also never located (R.W. vol. 2, 69). Degas also copied the Velázquez, and his work (Reed and Shapiro

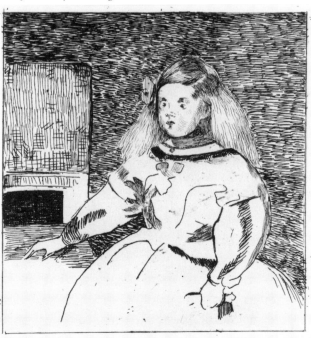

30 *The Infanta Marguerita*

16) is actually a more literal transcription than Manet's. Until recently the Degas was dated 1861, but now, like the Manet, it is dated c. 1862–1864.

Manet's reductive approach to this etching, with its linear clarity not unlike *Silentium*, was surely intentional, and Bareau concludes that the etching must come later in Manet's oeuvre, in late 1862 and possibly as late as 1864 when his etching production dwindled. In late 1862 and 1863 Manet was preparing a portfolio of fourteen of his etchings for private distribution to his friends, and like *Silentium*, he may have considered making this etching as a personal comment on an earlier interest in Velázquez. Appropriately though, Manet veers from a faithful reproduction of the original, such as his early prints *The Little Cavaliers* (no. 6) or *Philip IV* (no. 13 and 14), and offers a more interpretive approach that as Bareau points out reflects a study of Goya's early copies of Velázquez. Manet constantly searched through his earlier work for ideas or subjects, so a retrospective study of Velázquez, newly interpreted through his interest in Goya, would be typical of Manet's artistic approach.

The exhibited impression from the Lucas collection on a slightly tinted heavy laid paper, is similar to other proofs that can be identified as printed by Guerard before the posthumous edition by Dumont. These proofs could date from the later years of Manet's lifetime or could be posthumous since Guerard advised Manet's widow in the early posthumous editions of his etchings (see Legend). This proof, typical of Guerard's, is printed cleanly without the plate tone and retroussage of the Dumont edition.

31
*Felix Bracquemond*   (c. 1805)

Pen process etching (lift ground)
On heavy laid paper
First state of two
Sheet: 305 x 219 mm (12 x 8⅝ in)
Plate: 167 x 112 mm (6⁹⁄₁₆ x 4⅜ in)
Image: 95 x 91 mm (3¾ x 3⁹⁄₁₆ in)
Inscriptions: None
B. 49, I. 46, H. 42, G. 42, M.N. 60

*The Boston Public Library, courtesy, the Print Department*

After a period of inactivity as an etcher in 1864, Manet returned to printmaking sometime in 1865–1866, perhaps with a view toward a new publication of his etchings. In this period he benefited from the encouragement and technical advice of Bracquemond. One of the earliest works of this second period is the portrait *Felix Bracquemond*, never published in Manet's lifetime but posthumously printed as a frontispiece in Moreau-Nélaton's 1906 catalogue raisonné of Manet's prints. The print, exhibited here in a rare lifetime proof, is known in

31 *Felix Bracquemond*

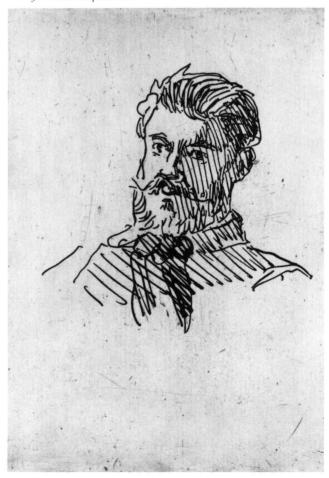

only a few such impressions (also, The Art Institute of Chicago, former Guerard collection). In his book, Moreau-Nélaton dated the print 1865, although it might have been executed a year later (Bouillon 1974, p. 5). Obviously, its style bears little relation to Manet's other prints and is more akin to his drawings. A secure dating of this piece will have to wait until the complicated problems of Manet's pen-and-ink drawings can be studied further.

For this print, Manet used a process that was invented by Bracquemond (Bouillon 1974, pp. 3–11) but only used by Manet in this one instance—the so-called pen process. The artist would draw on the carefully cleaned copper plate with a pen and regular ink. A light etching ground would then be applied over the ink, and the plate then submersed in water. The water would soften ink and ground above, so that when gently rubbed with flannel, after about forty minutes in the water, the ground would lift off, leaving the plate bare where the pen lines had been drawn. The plate would then be etched, resulting in broad, relatively shallow lines that correspond in character to the lines of a pen on paper. The difficulty came in the printing, as the lines were too wide to hold ink easily. In addition, as the plate was printed, the pressure of the press flattened the edges of the lines, making the problem even more acute. For this reason, the pen process could not be used for a large edition, as the poor quality of the Moreau-Nélaton printing indicates. To make these proofs successful, printing was done with great care, and a heavy film of ink was left on the plate to insure that all the vulnerable ink stayed in the shallow lines. In his 1866 treatise on etching, Lalanne describes the process clearly, giving credit to Bracquemond for developing the idea (Lalanne 1866). Manet's portrait is a lively rendition of this consummate printmaking technician. The print must have been considered by both to be an entertaining experiment, which if successful could have had the same autographic appeal as Manet's later use of transfer processes (see no. 65–71). The exhibited impression of this plate is from the former Guérin collection.

**32**
*The Philosopher*   (1865–1866)
Le philosphe

Etching, drypoint, in bistre ink
On light green laid paper, indecipherable watermark
Only state, from the 1894 Dumont edition
Sheet: 378 x 263 mm (14⅞ x 10⅝ in)
Plate: 314 x 233 mm (12⅜ x 9³⁄₁₆ in)
Image: 270 x 160 mm (10⅝ x 6¼ in)
Inscriptions: None
B. 50, I. 42, H. 47, G. 43, M.N. 35

*The George A. Lucas Collection of The Maryland Institute, College of Art, on indefinite loan to The Baltimore Museum of Art*
*B.M.A. L.33.53.5159*

During Manet's short stay in Spain in 1865, he was most enthusiastic about the paintings of Velázquez, especially the two full-length portraits of philosophers Aesop and Menippus. After returning to Paris, he began to work on two paintings, *The Philosopher* and *The Philoso-*

32 *The Philosopher*

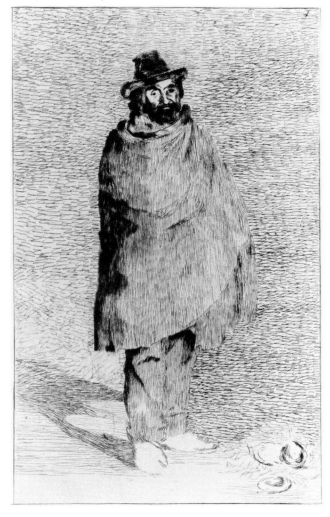

*pher with Cap* (R.W. vol. 1, 99 and 100), both now in The Art Institute of Chicago. Both works transform a Velázquez model into a contemporary Parisian type, the beggar-philosopher, who was disappearing because of the displacement created by Haussman's construction of a modern city.

With a probable view toward another edition of his prints, Manet began an etching after his painting *The Philosopher* but never finished the plate. It is known in only one incomplete state, which was not published until Dumont's 1894 edition of Manet's prints. The exhibited impression comes from this edition and is typically printed in a light brown ink on a colored paper, although the greenish paper of this impression is different from the more common blue-green paper used for Dumont's edition of thirty copies (see no. 34). This impression could also be a Guerard proof (see Legend). The only recorded lifetime proof is now in The Art Institute of Chicago, former Guerard collection. In this plate, Manet touched up his finely etched plate with a drypoint needle, which in the lifetime impression appears as feathery black patches against the etched lines elsewhere. In the Dumont impression, exhibited here, the drypoint areas are somewhat muted but still effective. Retroussage inking was used in this edition to retain the soft drypoint quality. In order to withstand the printing the copper plates were steel faced sometime during the three posthumous editions but probably not before the Strölin edition, for that was the one large edition of the three. The impressions from the Dumont edition do not appear to have lost much of their clarity, although they do tend to be somewhat overinked. The Strölin prints that are on a heavy paper, unsympathetic to Manet's etching style, suffer when compared with prints from other editions.

Evidence that this plate was abandoned includes the sketchy area at the bottom of the composition where the shoes and the still life of oysters with hay are only quickly drawn. Harris suggests that Manet abandoned the plate because it lacked forcefulness. This understated quality, with the slight touches of drypoint providing shaded accents, creates a graphic equivalent of the painting, an exquisite low-key harmony of blues, blacks, and greys. The finely drawn, parallel, and generously spaced lines of the cloak dissolve its substance much as the continuous zig-zag line in the background achieves a neutral but shimmering effect. Manet's working method for putting this composition on the plate is unclear since no intermediate drawings have been located and there are no signs of transfer on the plate. Perhaps he used a photograph of the painting because he carefully reversed his drawing on the plate so that the print would be in the same orientation as the original.

## 33
### *The Tragic Actor*   (1865–1866)
L'acteur tragique

Etching
On chine paper, mounted on white wove, not adhered
First state of two
Sheet (irregular): 367 x 220 mm (14½ x 8¹¹/₁₆ in)
Plate (trimmed): 366? x 218 mm (14⅜? x 8⁹/₁₆ in)
Image: 298 x 160 mm (11¾ x 6¼ in)
Inscriptions: In pencil, l. margin, ''L'acteur tragique—Rouvière dans le role d'Hamlet. Eau-forte de Manet''
M. 51, I. 41, H. 48, G. 44, M.N. 38

*Samuel P. Avery Collection, The New York Public Library Astor, Lenox and Tilden Foundations MN 38*

## 34
### *The Tragic Actor*   (1865–1866)
L'acteur tragique

Etching, in bistre ink
On blue-green laid paper
Second state of two, from the 1894 Dumont edition
Sheet: 376 x 239 mm (14¹³/₁₆ x 9⅜ in)
Plate (trimmed): 366? x 218 mm (14⅜? x 8⁹/₁₆ in)
Image: 298 x 160 mm (11¾ x 6¼ in)
Inscriptions: Signed in plate, l.r., ''Manet''
B. 51, I. 41, H. 48, G. 44, M.N. 38

*The George A. Lucas Collection of The Maryland Institute, College of Art, on indefinite loan to The Baltimore Museum of Art B.M.A. L.33.53.5141*

While Philibert Rouviere was one of the best known actors of his day, his lack of popular success contributed to a life of hardship and deteriorating health. Rouviere was famous for his role as Hamlet, and he performed in an exaggerated style and with great intensity, which earned him staunch admirers such as Baudelaire. Reff suggests that Rouviere may have modeled his stage manner on the poses and staging of Delacroix's Hamlet lithographs of 1843 that, when published a second time in 1864, were extremely popular and certainly known to Manet as well. Another dimension to Rouviere's popularity in Manet's circle was his activity as a painter who exhibited a self-portrait in the role of Hamlet in the Salon of 1864.

It is now generally agreed that Manet began his painting of Rouviere, which is now in the National Gallery of Art in Washington, D.C. (R.W. vol. 1, 106), after Manet's return from Spain in fall 1865. Yet Rouviere's death in October 1865 forced Manet to use other models to finish the portrait. Contemporary with Manet's paintings of beggar-philosophers, the portrait of Rouviere was influenced by Velázquez's portrait of actor Pabillos de Valladolid. But Solkin saw in the composition a more immediate reference to the long tradition of French popular prints depicting actors on stage—a tradition given artistic stature by such artists as Delacroix and Chassériau (Solkin 1975, p. 705). Since the print was made after Rouviere's death, Reff suggests that its possible purpose may have been to commemorate the actor. He found the dramatic diagonal lighting, with its mysterious spatial

implications that are different in the painting, to be an appropriate effect for a memorial (Reff 1982, 30). Whether or not this suggestion is correct, within the normal interpretive range of his etching Manet again took great care to insure this print's accuracy as a representation of the painting. Like *The Philosopher* (no. 32), *The Tragic Actor* was never published in Manet's lifetime and was distributed for the first time in the 1890 memorial portfolio. In some catalogues *The Tragic Actor* and *The Ballet Dancer* (no. 27) were considered tragic and comic pendants.

The etching is known in only two states, both of which are included in the current exhibition. The impression of the first state is one of two known impressions, while the second is from the Dumont edition of 1894, printed in a brownish ink on the typical blue-green paper of his edition of thirty copies. The etching is in the same orientation as the original, but like *The Philosopher*, there are no known preparatory drawings that would have helped

Manet transfer the composition to the copper plate. But an indication of a stylus transfer on the plate is visible in the first state. By this time Manet had developed a reliable working method for reversing the drawing of his compositions, possibly using photographs of the paintings. As mentioned above, Manet made a major revision to the composition in his treatment of the background. In the painting, he divided the space horizontally to indicate a floor and back wall and disclosed the light source with the shadow of Rouviere's legs and sword. But in the print this effect is even more pronounced—he eliminated the floor-wall relationship making the space even less specific. The effect is more theatrical because the stage lighting is exaggerated and the surroundings seem very artificial. The neutral background further accentuates the dark profile of the figure.

In the second state, Manet added shading to both Rouviere's costume and the background. The costume loses

33 *The Tragic Actor*

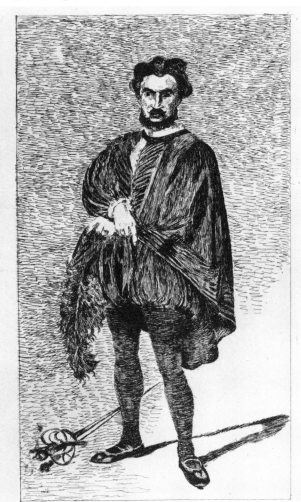

34 *The Tragic Actor*

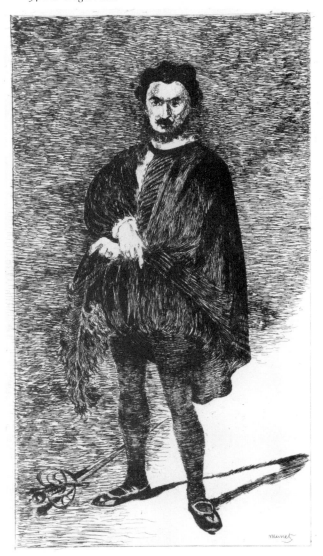

the surface texture that Manet achieved with directional shading and, instead, becomes a mass, more somber in effect. These changes to the plate between first and second state are exaggerated by the Dumont printing, where plate tone fills the spaces between lines, reducing clarity and enhancing the flat, dark profile. The brown ink and colored paper of this printing reduced the black-and-white contrast that made the first state so direct and spontaneous. Manet's prints frequently show areas of indecision, and one such instance in this print concerns the features and modeling of the face. In the painting, Rouviere's expression is carefully studied. With his head turned frontally against the leftward twist of his body toward the light, he theatrically looks to the right. In the first state of the etching, his expression is muddled, obviously not executed with much care. In addition, following the intense directional lighting suggested by the diagonal of light and dark in the background, Manet modeled the face with more shading on the right cheek than appears in the painting. In the second state, Manet removed some fine etched lines around the eyes, achieving a more concentrated stare, and it becomes clear that he has abandoned the painting's sideways glance in favor of a forward stare. This change, which gives Rouviere direct contact with the viewer, is too significant to have been accidental or the result of inability. The modeling of the face is also changed. By removing some of the shading on Rouviere's left cheek, Manet returned to the more frontal illumination of the painting and ignored the exaggerated lighting he chose to add to the print. This print is an excellent illustration of the creative dialogue that existed between print and painting.

## 35
*Marine*   (1865–1866)

Etching, aquatint, roulette, bitten tone (soft ground?)
On green laid paper (vedâtre)
Only state
Sheet: 194 x 255 mm (7⅝ x 10 in)
Plate: 138 x 200 mm (5⁷⁄₁₆ x 7¹³⁄₁₆ in)
Image: 120 x 179 mm (4¾ x 7 in)
Inscriptions: None
B. 45, I. 47, H. 40, G. 35, M.N. 39

*The George A. Lucas Collection of The Maryland Institute, College of Art, on indefinite loan to The Baltimore Museum of Art*
B.M.A. L.33.53.5111

Manet made only two landscape etchings: the first, one of his earliest prints, *The Travelers* from 1861–1862 (no. 7), and the second, *Marine* from 1865–1866. The relationship of this etching to the four catalogued marine scenes that he painted from summer 1864 into 1865, is problematic because there is no known painting of this exact composition. But all these works, including the etching, are closely interconnected in composition as well as in motif. In a 1962 article, Hanson tried to demonstrate that the etching, or the lost painting that it may have been based upon, was actually a pastiche of elements from various other canvases in this group (Hanson 1962, pp. 334–335). The 1864 series of works, some painted in the studio and others in Boulogne, began with *The Battle of the Kearsarge and the Alabama* (R.W. vol. 1, 76), now in the Philadelphia Museum of Art, and concluded with *Sea View, Calm Weather* (R.W. vol. 1, 78) in 1864–1865, now in The Art Institute of Chicago. The etching, with its turbulent sea, shows a fishing boat driven inward by the wind, as in the Chicago picture and the earlier *Fishing Boat Coming in before the Wind (Kearsarge at Boulogne)* (R.W. vol. 1, 75), now in a private collection. The porpoises were taken from a second picture in the Philadelphia Museum of Art, *Steamship* (R.W. vol. 1, 86).

Moreau-Nélaton first made the suggestion that the etching represented a lost painting, one of four marines exhibited by Manet at the Avenue de l'Alma exhibition of 1867, titled "Bateau de pêche arrivent vent arriere," a position Hanson supported (Moreau-Nélaton 1926, vol. 1, p. 63; Hanson 1962, pp. 333–334). The catalogue for the 1983 Manet retrospective proved convincingly, however, that all four works from this exhibition are the four marines mentioned above. The "missing" picture, with a title that could as well be given to the etching, is actually the painting Cachin now titles *Fishing Boat Coming in before the Wind*, or its traditional title of *Kearsarge at Boulogne*. A final complication is the Rouart and Wildenstein catalogue raisonné of paintings, which assigns the title of the "missing" picture to another totally different oil that Cachin feels is unrelated to this series.

Thus if there was a painting that served as the model for this etching, it has never been recorded or exhibited, an unusual situation for this much-studied artist. More likely the print represents one of those rare cases in Manet's oeuvre where a print is an original composition. It is puzzling that Manet would have chosen this option

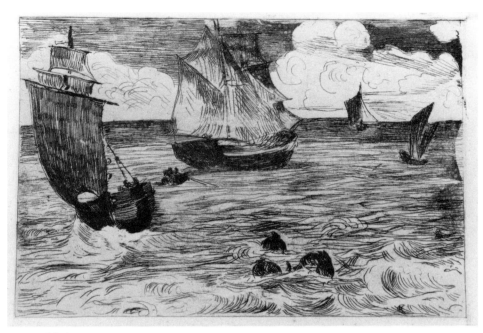

35 *Marine*

over an interpretation of an existing oil, especially since some paintings in the series had already been exhibited at the Galerie Martinet in 1865. Because of its topical theme, Manet could have been expected to work after his *The Battle of the Kearsarge and the Alabama,* which had been exhibited at Cadart's in 1864, or the related *Kearsarge at Boulogne,* showing the famous ship after the battle. Since one of the basic purposes of Manet's printmaking was to disseminate his art to a wider public, he clearly sought to benefit from the fame of certain pictures although most of the public comment on *The Battle* came after its exhibition in the Salon of 1872. Instead, Manet apparently devised an original composition, based on the other oils of this period, and drew directly on the plate without the guidance of intermediate drawings. The two-masted brig in the center of the etching is the same ship that appears in *Steamship,* but it is now repositioned with unfurled sails. Manet had filled sketchbooks with such scenes, which could have served as a model for this change. If after returning to his Paris studio, Manet painted the stylisitically different *Sea View, Calm Weather,* "the most remote from natural observation," as Cachin suggests, then the etching should precede this work, now dated 1864–1865 (New York 1983, p. 225).

In harmony with the broad paint handling of the oils, Manet executed this plate with vigor, conveying the animation of sea and wind-driven clouds. The distant horizon is suggested by a band of more closely spaced lines behind the masted brig. The ocean is darkened with the application of roulette and a bitten tone, stopped out at the right edge. An aquatint grain is visible, but the texture of the tone in the clouds may be the soft ground

described by Lalanne in his 1866 treatise as "mottled tints," where a regular etching ground is heated and pressed with a dabber covered with varnish, which picks up the ground in an irregular pattern (Lalanne 1866, p. 76, pl. 5, fig. 2).

These experimental effects suggest a direct approach to printmaking found also in *The Rabbit* (no. 36). With the encouragement of Bracquemond or possibly Guerard, Manet may well have intended to edit prints of a more reproductive nature, such as *The Philosopher* (no. 32), with more personal testaments of his artistic interests, such as *Silentium* (no. 23) or *The Infanta Marguerita* (no. 30), together with his examples of original printmaking, such as *Marine.* No edition of these two experimental etchings was ever realized, and there is no factual knowledge to determine why Manet was preparing these plates. Like many prints from this period, *Marine* was never published in Manet's lifetime. The exhibited impression is probably from the Dumont edition of 1894, the first edited printing of this plate. Yet its green rather than blue-green paper is unusual, although Dumont may have used different papers, or it could be one of the Guerard proofs (see Legend). The quality of this impression does not approach in strength or clarity the impression from Yale University, which must be one of the Guerard proofs pulled during Manet's lifetime. A similar impression can be found in The Art Institute of Chicago, former Guerard collection. Such impressions, printed on vedâtre paper similar to the exhibited impression, are very rare. The Dumont impressions, while better than the Strölin edition, are somewhat overinked so that retroussage blurs the lines that the use of brown ink weakened visually.

36
*The Rabbit* (1866)
*Le lapin*

Etching, drypoint, bitten tone
On laid paper, partial watermark WH
Only state
Sheet: 158 x 113 mm (6³⁄₁₆ x 4⁷⁄₁₆ in)
Plate: 135 x 102 mm (5⁵⁄₁₆ x 4 in)
Inscriptions: In pencil, l.l. margin, ''non decrit''
B. 56, I. 48, H. 62, G. 50, M.N. 64

*The George A. Lucas Collection of The Maryland Institute, College of Art, on indefinite loan to The Baltimore Museum of Art*
*B.M.A. L.33.53.17808*

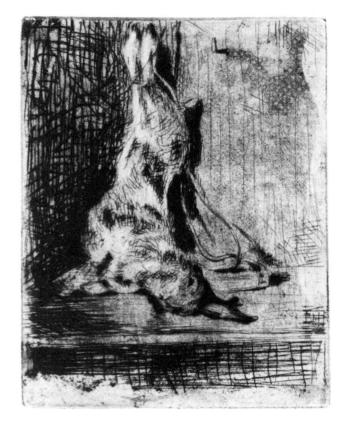

36 *The Rabbit*

*T*he Rabbit is one of two prints in Manet's oeuvre that conveys the artist's interest in still-life painting; the other is *Illustrated Cover for an Edition of Etchings (Hat and Guitar)* (no. 29). Manet's early still lifes show a great reliance on the art of the past, and clearly Manet's mentor for *The Rabbit* was Chardin. While there is no direct prototype in Chardin's oeuvre, Manet's painting relates to several still lifes of rabbits and is most often compared with a painting in the Louvre (Wildenstein 705). This rare etching, known in only five impressions, is a reversed copy of a Manet painting dated 1866 (R.W. vol. 1, 118), exhibited in the Avenue de l'Alma exhibition of 1867. In addition to the Lucas impression there is also an impression at The Detroit Institute of Arts, the former Rouart collection impression.

The spontaneous directness of this small print suggests that Manet worked directly on the plate, his painting in mind, but unaided by the use of intermediate drawings. If so, his approach was similar to that of *Marine* (no. 35). Here his drawing style is rapid and immediate and like his earlier prints, somewhat impatient and impulsive. The left side of the background, for example, is roughed in with strong parallel lines, crossed with slashing diagonals. The rabbit's fur is drawn with short strokes in various directions, accented with patches of dark crosshatching. The feathery black of drypoint lines outlines the ears and shades the right profile of the rabbit. In this impression, the rich black character of drypoint and etched lines is enhanced with the use of retroussage, where ink had been carefully pulled from the lines, reducing sharpness. One detail, striking because of its visual clarity, is the hook in the wall—simply drawn with a shaded stem and a highlighted face that jumps forward like a detail in a trompe l'oeil painting. The final important component of Manet's etching technique in this plate is the introduction of tone, using aquatint or another corrosive process, thereby enhancing the painterly effects of the etching. One of these rare proofs belonged to Bracquemond, and he very likely helped Manet apply tone to the plate, printing the impressions as well. While possibly an aquatint, the tone has a textural, irregular component that could have incorporated the soft tone of a sulphur tint, the direct application of acid to the plate, or the ''mottled tints'' described by Lalanne (see no. 36), which can create irregular, almost accidental textures. The spotty effect in the upper right is reminiscent of the

difficulties Manet experienced in the aquatint additions to *At the Prado* (no. 47). There do not appear to be any differences between the rare proofs of this print, so the recording of only one state is an accurate reflection of the more experimental and direct rendering of this design. It has been assumed that the rarity of this print, abandoned unfinished after a few proofs, somehow reflected technical failure and a lack of precise draftsmanship, a position that overlooks its intimate charm as a spontaneous, personal work.

Manet's purpose in making this plate is not known, although it is possibly related to his independent exhibition in the Avenue de l'Alma in 1867, which included the cognate painting. Perhaps it was part of an edition of prints planned to show a more personal, wider view of his printmaking activities, including such prints as *Marine*. Or like the portrait *Felix Bracquemond* (no. 31), a collaborative effort with Bracquemond, it could have been an exercise in printmaking for the artist's own enjoyment that he never intended for publication.

37
*Dead Christ with Angels*   (1866–1867)
Christ aux anges

Etching, aquatint
On chine paper
First state of three
Sheet: 443 x 327 mm (17⅜ x 12⅞ in)
Plate: sheet trimmed to plateline, 392 x 327 (15⁷⁄₁₆ x 12⅞ in)
Image: 327 x 278 mm (12⅞ x 10¹⁵⁄₁₆ in)
Inscriptions: In pencil, l.l. margin, ''Manet'' (not Manet's
   signature)
N.Y. 76, B. 44, I. 51, H. 51, G. 34, M.N. 59

*The Detroit Institute of Arts, Founders Society Purchase
   General Endowment Fund 70.588*

38
*Dead Christ with Angels*   (1866–1867)
Christ aux anges

Etching, aquatint
On chine paper
Third state of three
Sheet: 515 x 380 mm (20⁵⁄₁₆ x 15 in)
Plate: 398 x 330 mm (15¹¹⁄₁₆ x 13 in)
Image: 331 x 281 mm (13¹⁄₁₆ x 11¹⁄₁₆ in)
Inscriptions: In pencil, l.r. margin, ''Le christ aux anges''
N.Y. 76, B. 44, I. 51, H. 51, G. 34, M.N. 59

*Samuel P. Avery Collection, The New York Public Library
   Astor, Lenox and Tilden Foundations MN59*

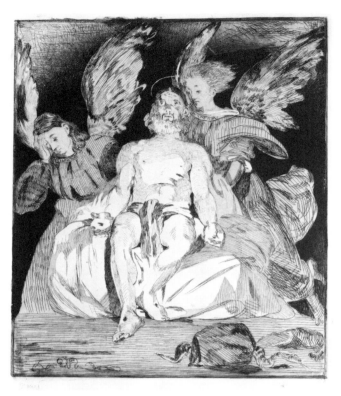

37 *Dead Christ with Angels*

M anet exhibited his large canvas *Dead Christ with Angels* (R.W. vol. 1, 74), now in The Metropolitan Museum of Art, in the Salon of 1864, along with *Episode from a Bullfight*, which he later cut into fragments. Both works provoked a great deal of negative criticism, which was only exceeded in the following year when he exhibited *Jesus Mocked by the Soldiers* (R.W. vol. 1, 102) and *Olympia*. Viewing *Dead Christ*, critics were especially vehement in their objections to the cadaverlike realism of the Christ figure. There was some favorable comment, however, perhaps best represented by Gautier who, while objecting to the vulgarity of the picture, greatly admired Manet's ''painting'' (Hamilton 1954, pp. 57–58). The canvas was exhibited again in Manet's Avenue de l'Alma exhibition in 1867, accompanied by Zola's pamphlet, where the painting was given tremendous praise. About the time of this exhibition Manet began work on his largest etching, an ambitious interpretation of this important and notorious painting. Bareau suggests that Manet may have intended to show this etching along with several other prints in a section of the Avenue de l'Alma exhibition. Certainly the size of the plate would have been an obstacle to its publication in normal journals or portfolios. The etching, however, was not included in the exhibition. Because Manet's purpose in making this etching was to achieve an accurate rendition of the painting in the proper orientation, he prepared a fully realized watercolor (see fig. 5), in reverse, that was probably traced from a photograph. Then, perhaps using another tracing, since there are no indentations of a sty-

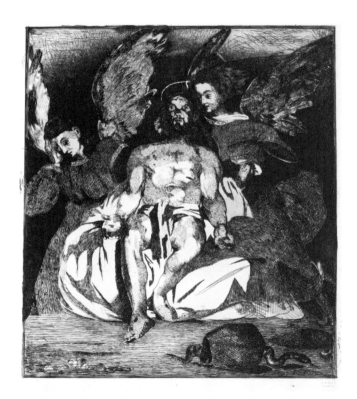

38 *Dead Christ with Angels*

FIG. 5 *Dead Christ with Angels,*
Réunion des Musées Nationaux,
Paris

lus on the drawing, Manet transferred the exact outlines of his watercolor to the plate. The watercolor, now in the Louvre, was given at that time to Zola in recognition of his collaboration in this important exhibition.

Included in the current exhibition are two states of this impressive print that when seen together convey the details of Manet's approach to this ambitious undertaking. The changes that occur from the first to the final state of the print reflect the very nature of Manet's interest in printmaking. They also illustrate the creative tension that grew from the confluence of Manet's dual interests in printmaking as an end in itself and as a desire for faithfulness to a model. The first state is known in only two impressions: the exhibited impression from the Rouart collection and the other from the Bibliothèque Nationale. This state shows the absolute dependency on the outlines of the watercolor's composition. Bareau has demonstrated how details in the print correspond exactly to the watercolor, such as the highlights, which are stopped out against the light aquatint grain, that follow the white gouache highlights of the watercolor. In the watercolor the black wash did not meet the wrist and robe of the weeping angel (to the right), leaving a blank area. In the print, this same area is visible, but Manet filled it in with several lines, making a transition to the angel's sleeve. As can be seen, the aquatint was applied like the wash of the watercolor. With the compositional elements basically secure, Manet seems to have worked confidently on the plate with a masterful sense of control, which allowed a freedom of drawing within the model's frame of reference, surely the watercolor and not the painting. For each compositional element he had at his command an etching style based on past experience, which is well illustrated by comparing the two angels. The more stationary weeping angel, which is in a shadow and bends down farther behind the body of Christ, is shaded with widely spaced parallel lines suggesting a more stationary, flat plane. The other angel, which comes forward to support the body, is animated by freer, more calligraphic drawing suggested in the billowing robe. The musculature of Christ's body, only realized in the final state, is delineated here with shorter strokes and parallel lines that change in direction to model forms.

A preference for the more original and experimental aspects of Manet's printmaking can easily be rewarded in the study of the first state of this etching. If it is viewed as an object isolated from the final state and without a knowledge of Manet's concerns as a printmaker, this intermediate stage is perhaps the masterpiece of the artist's oeuvre. And at one time this impression belonged to Degas. In spite of its ambitiously realized complexity, it has an immediacy derived from an unconventional use of etching techniques. Manet had no exact models to follow, just the accumulated insights of his past work and the study of other artists such as Goya and Rembrandt. But after only a few proofs, Manet continued to work on this plate, because in his view it was not complete. In the first state, he had not adequately approached a graphic equivalent to his painting, but neither did he make an original creative statement into a mere reproduction of ideas from another medium in the final state. That state has a tremendous impact even though it does not have the appeal of a preliminary sketch.

The refinement of the next two states brought the print closer to its original model, the painting. The second state is only known by Guérin's description, but in the third and final state exhibited here, Manet refined the elements he suggested in the first state. The angels, whose relative scale and spatial position were unclear in the early state, are in the third state more accurately situated in the composition—visually separated from Christ. All the areas that were lightly bitten with aquatint or widely spaced lines were covered with a fabric of parallel lines and crosshatching. The drapery is now modeled with strong contrasts of light and shade, and additional work to Christ's body conveys a sense of musculature, closer to the figure in the painting, which critics found unwashed and vulgar.

Bareau observes that these changes resulted in a significant change in mood. The first state has an immaterial quality while the third, more somber and dark, is perhaps more realistic and closer to the effects of the painting so objectionable to the critics. In the early state, the bright white areas on the figure of Christ and the surrounding drapery resulted from strong illumination from below. The highlighted area of the dead Christ's body is contrasted against the almost solid black background that is gradually diffused toward the top of the composition. This ethereal lighting is very much diminished by the reworking of the final state.

*Dead Christ with Angels* was never published, either in Manet's lifetime or posthumously. Even the final state is known in no more than nine or ten impressions, and Guerard probably printed all of them. These proofs show great variety in the printing—some are cleanly wiped and others are covered with a heavy tone exaggerating the already somber character of the plate. While the other plates from which Guerard probably printed proofs were returned to the artist and recorded in Manet's estate, the plate from *Dead Christ* remained in the printer's possession and was recently purchased, together with an extraordinarily rich proof of the final state, by The Art Institute of Chicago.

## 39
*Olympia* (small plate)   (1867)

Etching
On laid paper, unidentified watermark
Second state of six
Sheet: 102 x 220 mm (4 x 8⅝ in)
Plate: 88 x 207 mm (3⁷⁄₁₆ x 8³⁄₁₆ in)
Inscriptions: None, but traces of thumb mark in ink on pillow
N.Y. 69, B. 47, I. 53, H. 53, G. 39, M.N. 17

*The Detroit Institute of Arts, Founders Society Purchase
   General Endowment Fund 70.589*

In the months preceding Manet's Avenue de l'Alma exhibition of 1867, Zola suggested that a pamphlet be prepared for distribution during the exhibition that would reprint his recent review of the artist's paintings. Manet responded favorably to the proposal, and in a letter (New York 1983, Appendix I, letter 5), Manet offered a portrait frontispiece of himself by Bracquemond (no. 76), and also expressed his desire to include (if not too expensive) a wood-engraved reproduction of *Olympia*. Evidently, Manet had already drawn on a block in preparation for a wood engraving that was to be used in Lacroix's *Paris-Guide* but that was not included. A wood engraving of *Olympia* by Moller is described by Guérin, but its size would have precluded its inclusion in the Lacroix book. Instead of a wood engraving, Manet, who was unclear about the format of Zola's publication, produced an etching of *Olympia*, probably working from a drawing, now lost, that appears to be a reversed tracing (R.W. vol. 2, 378). The first state of this plate, known in only two impressions (see fig. 6), was eventually reworked with extensive and deeply bitten etched lines. Whether because of this ineffective rework or because the print was obviously too large for the pamphlet, Manet soon began another, smaller plate.

The second plate was traced from the first and the smaller format was achieved simply by cutting off a few millimeters at the top and bottom of the design. Unlike the very open style of the first plate, Manet was more thorough and methodical for the second attempt. After drawing the Olympia, the maid, and the bed using finely etched lines, he completed the darker background with lines in various directions to denote the different materials of the backdrops, such as curtains and screen. This work was done in one state; then, after the plate was lightly bitten, the foreground was stopped out, and the background allowed to etch longer, creating darker lines. The use of this stop-out technique heightened the strong division between background and foreground areas, but unfortunately, even with the help of Bracquemond, the biting did not succeed. The light lines in the foreground did not etch long enough as they are irregular and hold ink poorly. In the progressive states, including the exhibited second state from the Rouart collection, the back-

FIG. 6   *Olympia*, The New York Public Library,
Samuel P. Avery Collection

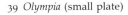

39 *Olympia* (small plate)

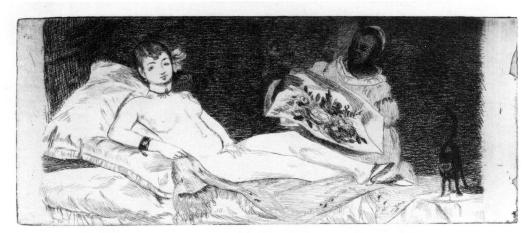

ground was enhanced with additional etching, which reduced the interesting differentiation of background textures visible in the first state. In the third state an aquatint grain was applied, and eventually the blank strips at either side were cut away.

One of the two known proofs of the first state, which once belonged to Bracquemond, he inscribed "bitten and printed by Bracquemond" (New York 1983, p. 189). This indication of his involvement in the production of the plate is not surprising, and he most likely offered similar assistance with many of Manet's plates, especially in the application of aquatint. Bracquemond's statement led some critics to suggest that the etching was not Manet's, a view reinforced by the technical problems just noted. Yet this is clearly not the case because the print is entirely consistent with Manet's approach. Even Zola thought the plate was "manquée" (a failure) (Adhémar 1965, p. 231), and although his reasons for thinking so are not known, one could surmise it might be a reaction to the weakly realized foreground and the general lack of graphic impact. Considering Manet's high standards for prints after his paintings, especially one to be widely distributed, he probably would not have been satisfied with this result, for as Bareau observes, "the Olympia . . . has a finicky appearance . . . that is only partly the result of the cramped format, which destroys the rhythm and harmony of the original composition" (New York 1983, p. 189). This small plate is a failed effort in an oeuvre of truly original interpretations.

40
*The Smoker*  (1866 or 1867)
Le fumeur

Etching
On blue-green laid paper
Second state of two, from the 1894 Dumont edition
Sheet: 309 x 249 mm (12⅛ x 9½ in)
Plate: 174 x 158 mm (6⅞ x 6³⁄₁₆ in)
Image: 152 x 132 mm (6¹⁄₁₆ x 5³⁄₁₆ in)
Inscriptions: Signed in plate, u.l. corner, "Manet"
B. 55, I. 50, H. 50, G. 49, M.N. 33

*The George A. Lucas Collection of The Maryland Institute, College of Art, on indefinite loan to The Baltimore Museum of Art*
*B.M.A. L.33.53.5151*

*T*he Smoker is as deliberate as *The Rabbit* (no. 36) and *Marine* (no. 35) are unconstrained. This etching reproduces in the same orientation Manet's painting of 1866 (R.W. vol. 1, 112), now in The Minneapolis Institute of Arts. The painting and print portray a worker, Janvier, who also was the model for the figure of Christ in Manet's controversial painting *Jesus Mocked by the Soldiers*. In the print, the figure is cropped to bust length, so his right hand resting on his leg is no longer visible. The composition is also reduced at the sides. By this time, Manet had developed a working method that allowed very literal transcriptions of paintings, producing prints in the same orientation without the use of intermediary drawings (if there were drawings, none have been located). It is more likely that Manet used photographs, which would easily explain how he cropped the composition without changing the scale of his work.

That Manet initially intended to cut off the bottom part of the composition is not clear, and the size of the plate in the first state (235 x 158 mm) would have accommodated the entire design. In fact, the bust is situated in the upper part of the plate as it appears in the later drypoint of the same subject (no. 74). In the second state, which is in the exhibition, the plate was cut to reduce the composition. This is the only change between these two states. The painting was exhibited at Manet's 1867 exhibition in the Avenue de l'Alma, and it is possible that the plate, which so faithfully reproduces the original, was made at that time. It was never published, however, and only appears for the first time in the 1890 memorial edition. The exhibited impression comes from the 1894 Dumont edition, typically printed on a blue-green laid paper, but this time printed with a black ink, cleanly wiped to suggest the black-and-white contrasts so integral to the design. Very few impressions exist, and among these is an impression of the first state from the Guerard collection, suggesting that this printer may have pulled several proofs from the plate before Manet's death.

Manet used an etching style for this plate that transcribed the stark simplicity of both the composition and the rendering of the painting. As before, and reflecting the influence of Goya's early etchings after Velázquez, Manet drew the smoker's coat with parallel lines, closely spaced, with no crosshatching. For his treatment of the left forearm, these same lines are curved to suggest vol-

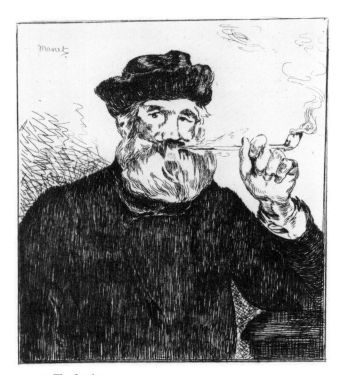

40 *The Smoker*

ume, and the arm comes forward in foreshortened perspective. The figure is not outlined with a continuous contour line, and the edges of the shape are defined by the termination of these vertical parallel lines. Against the white background, which is filled with a few rapid, slashing strokes over the figure's right shoulder, the flattened coat becomes a silhouette. In the painting, the coat, while darkly painted, is still modeled showing folds that convey the weight of the fabric. In the etching, the vertical parallel lines are almost relentless and cover the coat with a uniform tone creating a flat surface. But Manet's intention is clear, for he achieves a striking visual contrast to the freely drawn, highlighted areas of the face, beard, and hand. Manet's sensitive drawing of the face captures the cockeyed expression of the painting together with the lively modeling of face and beard. This freer technique is a graphic equivalent of the broad brushwork of the painting. The cropping of the plate made it difficult for Manet to draw effectively the arm resting on the table, and it is one of the awkward passages that occur occasionally in Manet's prints, even works otherwise so carefully rendered.

## 41
*Boy Blowing Soap Bubbles* (1868)
L'enfant aux bulles de savon

Etching, aquatint, roulette
On heavy laid paper
Second state of four
Sheet: 312 x 262 mm (12½ x 10¼ in)
Plate: 249 x 210 mm (9¹³⁄₁₆ x 8¼ in)
Image: 194 x 160 mm (7⅝ x 6¼ in)
Inscriptions: None
N.Y. 103, B. 60, I. 62, H. 63, G. 54, M.N. 36

*The George A. Lucas Collection of The Maryland Institute, College of Art, on indefinite loan to The Baltimore Museum of Art*
*B.M.A. L.33.53.5162*

There is little consistency among Manet's later etchings, a fact that this plate illustrates well. It is less precise than *The Smoker* (no. 40), but not as freely realized as *The Rabbit* (no. 36). All these works were executed within a year or two of one another, but *Boy Blowing Soap Bubbles* is the latest of this group. It is based on an oil of 1867 now in the Calouste Gulbenkian Museum in Lisbon (R.W. vol. 1, 129) but is in reverse. The plate was published for the first time in the 1890 memorial edition of Manet's prints, and like most of the works of this period, Manet's intentions when he etched this plate are unclear. The oil was completed in time for the 1867 exhibition at the Avenue de l'Alma, and Manet conceivably could have prepared the etching to publicize the painting, as he might have done for *The Smoker*. His production as an etcher declined after the first two editions of his prints in 1862–1863. It is conceivable, however, that he intended the few plates he produced after his own edition of fourteen etchings to be included in a new publication of his prints.

We know that Guerard was involved in the production of this plate, which perhaps marks his increasing popularity with Manet as a technical adviser. The rare proof of the first state in the Avery collection carries the inscription from Guerard, which says that he printed the plate. Guerard was undoubtedly involved in the experimental color printing (à la poupée) of the impression of the third state in The Art Institute of Chicago. In fact, most of the known lifetime impressions of this plate, including the Avery first state that was purchased through Lucas from Guerard, another first state also in Chicago, and the Lucas impression of the second state, come from Guerard's collection.

This work, like *The Rabbit*, gives evidence of the influence of Chardin. The Chardin model could have been any one of many variant paintings of the theme of a boy blowing bubbles, taken up in a somewhat sentimental manner by Manet's teacher Couture. In spite of the method that Manet had developed to transcribe compositions in order to insure the same orientation as the original, at times using photographs, here he did not bother to reverse the composition (see no. 40). There are no intermediate drawings recorded, and Manet probably drew directly on the plate. The boy's figure is executed with widely spaced parallel lines of varying lengths,

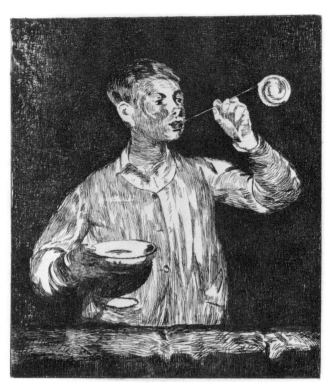

41 *Boy Blowing Soap Bubbles*

His experiments included printing the plate in a pastel color scheme very uncharacteristic of Manet. The exhibited impression is most likely one of the rare proofs pulled by Guerard during Manet's lifetime or shortly after his death. The impression is printed on a warm-toned, heavy laid paper similar to other Guerard proofs and comparable impressions in the Lucas collection, which do not correspond to the characteristics of prints from the posthumous editions (see Legend).

grouped to create intermittent patches of light and dark. For the face and neck Manet used more regular parallel lines that vary in direction to model form. This area is not particularly successful, however, because the lines form distracting patterns and shapes that seem to move around the neck and across the face. In the print, Manet also had difficulty with the hand holding the bowl and left it unfinished. In the second state, exhibited here, it is covered over with an aquatint without any apparent explanation other than to obscure this awkward area. In the third state, the aquatint is burnished back to a less noticeable shade.

In the first state, Manet created an almost solid black background. But in the second state, he applied the aquatint grain mentioned above over the entire background. In the area of the hand the aquatint was accidently stopped out, requiring the application of roulette to fill in the highlight. Harris correctly observes that the distinction between figure and background is blurred as the two elements alternately infringe upon each other (Harris 1970, p. 175). The same observation can be applied to the painting, especially since Manet revised the profile of the boy's shoulder, painting over the white with the dark paint of the background.

It is tempting to conclude that Manet, perhaps for good reason, was not entirely pleased with the results of this plate and abandoned it. Guerard may have wanted to strengthen the shading of the background and to obscure the unfinished and awkward work by applying the aquatint grain himself, possibly without Manet's supervision.

## 42

*Charles Baudelaire, Full Face, after a Photograph by Caspar Felix Tournachon Nadar*  (French, 1820–1910) (version three)  (1868)

Etching
On tissue-weight laid paper
First state of four
Sheet: 215 x 138 mm (8½ x 5⅜ in)
Plate: 173 x 104 mm (6¹³⁄₁₆ x 4⅛ in)
Image: 165 x 98 mm (6½ x 3⅞ in)
Inscriptions: Signed in pencil, l.r. margin, "Manet"; below, in
    another hand, "Baudelaire/reproduire il cette grandeur (par le
    fond)"
N.Y. 58, B. 46, I. 61, H. 61, G. 38, M.N. 16

*The George A. Lucas Collection of The Maryland Institute, College of
    Art, on indefinite loan to The Baltimore Museum of Art
    B.M.A. L.33.53.5154*

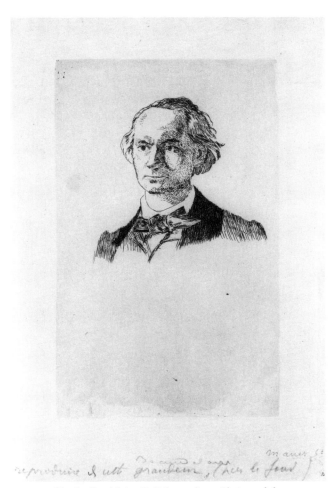

42 *Charles Baudelaire, Full Face, after a Photograph by
Caspar Felix Tournachon Nadar*

Not long after Baudelaire's death in August 1867, Manet learned that Charles Asselineau was preparing a biography and edition of Baudelaire's complete work. Manet wrote to Asselineau, offering two portrait etchings for inclusion in the volume as a reflection of his friendship and personal admiration for Baudelaire, a kindred spirit in life and art. Manet thought the first, of Baudelaire in a hat, recalling the flâneur in *Music in the Tuileries*, could accompany "Spleen de Paris," while the second, a bare-headed portrait known in three versions, the third exhibited here, "would go well in a book of poetry" (New York 1983, p. 158). The design for the full-face portraits came from a photograph made by Nadar in 1862. All three versions—H. 46, 60, and the exhibited plate—are in the same orientation as the photograph and follow its details exactly, including the tie and mussed hair. As Manet proposed, two of his portraits were included along with those by other artists, such as Courbet and a self-portrait by Baudelaire, translated into an etching by Bracquemond. The third version of the full-face portrait that was included in the Asselineau volume is exhibited here in an extremely rare impression of the first state, which itself is known in only three impressions. The other impressions are in a private collection and in The Art Institute of Chicago, former Guerard collection.

Unfortunately, the letter to Asselineau does not help identify or definitively date the various Manet portrait etchings of Baudelaire. Two were presumably finished when the letter was written; upon Asselineau's agreement, Manet must have begun the later versions of each portrait—with the hat and full face. Asselineau himself confused the issue in his book because he dated *Baudelaire with Hat* (H. 59) as 1862, and the full-face portrait three years later. These dates may have referred to works on which the portraits were based. Asselineau's book was published in 1869, and after two earlier attempts, possibly dating back to 1865, Manet completed the full-face portrait etching in 1868.

The first version of the full-face portrait, known in only three impressions of two states (Bibliothèque Nationale, Paris, first and second; Avery collection, second), is very similar to the third, exhibited, version in its dramatic chiaroscuro effects. It was probably abandoned because of evident problems in the handling of the face, as well as the confused relationship of modeling and the dark background. The second version, known in only one impression in the Bibliothèque Nationale, uses a background of a sparse but even aquatint grain. This image is surrounded by a ruled etched border, giving it the appearance of a commemorative. While the more subtle relationship of head to background is very appealing, the aquatint would not have been practical for a large edition, and perhaps this solution also lacked the dramatic impact of the other versions. Finally, in the third version, Manet returned to his earlier approach of darkly shaded portraits, and in several states was able to solve the problems of the first version. Complete in the fourth state, this version was published in the Asselineau volume in 1869 and subsequent re-editions.

For this version Manet took a more careful, methodical approach, transcribing the details of the Nadar photograph with a confident etching style similar in character to that of *Boy Blowing Soap Bubbles* (no. 41). His more deliberate progress avoided the pitfalls of the expressively rendered first version (see fig. 7). At least in the first

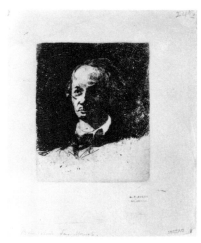

state, this simple directness conveys Baudelaire's youthful earnestness. But this stage was only preliminary, for in the subsequent states, Manet filled in the background with a dark fabric of lines and added to the face a dramatic shading that, in fact, exaggerates the lighting in the photograph. The right side of the face is covered in shadow, as in the first state, with a prominent highlight below the eye. His face now looks drawn and the mood is somber and somewhat mysterious. The Lucas impression of this state, exhibited here, carries an inscription concerning a reproduction of the print, either for its illustration in Moreau-Nélaton's catalogue raisonné or, more likely, for a photomechanical reproduction of the etching in the same scale found in the Lucas archives. The archives contain a letter from Moreau-Nélaton to Lucas dated March 1, 1906, concerning several photomechanical reproductions made by Moreau-Nélaton from prints in Lucas's collection.

The space below the image was left blank for the addition of a banderole that would memorialize Baudelaire. Manet apparently took great pains over this design, sketching first a banderole based on Dürer's engraving *Melancholia* (R.W. vol. 2, 677) with the addition of elements from Goya's Caprichos print, *The Sleep of Reason*, and other plates from this series (see Hauptman 1978, p. 216, for an analysis of the banderole's content). A simpler version, without the involved symbolism, was finally etched on the plate, only to be cut off when the plate was reduced in size for publication in Asselineau's book.

## 43
*Dead Toreador*  (1867–1868)
Torero mort

Etching, aquatint
On white wove paper
Fifth state of seven
Sheet: 153 x 245 mm (6¹⁄₁₆ x 9⅝ in)
Plate: 155 x 223 mm (6⅛ x 8¾ in)
Image: 95 x 194 mm (3¼ x 7⅝ in)
Inscriptions: Signed in plate, l.l. corner, "Manet"
B. 43, I. 55, H. 55, G. 33, M.N. 13

*Davison Art Center, Wesleyan University, Middletown, Connecticut 1949. D1-1(8)*

## 44
*Dead Toreador*  (1867–1868)
Torero mort

Etching, aquatint, in bistre ink
On faint green laid paper, indecipherable watermark
Seventh state of seven
Sheet: 242 x 341 mm (9½ x 13⅜ in)
Plate: 155 x 223 mm (6⅛ x 8¾ in)
Image: 97 x 193 mm (3¾ x 7⅝ in)
Inscriptions: Signed in plate, l.l. corner, "Manet"
B. 43, I. 55, H. 55, G. 33, M.N. 13

*The George A. Lucas Collection of The Maryland Institute, College of Art, on indefinite loan to The Baltimore Museum of Art B.M.A. L.33.53.17799*

Both of Manet's submissions to the Salon of 1864 were accepted by the jury, including *Dead Christ with Angels* (see no. 37 and 38) and *Episode from a Bullfight*. Sometime before his exhibition in 1867, at the Avenue de l'Alma, Manet cut the second canvas into fragments, repeating a process followed earlier in his career when he cut his canvas *The Gypsies* (see no. 15 and 16). In spite of the vehement disapproval of the critics when the entire canvas was exhibited in the Salon, the painting was not dismembered out of anger, but rather for artistic reasons. The canvas was divided into two fragments, The Frick Collection picture *The Bullfight* and *Dead Toreador* (R.W. vol. 1, 72 and 73), now in the National Gallery of Art in Washington, D.C. Both paintings were reworked as single compositions. *Dead Toreador* was first exhibited in the 1867 Avenue de l'Alma show, and the etching dates either from that time or shortly after. It was exhibited in the Salon of 1869 with *Exotic Flower* (no. 45 and 46), which is stylistically similar and also of a Spanish theme.

The progression of states for this plate includes at least seven stages and possibly more not yet recorded. Along with *Olympia* (no. 39) it is the most complicated in Manet's oeuvre. The progress of Manet's work on this plate has been confused by the catalogues raisonné, and it was only when Bareau was able to reorder the states of this etching in her 1978 catalogue that it was possible to determine the artist's intent. Because most of the changes have to do with the application of the aquatint background, with each state being known by very few proofs, the discovery of additional proofs will most likely add further to the number of states. But these additions

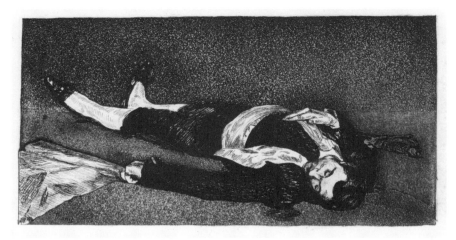

43 *Dead Toreador*

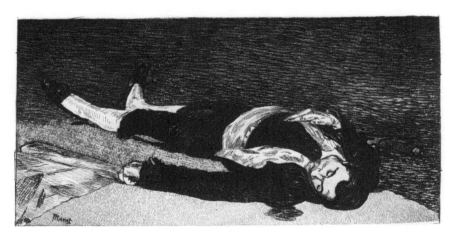

44 *Dead Toreador*

would probably not alter the current understanding of how this plate developed. Two states of this etching are exhibited: one of the few impressions of an intermediate state, the fifth (from the Rouart collection in Detroit), and an impression from the final, published state, in this case from the Dumont edition of 1894. This plate was published in Manet's lifetime in the 1874 Cadart edition and also appeared in the first posthumous portfolio of 1890.

According to Moreau-Nélaton, Manet required the technical assistance of Bracquemond, as he had for *Olympia*, to bite the plate with the aquatint grain. But here the repeated changes in states that involve the aquatint tone are not the result of technical complications, but rather are formal concerns that relate directly to the division of this composition from a larger canvas and Manet's attempt to rework it so that it could succeed independently. Reff states that "in its composition, the print goes beyond the painting of four years earlier—even in its revised state, after having been detached from the *Incident in a Bullfight*—in the extent to which the figure and

setting are integrated in a strong two dimensional pattern'' (Reff 1982, p. 220). The painting has a continuous neutral background, with only a slight lightening in the immediate foreground and the indication of shadows from the figure on the ground. Reff suggests that Manet may have seen an etching by Flameng after what was then thought to be a Velázquez painting. The etching was probably a compositional model for Manet's painting, which also gave him the idea of separating the background horizontally in the print. The first state reflects this separation, suggested with a light and dark aquatint grain divided horizontally at the feet (the same as the Flameng etching). Manet left this division and in the following states darkened the figure and added more aquatint to the background. The next major change occurs in the fourth state, where he added a middle ground as a diagonal swath in an intermediate aquatint tone. This tone extends from the horizontal division, from the cape on the left and to the toreador's right shoulder on the right. This change suggested a solution to Manet's

problem of integrating the figure in a background, but he did not like the three planes with a dark band under the figure. So, in the fifth state, exhibited here, he burnished this area back so that it blended better with the other areas. The outlines of the original aquatint are still visible in this state. In the sixth state he covered over the right area near the toreador's head with a wash of aquatint to obscure the previous area and equalize the tone with the background. And in the final state, also exhibited, the entire background, and what was the middle ground on a diagonal that followed the recession of the figure, is covered with additional aquatint and the familiar continuous zig-zag line. The horizontal is now eliminated, and the figure is integrated with a dynamic background. In this solution, Manet has also suggested a somber mood, appropriate for the depiction of this dead Spanish hero.

45
*Exotic Flower (Woman with a Mantilla)*  (1868)
Fleur exotique (La femme à la mantille)

Etching, aquatint
On thin japon paper
First state of three
Sheet: 203 x 194 mm (8 x 7⅝ in)
Plate: 179 x 129 mm (7⅛ x 5⅛ in)
Image: 162 x 116 mm (6⅜ x 4³⁄₁₆ in)
Inscriptions: None
B. 57, I. 56, H. 57, G. 51, M.N. 18

*The George A. Lucas Collection of The Maryland Institute, College of Art, on indefinite loan to The Baltimore Museum of Art*
B.M.A. L.33.53.5137

46
*Exotic Flower (Woman with a Mantilla)*  (1868)
Fleur exotique (La femme à la mantille)

Etching, aquatint, in bistre ink
On laid paper, indecipherable partial watermark (Double Volute?)
Third state of three, from the 1869 *Sonnets et eaux-fortes* edition
Sheet: 308 x 236 mm (12⅛ x 9¼ in)
Plate: 175 x 117 mm (6⅞ x 4⁹⁄₁₆ in)
Image: 161 x 107 mm (6⁵⁄₁₆ x 4³⁄₁₆ in)
Inscriptions: Signed in plate, l.l. corner, "Manet"
B. 57, I. 56, H. 57, G. 51, M.N. 18

*The George A. Lucas Collection of The Maryland Institute, College of Art, on indefinite loan to The Baltimore Museum of Art*
B.M.A. L.33.53.5138

In June 1868 Burty wrote to Manet asking for his participation in a publication he was initiating, *Sonnets et eaux-fortes*. He was hoping that Manet would contribute an etching to accompany a sonnet by Armand Renaud, entitled "Fleur—exotique," which Burty felt was especially compatible with Manet's prints (G. 51). Burty's publication is listed in the Depot Legal in December 1868 and carries the publication date of 1869. It included forty-one etchings by artists such as Bracquemond, Daubigny, Doré, Jongkind, and Millet, as well as many less known regular contributors to the Société des Aquafortistes folios. *Sonnets et eaux-fortes* was edited with great care, and prints were available on various papers, including more limited deluxe editions in addition to the regular printing of 350 copies. This kind of publication, under the supervision of Burty, the critical voice of the etching renaissance, is indicative of the relationship writers like Burty tried to establish between literature and etching—a printmaking technique they considered synonymous with originality and creativity. Harris suggests that Manet may have prepared his plate *The Odalisque* (H. 56) as an earlier, but rejected, submission for this project and that he might also have considered *At the Prado* (no. 47), which he had reworked in 1866–1867.

Aside from the possible addition of the flower, Manet's print *Exotic Flower* was not inspired by, nor does it illustrate, Renaud's sonnet. Instead, its model was Goya, specifically one or two plates from Los Caprichos, plate

five and fifteen (T. Harris 1964, 40 and 50), both showing a maja in a black dress with a low bodice, a mantilla across her shoulders. She is facing sideways with her head turned almost back to the picture plane. While earlier prints such as *The Espada* (no. 19) or *At the Prado* (no. 24 and 28) readily convey the influence of Goya, *Exotic Flower* is an original composition not based on a painting. Unlike Goya, however, Manet isolated his figure, both visually and from any thematic context. The aquatint background reminiscent of Goya is a flat background without modulation, similar to what Manet attempted earlier with the second version of the full-face Baudelaire portrait (H. 60). Like Goya, Manet used the white of the paper to achieve bright highlights, leaving large areas bare of lines opposed to strong etched lines and aquatint tone elsewhere. Furthermore, the figure is drawn, like Goya's etchings, in overlapping parallel strokes. In his letter to Manet, Burty told him of Bracquemond's willingness to assist in the biting of the plate, and surely Bracquemond helped with the application of the even aquatint background.

*Exotic Flower* is exhibited in two states: the only recorded impression of the first state, as illustrated in Mo-

reau-Nélaton, Guérin, and Harris, and an impression in bistre ink from the edition of *Sonnets et eaux-fortes*. The published impression is the third state, which differs from the second only in the reduction of the plate size. In the first state, the plate was complete except for certain refinements to the figure that have great significance. Initially, Manet did not complete the facial features of the maja, for he drew only a mouth, the nostrils of the nose, and widely spaced eyes, with no connection through a brow or nose bridge. Without these details the spatial position of the head is vague, and except for the chin, no shading is indicated, so the face seems flat in spite of the turn of the body. On the right side of the face, the line separating chin from neck dissolves in full illumination, but this detail was not effective until the changes were made in the second state. In the later state Manet added the subtle touches needed to situate the position of the head—a brow, which brings the eyes together, and the lightly shaded bridge of a nose. He also made the mouth larger. A change in expression naturally resulted from these additions, making the maja seem more aloof. Aside from reworking the face, Manet filled in the transparent lace of the bodice and extended the mantilla so that it

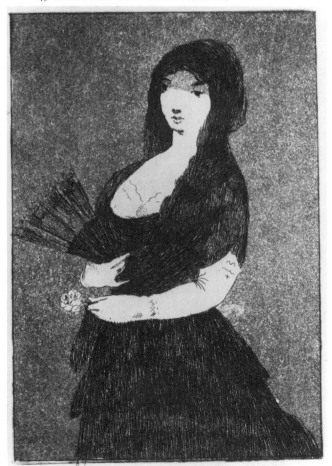

45 *Exotic Flower (Woman with a Mantilla)*

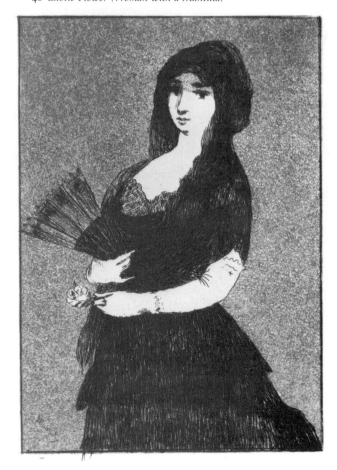

46 *Exotic Flower (Woman with a Mantilla)*

passes through one hand to be held by the same hand that holds the fan. The contours of the headdress are also modified with additional etched lines. A small defect in the aquatint grain near the maja's left elbow is also rectified in the second state.

The two impressions are printed with different inks, one in black, and the published impression, in a brown ink. Both these inking possibilities were available in the deluxe limited editions of the publication. Because of heavier inking, the edition impression is darker, both in the aquatint areas and in the etched figure. The dress becomes a more solid shape, less textured than in the first state printing but still with a degree of surface shimmer. *Exotic Flower* is a simple, concentrated graphic statement that belies its stylistic sophistication.

47
*At the Prado*   (1863) (Second state c. 1867)
Au prado

Etching, aquatint, roulette, bitten tone
On japon paper
Second state of two, from the 1910–1912 Porcabeuf edition
Sheet: 349 x 275 mm (13¾ x 10⅞ in)
Plate: 225 x 154 mm (8⅞ x 6⅛ in)
Image: 220 x 148 mm (8¹¹⁄₁₆ x 5⅞ in)
Inscriptions: Signed in plate, l.l. corner, "Manet"; verso, c., collector's mark, "BW" (Bernard Walker)
B. 53, I. 40, H. 45, G. 46, M.N. 62

*The Detroit Institute of Arts, Gift of Mr. and Mrs. Bernard F. Walker 71.411*

Like the fourth state of *Boy with a Sword* (no. 48), this impression of the second state of *At the Prado* has been separated chronologically from the first state (no. 28) to illustrate better the changes in Manet's printmaking between 1863 and 1866–1867. During this later period, perhaps with the hope of printing a new edition of his prints, Manet returned to a number of his early plates and reworked them with a heavy aquatint ground. This

47 *At the Prado*

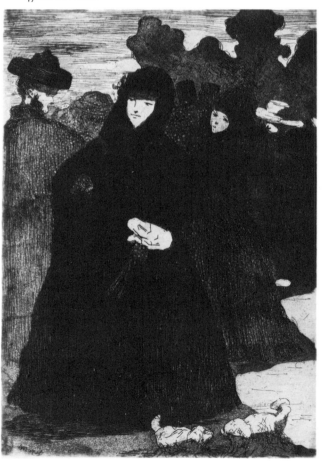

change was indicative of his new printmaking style, pursued with the technical guidance of Bracquemond and later Guerard. None of the reworked plates were published in Manet's lifetime, and this impression of *At the Prado* comes from an edition of 1910–1912 made on japon paper by Bracquemond's uncle, Porcabeuf. Very few proofs before this edition have been located (Kunsthalle, Hamburg).

Generally these reworked states are not particularly successful because the nuances of Manet's drawing on the plate are sacrificed for a somewhat monotonous although dramatic effect. Two plates, this one and *Boy with a Sword*, are more successful, because the aquatint is better controlled and more sympathetic to the style of the original plates. In spite of his advisers, Manet encountered technical difficulties in applying the aquatint to this plate, which the spotty pattern in the darkest areas shows. But its success results from the fact that Manet needed only to heighten the effects already on the plate. Manet's interest in aquatint extends from his very earliest prints to those works more influenced by Goya, such as *The Espada, Lola de Valence,* and the early states of *At the Prado*. But in each period his use of the technique changed to reflect his current printmaking goals. In this reworking of *At the Prado*, the maja becomes a black silhouette against the intermediate tone of the middle ground. Individual lines are sacrificed to overall tone. The additional shading here completely changes the effect of a shimmering unstable surface that Manet achieved in the first state with the use of a continuous zig-zag scribble. The middle ground gets gradually darker, moving toward the distant right side of the composition. The visual highlights, which led the viewer's eye to the distance in the early state, are accentuated here because Manet stopped out certain areas that now appear as gleaming whites next to the dense aquatint tones. The trees seem even more like cutout shapes against the light sky. It is not surprising that the almost abstract graphic impact of this print has made it one of his most popular prints with modern audiences.

## 48
### *Boy with a Sword (Turned Left)*   (1862) (fourth state, c. 1867)
L'enfant à l'épée

Etching, roulette, aquatint
On chine paper
Fourth state of four
Sheet: 314 x 213 mm (12⅜ x 8⅜ in)
Plate: sheet trimmed within platemark
Image: 272 x 183 mm (10¾ x 7³⁄₁₆ in)
Inscriptions: Signed in plate, l.l. corner, "éd. Manet"
N.Y. 18, B. 27, I. 22, H. 26, G. 13, M.N. 52

*Samuel P. Avery Collection, The New York Public Library*
*Astor, Lenox and Tilden Foundations MN52*

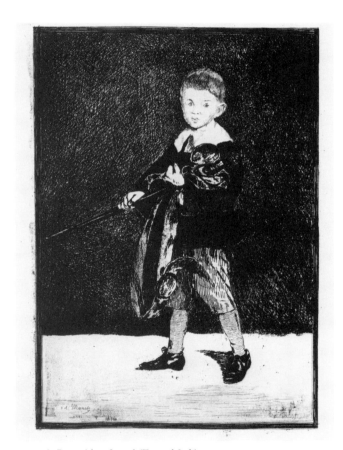

48 *Boy with a Sword (Turned Left)*

This rare impression is the fourth and final state of Manet's etching, *Boy with a Sword* (see no. 17 and 18), based on his 1861 painting now in The Metropolitan Museum of Art. This state has been separated from the early states to convey more accurately the progression of Manet's printmaking ideas. In the second major period of Manet's etching activity, 1865–1867, the artist, probably with help from Bracquemond and later Guerard and certainly with the inspiration of Goya, frequently used aquatint in his plates. This interest extended to reworking his early plates, including *The Candle Seller, The Absinthe*

*Drinker, Philip IV,* and *At the Prado.* His printmaking activity in these years, together with the energy he put into revising his early plates, suggests that he was anticipating a new edition of his prints, which failed to materialize.

His reworking of earlier plates, using the tone of the aquatint grain, was generally not successful. The aquatint was not applied with much sensitivity, and it only muddled the linear clarity of these plates. Aquatint covers over areas already dark with etched lines, destroying the harmonious balance among compositional elements. While some dramatic area such as a face might be spared, the tone filled the spaces between lines so that there was no longer any surface articulation. Of those aquatinted versions, *Boy with a Sword* is the most successful because it avoids this problem. The aquatint is more controlled, allowing highlights to be distributed throughout the composition, not just in one dramatic area. This occurs because Manet has essentially stopped out the figure, so that here, where his work with the etching needle was the most successful, the space between lines is not filled with tone.

## 49
### *The Execution of Maximilian*  (1868)
L'exécution de Maximilien

Crayon lithograph with scraping
On chine collé, wove paper
First state of three
Sheet: 454 x 533 (17⅞ x 20¹⁵⁄₁₆ in)
Stone: 357 x 464 (14⅛ x 18¼ in)
Chine: 336 x 432 (13¼ x 17¹⁄₁₆ in)
Image: 334 x 432 (13³⁄₁₆ x 17 in)
Inscriptions: Signed in stone, l.l., "Manet"
N.Y. 105, B. 77, I. 54, H. 54, G. 73, M.N. 79

*The George A. Lucas Collection of The Maryland Institute, College of Art, on indefinite loan to The Baltimore Museum of Art*
*B.M.A. L.33.53.13696*

Manet's lithograph *The Execution of Maximilian* is an important stage in the evolution of the artist's composition for a major painting based on a significant political scandal of the Second Empire. Between June 1867 and late 1868, Manet worked on three canvases and the lithograph before completing his final version, now in the Städtische Kunsthalle in Mannheim (R.W. vol. 1, 127). Rather than being an interpretation of one of these works, the lithograph represents a variant composition that can be placed in sequence between the second version of the painting, now in fragments but known in its damaged state through a Lochard photograph, and the sketch for the final version (R.W. vol. 1, 126 and 125).

49 *The Execution of Maximilian*

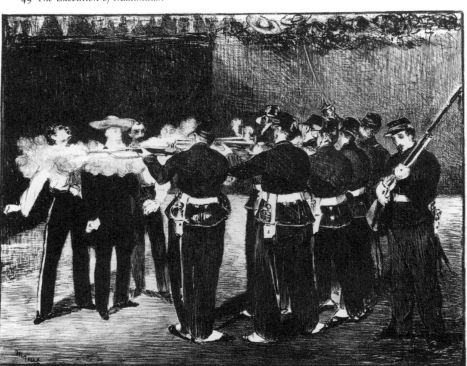

Since his independent exhibition on the Avenue de l'Alma was already in progress when news of Maximilian reached Paris, Manet probably intended his painting for submission to the Salon of 1869. In anticipation of this possibility and seeking to capitalize on the publicity of the Salon, he may have begun the lithograph at about the time he was painting the sketch for his final version. In the tradition of Daumier, Manet probably turned to lithography for its immediacy, allowing a wide distribution of his powerful visual statement, which condemned by implication Napoleon III's betrayal of his half-brother Maximilian.

Maximilian had been installed by the French on the throne of Mexico, but gradually Napoleon III withdrew military support. When the government finally fell to Juarez's forces, Maximilian was executed along with his two Mexican generals, Mejía and Miramon, on 19 June 1867. His execution was widely seen as Napoleon's responsibility and became a major scandal for the Second Empire. Manet's republican views were antipathetic to Napoleon and the establishment of the Second Empire. Soon after details of the execution appeared in French newspapers, Manet began work on the first version of the painting, revising details as more was learned about the actual event through written descriptions, prints, and photographs. The sequence of Manet's struggle to complete a major painting of this theme has been meticulously analyzed by Sandblad. In the 1983 Manet catalogue Cachin summarized this analysis (N.Y. 104).

The most significant differences between the lithograph and the destroyed second version (abandoned before Manet began work on the stone) and the painted sketch for the final version involve the positions of Maximilian and his two generals in relation to the firing squad. The landscape scene in the painting became the walled courtyard in the lithograph. In the lithograph the area between victims and soldiers has been reduced to point-blank range. Strong diagonals accentuated by shadows on the ground unify each group and separate one from the other, a device used in the second painted version as well as the last revision. In the final Mannheim canvas, Manet emphasized this diagonal division even more strongly with heavier shadows and by the position of the general to the left, who is thrown backward by the shots. Manet added a wall in the lithograph, replacing the landscape horizon line in the second version. According to Bareau, in the course of working on the stone, Manet redrew this wall, which appears flat in the sketch for the final version, at an angle to represent an enclosed space. The darkened part of the wall behind the emperor and the generals provides a dramatic visual background for their pale faces and the smoke from the fusillade. At the top of the wall Manet drew a crowd of onlookers, perhaps inspired by those in Goya's lithographs and etchings of bullfights. To the left, the crosses and roofs of tombs denote a cemetery on the other side of the high wall, giving the event a very specific location.

Unlike the lithographs that follow this image in the 1870s, The Execution of Maximilian is, except for the more freely rendered crowd, remarkably restrained in its draftsmanship. Whereas the later lithographs are characterized by vigorous strokes that retain their visual integrity as marks, here Manet drew on the stone very carefully, creating solid black that minimizes surface texture. He did not use the side of the crayon for wide areas, as he did in Civil War (no. 55) or The Barricade (no. 54), choosing a sharpened crayon instead. He then scratched through the stone to add final refinement. In this case he covered the right wall with scored lines that lighten its surface in contrast to the more densely shaded wall on the left. Additional scratches help delineate forms, whether black or white, against the middle tone of the background.

The publication history of his image, sometimes termed the "Maximilian Affair," provides valuable information about the furor Manet's paintings and prints produced even before they were widely seen (see New York 1983, Appendix II). While the earliest proofs were being pulled by Lemercier, Manet received word that he would not be allowed to publish or print his lithograph, even though the proofs without printed title would refer to the subject only by implication. Manet was also told the Salon jury would not accept his painting. In a letter to Zola, Manet said that the censorship of his image "speaks well for the work" (New York 1983, Appendix II, letter 1). Against Lemercier's wish to efface the image, the artist then tried to get the stone back. With the intercession of Zola, Galichon, and commentaries by others in journals, the stone was returned to Manet in February 1869, where it remained in his studio until his death. The lithograph was finally included in the 1884 posthumous edition, along with four other images also not published in Manet's lifetime. Bareau demonstrates that the actual size of the edition as recorded by Lemercier in the Depot Legal was fifty impressions, not the previously recorded one hundred (New York 1983, p. 279).

The exhibited impression is a rare before-the-letter proof. It is very richly inked and in fine condition so that the black-and-white contrasts are very stark. But distinguishing between the several proofs that Manet wrote were printed in 1868 (New York 1983, Appendix II, letter 8) and the before-the-letter proofs that were made at the time of the posthumous edition, following normal practice, is impossible. The only difference between the two lettered states, the second and the third, is a variation in the printer's address (letters were not added to the stone in 1868). A rare impression of the second state in the Philadelphia Museum of Art shows the printer's address as it appeared on the Civil War lithograph published in 1874, which was changed to the shortened version standard for the 1884 edition of the five lithographs. Variations between this proof and other before-the-letter proofs do not reveal significant differences that can distinguish the lifetime from the posthumous proofs. In any case, the editions were so small that one does not expect the stone to have lost detail, although damage could have occurred in the course of its storage in Manet's studio from 1869 until 1884. Minor changes among proofs are more accurately explained as printing variations. To confirm the existence of lifetime proofs printed for the artist, a careful and systematic study must be made, comparing before-the-letter proofs to document the actual printing history.

50
*The Cats' Rendezvous*   (1868)
Le rendez-vous des chats

Crayon lithograph with scraping
On chine collé, white wove paper
Second state of two
Sheet: 566 x 419 mm (22⅝₆ x 16½ in)
Chine: 451 x 351 mm (17¾ x 13¹³⁄₁₆ in)
Image: 435 x 329 mm (17⅛ x 12¹⁵⁄₁₆ in)
Inscriptions: Signed in stone, l.l. corner, "Manet"; in margin,
   l.r., "Lith du Senat, Barousse, Paris"
N.Y. 114, B. 78, I. 57, H. 58, G. 74, M.N. 80

*Samuel P. Avery Collection, The New York Public Library*
   *Astor, Lenox, and Tilden Foundations MN 80*

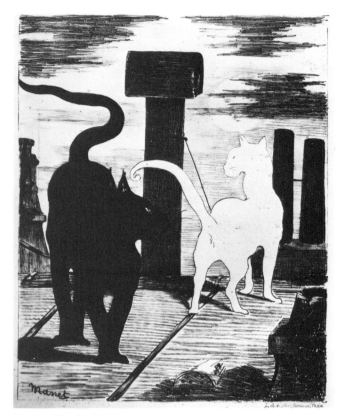

50  *The Cats' Rendezvous*

To publicize Champfleury's book *Les Chats*, Manet cre-
ated *The Cats' Rendezvous*, which was mounted on a
poster size sheet, lettered to advertise the book (see fig.
8). The poster was registered with the Depot Legal in
October 1868. Champfleury's book was enormously pop-
ular and appeared in three editions before a deluxe edi-
tion was published in 1870 (see no. 52). For the second
edition Manet's print was also used for a smaller adver-
tisement, but both are equally rare now, undoubtedly
because of their use as publicity. Less than ten impres-
sions of the single sheet have been recorded, including
the exhibited print. With its composition of black-and-
white contrasts, Manet's lithograph made a very effective
poster. The originality of its design, together with its
amusing subject matter, made it a popular work. Shortly
after it was made it was reproduced full size in *La Chro-
nique Illustrée*, a copy of which is contained in the Lucas
archives. In the smaller edition of the book in 1869, an
engraved reproduction of Manet's design for *The Cats'
Rendezvous* was included.

Even though as a critic Champfleury was identified by
his advocacy of realism and especially the work of Cour-
bet, Champfleury also found much to praise in Manet's
work and agreed with Baudelaire's views about painting

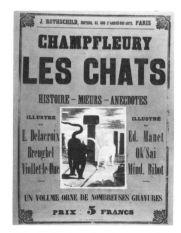

FIG. 8  Poster advertisement for
Champfleury's book *Les Chats*,
Bibliothèque Nationale, Paris

modern life. Manet included Champfleury along with
Baudelaire and other associates in his painting *Music in
the Tuileries*. Manet and Champfleury also shared an in-
terest in Spanish art and, obviously, a fascination with
cats. Among the chapters in the book is one on painters
of cats and the general topic of cats in art. Champfleury
also drew connections between Japanese art, particularly
Hokusai and Goya: "He has Goya's caprice and fantasy;
even his engraving style is sometimes markedly similar to
that of the author of the Caprichos" (New York 1983, pp.
300–301). This intermingling of Japanese and Western art
so typical of the book is carried through to Manet's
prints, especially his etching *Cat and Flowers* (no. 52)
prepared for the deluxe edition of *Les Chats*.

The flattened shapes of the cats, their fluid move-
ments, and the raking perspective of the rooftop all sug-
gest the influence of Japanese prints, but an examination
of the preparatory drawings for this print confirms the
design's genesis in sketches from life. These drawings are
part of a sketchbook (R.W. vol. 2, 620–646) showing Ma-
net's observations of cats in various positions and activi-
ties. One of these, in the Louvre (see fig. 9), supplied the
original position of the black cat on a rooftop as seen in
an early preparatory drawing (R.W. vol. 2, 618) where
Manet has basically achieved his composition. For the
final design, which takes form in a gouache (R.W. vol. 2,
619), the black cat is on his feet, tail extended, in a
sinuous mating dance with the white cat, his visual op-

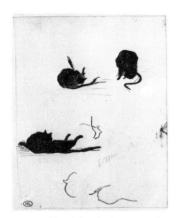

FIG. 9 Sketchbook drawing of cats, Réunion des Musées Nationaux, Paris

posite. The lithograph is in reverse to this final gouache, which was probably the source of the reproduction in the early edition of Champfleury's book. The influence of Japanese prints such as Hokusai's or Hiroshige's depictions of cats could have occurred at any time during the creation of this composition. What is significant, however, is that Manet devised an almost abstract design from the beginnings of his casual observations of cat forms and movement.

An appreciation of this striking image could not be better expressed than in the following quotation by Bareau from the 1983 Manet exhibition catalogue:

Manet offers sly humor, and original presentation, elegant refinement in the treatment of an inherently inelegant subject—the mating of cats on a rooftop—and sheer delight in the voluptuous nature and barefaced, shameless sexuality of his cats. His lithograph is a tour de force of whimsical, mocking wit and of concise graphic tension. (New York 1983, p. 301)

## 51
### The Cats (1868–1869)
Les chats

Etching, aquatint, in bistre ink
On laid paper, MBM watermark
Only state
Sheet: 306 x 450 mm (12$\frac{1}{16}$ x 17$\frac{11}{16}$ in)
Plate: 177 x 221 mm (6$\frac{15}{16}$ x 8$\frac{11}{16}$ in)
Image: 165 x 208 mm (6$\frac{1}{2}$ x 8$\frac{3}{16}$ in)
Inscriptions: None
B. 58, I. 58, H. 64, G. 52, M.N. 43

*The Detroit Institute of Arts, Founders Society Purchase General Endowment Fund 70.593*

Between Manet's two commissions for Champfleury's *Les Chats* came a simple caprice that reflects Manet's inherent joy with cats—their behavior and sinuous movements. The artist's motivation for making this etching of cats cannot be determined, for its format made it too large for inclusion in Champfleury's book. The design is based on Manet's numerous sketches of cats in his studio and elsewhere, including one brush-and-wash drawing (R.W. vol. 2, 621; see fig. 10) of a cat under a chair, which is repeated in reverse orientation as one of the three motifs in the etching. Other cats appear on different sheets of the sketchbook, but Manet undoubtedly was influenced by prints from Hokusai's *Manga,* specifically, an entire page devoted to cats in various positions, pursuing various activities, each drawn schematically as flattened shapes against white paper (Weisberg 1975, pp. 40–41). This etching was never published in Manet's lifetime but appears in all three posthumous editions.

The exhibited impression is one of the rare lifetime proofs of the print on a tinted laid paper and was probably printed by Guerard. Bareau catalogued another impression on similar paper with the Rives watermark in 1878, from the Guerard collection. Guerard commonly used tinted laid papers, which were a precedent for the

FIG. 10 Sketch of a cat under a chair, Bibliothèque Nationale, Paris

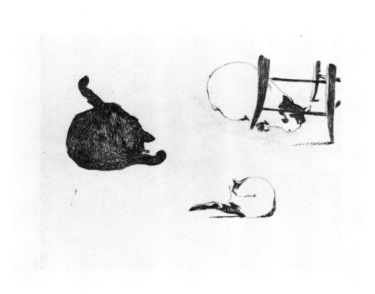

51 The Cats

blue-green papers Dumont used in 1894. The exhibited impression is also printed in a brown ink, which gives the print a warm tone, lessening the stark contrasts of dark shapes on a white ground. Manet used a slight touch of aquatint below the cat and the chair. This light aquatint is slightly stronger in this impression than it appears in the posthumous printings. What appear to be drypoint accents on the lower cat's tail and at the end of the left cat's tail, are actually finely etched lines given the look of a feathery drypoint through retroussage.

Of the three feline shapes on this otherwise blank page, only one has a spatial environment—the cat underneath the chair taken from the Bibliothèque Nationale drawing mentioned above. The legs of the chair delineate a real space, and both cat and chair create shadows on the otherwise blank page. In Champfleury's book single cats were taken from Hiroshige's illustrations (erroneously identified as Hokusai) and placed throughout the book. In the etching Manet brought together three independently observed sketches, but all are interrelated in pose and behavior. The left cat is drawn with parallel strokes and not otherwise outlined. Manet used a similar technique in *Line in front of the Butcher Shop* (no. 53) or the etched portrait *Berthe Morisot* (no. 58) of this same period. The black cat appears as a flat cutout shape, similar to the cat in *Luncheon in the Studio* (R.W. vol. 1, 135) or its earlier relative in *Olympia*. The cat at the bottom, smaller in scale compared with the other two, seems to be the same cat as the one peering from under the chair above. The bottom cat, like the one above, casts a slight shadow on the ground beneath. Both these cats, white with dark patches, are visual opposites of the dark cat, and while they are drawn with an outline contour that relates them to Hiroshige's cats, the contour is achieved with parallel curved strokes, suggesting the rounded volume of the cats' bodies.

## 52
### Cat and Flowers (1869)
Le chat et les fleurs

Etching, aquatint
On japon paper
Third state of six
Sheet: 319 x 212 mm (12⁹/₁₆ x 8⁵/₁₆ in)
Plate: 202 x 151 mm (8 x 5¹⁵/₁₆ in)
Image: 173 x 129 mm (6¹³/₁₆ x 5⅛ in)
Inscriptions: Signed in plate, l.l. margin, "Manet"; in pencil, l.r. margin, "très rare"
N.Y. 117, B. 59, I. 63, H. 65, G. 53, M.N. 19

*Samuel P. Avery Collection, New York Public Library*
*Astor, Lenox and Tilden Foundations MN19*

Champfleury's very successful book *Les Chats* was published several times before his publisher Rothschild made plans for a deluxe edition with better illustrations. Manet had already supplied his design for *The Cats' Rendezvous* as an engraved reproduction in the early editions, so it was appropriate that he should be asked for an original print to be included in the new, larger format, edition. He etched *Cat and Flowers,* and it appeared with the book in 1870. Like *Exotic Flower* (no. 45 and 46) Manet conceived an original composition for this commission, and there are no preparatory studies located for it beyond the sketchbook drawings of cats. A similar balcony scene with railing, flowers, and the same Japanese-style porcelain planter but with a dog can be found in Manet's painting *The Balcony* (R.W. vol. 1, 134), on which he was working when he received this assignment. Goya's influence, integral to the painting, is also apparent in the print, specifically in Manet's etching technique, with parallel strokes and the aquatint grain.

Manet's etching *Cat and Flowers* illustrates the relationship between Eastern and Western visual traditions, specifically between Goya and Hokusai, a comparison noted in the Champfleury text (see no. 50). Ives suggests two Hokusai prints from the *Manga* that might have influenced Manet's design, including one of a preening weasel and another of a black-and-white patched cat in front of a screen (Ives 1974, pp. 26–27). While this print of a large cat situated in a shallow gridlike composition is reminiscent of Japanese prints, Manet's cat is realistically rendered, and the etching technique, with strong etched lines in parallel strokes and aquatint, derives from Goya. In contrast to the severe composition and a generally uniform application of aquatint, Manet drew the flowers with more freedom and also distributed highlights throughout the design by stopping out the aquatint and using the white of the paper. Whether a scene from his painting *The Balcony,* only looking out, or a composition infused with the experience of Japanese art realized with the technique of Goya, this print is one of Manet's more inventive original designs, based at least initially on the observations he made in his sketchbooks.

The third state, exhibited here, represents the finished etching before the addition of titles for publication. In the earliest stages of his work on the plate, Manet added etched lines to the porcelain planter in the foreground, as

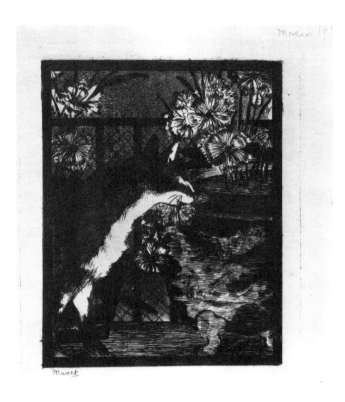

*52 Cat and Flowers*

53
*Line in front of the Butcher Shop (Siege of Paris)*
(1870–1871)
Queue devant la boucherie (siège de Paris)

Etching
On blue-green laid paper
First state of two, from the 1894 Dumont edition
Sheet: 332 x 247 mm (13⅛ x 9¹¹⁄₁₆ in)
Plate: 238 x 159 mm (9⅝⁄₁₆ x 6³⁄₁₆ in)
Image: 169 x 147 mm (6¹¹⁄₁₆ x 5¾ in)
Inscriptions: None
N.Y. 123, B. 64, I. 71, H. 70, G. 58, M.N. 45

*The George A. Lucas Collection of The Maryland Institute, College of
Art, on indefinite loan to The Baltimore Museum of Art
B.M.A. L.33.53.5166*

well as in other areas, and gave further emphasis to the compositional function of the railing with the addition of the crossed diagonal wires, which were added in the exhibited state. Two hand-corrected proofs, one from the first state in the Bibliothèque Nationale and one of the second state in the Avery collection, prefigure the changes made to the plate. Bareau suggests that these changes convey Manet's attempt to harmonize more successfully the two-dimensional oriental background with the more realistic passages, including the drawing of the cat (New York 1983, p. 310). Harris, in integrating this print within Manet's painting chronology, observes that the reversal of the normal figure-ground relationship in this design—the large cat in the foreground with more detail behind—reflects the direction of Manet's painted compositions in the 1870s. This etching has always been among the most popular in Manet's oeuvre, and cat lovers aside, the appeal of its strikingly original composition can still be experienced today. In addition to the Champfleury edition and another by Megnin in 1899, there have been numerous modern editions, some quite recent, on a white wove paper.

At the time when Manet's interest in etching began to wane, he produced some of his most unconventional and inventive prints in designs that generally were created for printmaking. Although he had little success at publishing his works, he was at this time less interested in the reproductive potential of the medium (see no. 76). This more original approach to etching parallels the growing interest in lithography in this period. In addition to the etchings of cats, connected to Champfleury's commissions, the best example of this final moment of etching activity is *Line in front of the Butcher Shop.* The scene depicted is described in Manet's letters to his family, who were safely away from Paris while the artist remained as part of the National Guard during the Prussian siege of the city in the winter of 1870: "[T]he butcher shops open only three times a week, and there are queues in front of their doors from four in the morning, and the last in line get nothing" (New York 1983, pp. 321–322). It was a time of tremendous hardship and widespread hunger when even rats were butchered. The line at the butcher shop became a symbol for the worsening economic conditions, as satired by Cham in the 8 December 1870 edition of *Le Charivari,* when he showed a line of people, guard nearby, waiting for a rat to appear from a gutter. In Manet's etching, the sole indication of the military control of this panic for food is the bayonet rising in the center of the composition above the umbrellas.

Like his etchings of cats, this design is again a confluence of Eastern and Western prototypes, although here the most important influence for both content and technique was Goya. Manet owned a set of Goya's The Disasters of War, first available in a posthumous edition of 1863. He had studied these prints in his preparations for the painting *The Execution of Maximilian,* and it was entirely characteristic of Manet to turn again to Goya in search of thematic and technical inspiration for his own scene of the social havoc of war. Working in an etching style close to that of the Disasters prints, Manet etched his figures with widely spaced parallel strokes that define shapes without the restraint of continuous contour lines. For the most part the direction of these strong lines alternates between horizontal and vertical, from figure to figure. This technique creates luminious, insubstantial surfaces, heightened by the Goya-like organization of

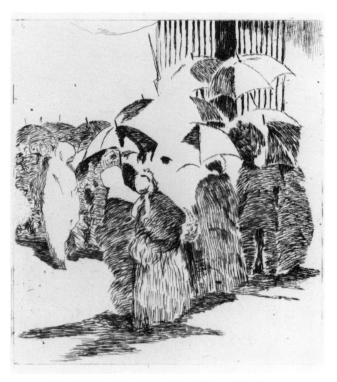

53 *Line in front of the Butcher Shop (Siege of Paris)*

cleanly in the peripheral areas of the plate, the figures in the center foreground are muddy from too much ink and retroussage.

Because of its strikingly unconventional conception, remarkably distinctive even within the artist's oeuvre, *Line in front of the Butcher Shop* has been described as Manet's masterpiece of printmaking and a true impressionist etching (Melot 1974, p. 62). Contours are dissolved in luminosity, but Harris suggests that this effect may result from the plate being left unfinished, although she admits that Manet has finalized the tonal relationships of the plate. Furthermore, unlike the first state of *Dead Christ with Angels* (no. 37), the plate was strongly etched without indication of elements in need of additional refinement. Contrary to Harris's suggestion, what Manet achieved in this plate was intentional, and the elements of his design were carefully analyzed with a reductive deliberateness. Manet's direct observation of the scene, in fact his actual participation in the events of the siege, provided thematic content, while his own visual experimentation, stimulated by Goya and the experience of Japanese prints, conspired to create this remarkable object.

light and dark areas across the otherwise blank paper. Ives suggests that Manet may have again looked at a Hokusai print from the *Manga,* in this case a sheet where figures are grouped beneath their umbrellas, plane upon plane, and somewhat flattened against the open pages. The *Manga* was especially popular with Manet and his contemporaries, and the artist copied a motif from this series in his illustrations for Mallarmé's *L'après-midi d'un faune* (no. 72). Unlike Hokusai's flat decorative shapes, Manet's umbrellas, although somewhat schematic, are realistically shaded.

This etching is one of Manet's rare forays into purely original printmaking from design to execution, and he apparently had no publication project in mind except for a possible new edition of his prints. It is conceivable that he meant to edit his "souvenirs of the siege" along with more realistic views like Lalanne's and others, but this seems unlikely (New York 1983, p. 322). The print was published only in posthumous editions, and the few proofs printed other than these editions were probably pulled by Guerard during the artist's lifetime. One such proof, formerly in Guerard's collection and now in The Art Institute of Chicago, must be closest to Manet's intentions for a printing of this plate. It is on a tinted laid paper typical of the Guerard proofs, and a precedent for the later Dumont edition, such as the exhibited impression on blue-green paper with a bistre ink. But unlike this impression, the Chicago proof is carefully printed with great clarity, enhancing the stark black-and-white contrasts of the image. The Dumont edition is the best posthumous printing of the plate. Yet although printed

## 54
*The Barricade* (1871)
La barricade

Crayon lithograph with scraping
On chine collé, white wove paper
Second state of two
Sheet: 594 x 450 mm (23⅜ x 17¾ in)
Chine: 465 x 334 mm (18⁵⁄₁₆ x 13⅛ in)
Inscriptions: On stone, below image, lower margin, c., "Imp.
 Lemercier & Cⁱᵉ, Paris"
N.Y. 125, B. 80, I. 72, H. 71, G. 76, M.N. 82

*The George A. Lucas Collection of The Maryland Institute, College of
 Art, on indefinite loan to The Baltimore Museum of Art*
 *B.M.A. L.33.53.13694*

That Manet was in Paris during the "semaine san-
glante," the bloody end in May 1871 to the Commune
of Paris, is not certain, although Reff states that execu-
tions of the communards continued until mid-June when
Manet had returned to Paris (Reff 1982, p. 204). *The
Barricade,* whether based on personal observation or pho-
tographs, conveys an approach typical for Manet, where
scenes of contemporary life are conceived with quotations
taken from his own art and the art of the past, in this
case Goya's scenes of war-ravaged Spain. Manet first

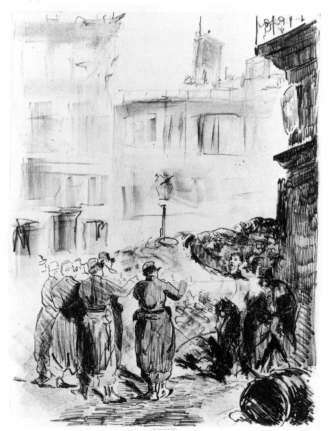

54 *The Barricade*

made a watercolor of the execution at the barricade (R.W.
vol. 2, 319), now in the Szépmüvézeti Muzeum in Buda-
pest. The central group of soldiers was taken directly
from the lithograph *The Execution of Maximilian* (no. 49),
which a tracing on the verso of the watercolor shows (see
N.Y. 124). The composition of the lithograph follows the
outlines of the central group very closely, although in
reverse, suggesting Manet used a tracing from a photo-
graph of the drawing because the figures are slightly
smaller. On the left, a soldier remains only partially
traced, so that only the head shows. This figure, who in
the Maximilian composition holds the raised sword, is cut
off in the drawing as well. That Manet used the earlier
composition with its specifically republican sympathies is
reinforced by a reference to Goya's painting *The Third of
May* and his etchings from The Disasters of War series.

Bareau points out that the lithograph is drawn in two
different styles, which reflects the manner in which Ma-
net drew his composition on the stone (New York 1983,
p. 326). The outlined figures of the soldiers appear to be
traced from an optically reduced photograph of the draw-
ing, while the setting, including the surrounding build-
ings, the barricade, and the victims themselves, is more
freely rendered. This broader approach suggests that
these areas were conceived directly on the stone. As in
*Civil War,* Manet drew the distant background with wide
strokes using the side of the crayon. He then worked
over the broad surface areas with finer lines to add detail
and, at the very end, scratched highlights through the
crayon. The print shows an expanded foreground and an
extension of the composition to the left, isolating the
soldiers as a group. This composition could reflect the
original condition of the drawing before repair and trim-
ming. Other vague areas in the drawing are clarified in
the lithograph, most important the position of the victims
against the barricade and the prominence given to the
tallest of them, who gestures defiantly.

Manet's well-documented sympathy for the commu-
nards is readily apparent here, even though, through his
reference to other works, such as his own *Execution of
Maximilian* and works by Goya, he transforms his efforts
into a more universal commentary of governmental
oppression of republican principles. This lithograph was
probably censored in the years immediately following the
fall of the commune, which is perhaps why *Civil War,*
which is less inflammatory, was chosen instead for the
1874 edition. *The Barricade* was not published until the
posthumous edition of 1884. Moreau-Nélaton quotes
Lemercier's printer Clot, who believed the stones used
for this posthumous edition had never before been
printed, even for proofs for the artist. While this seems
unlikely, an examination of before-the-letter proofs yields
no definitive evidence to the contrary. Like *The Races* (no.
56), which was also published for the first time in this
edition, there are some before-the-letter proofs printed
before the removal of a few errant lines on the left side of
the composition that had extended beyond the chine.

Bareau suggests that Manet may have intended the
watercolor as a preparatory sketch for a large canvas to
be submitted to the Salon of 1872. This possibility would
have encouraged him to prepare a lithograph for exhibi-

tion and sale at the same time. Tabarant relates that during this period, after the war and fall of the commune, Manet experienced a severe nervous depression that prevented him from doing serious work until spring 1872, making it impossible for him to complete such an ambitious canvas in time for the spring Salon (New York 1983, pp. 325, 327). Instead, Manet exhibited *Battle of the Kearsarge and the Alabama*, a scene from another civil war.

## 55
*Civil War* 1871  (1871–1873)
Guerre civile

Crayon lithograph with scraping
On violet toned chine collé, white wove paper
Second state of two
Sheet: 473 x 574 mm (18⁹/₁₆ x 22⁹/₁₆ in)
Chine: 396 x 508 mm (15⁹/₁₆ x 20 in)
Inscriptions: Signed in stone, l.l., ''Manet 1871''; below image, l.l., ''Tiré à cent exemplaires''; below image, c., ''GUERRE CIVILE''; l.r., ''Imp. Lemercier & Cⁱᵉ R. de Seine 57 Paris''
B. 79, I. 73, H. 72, G. 75, M.N. 81

*The George A. Lucas Collection of The Maryland Institute, College of Art, on indefinite loan to The Baltimore Museum of Art*
*B.M.A. L.33.53.13693*

According to Manet's biographer, Duret, this lithograph depicting a dead National Guard soldier at a broken barricade, was sketched from life at the intersection of the Boulevard Malesherbes and the Rue de l'arcade, near the Church of the Madeleine (Duret 1902, p. 127). The church with its columned portico and surrounding iron fence is in the upper left. For Manet, lithography's appeal went beyond its immediacy as a graphic medium. He also appreciated its long tradition as visual communication for the masses, especially effective for political and social satire, best represented by the work of Daumier. In his print *Civil War*, Manet transformed his sketch made in the streets of Paris into a heroic subject, a masterpiece of lithography that, using visual quotations from his own work and from the art of the past, carries much weightier associations than just the events surrounding the ''semaine sanglante'' and the fall of the commune.

The figure of the soldier is taken directly from Manet's 1864 painting *Dead Toreador* or from the etching after the painting (no. 43), but it is in reverse orientation to the canvas and etching. In referring to his earlier painting Manet also introduces through association memories of *Dead Soldier* then attributed to Velázquez or the Gérôme painting *The Dead Caesar* from 1859, now in the Walters Art Gallery. In a 1967 article, Ackerman suggested another more contemporary source in a second painting by Gérôme exhibited in the Salon of 1868, *The Execution of Marshal Ney*, which also shows the dead man lying horizontally across the road (Ackerman 1967, pp. 170–171). But beyond these examples, which could have served as models for the central figure of the dead soldier, the conception of this lithograph owes much to Daumier's famous scene *The Rue Transnonain* from 1834 (Delteil 135), which like *The Execution of Maximilian* (no. 49) was censored by the government because of its potential for inflaming public passion against those in power. Daumier also used a large central figure lying diagonally across the composition, only propped up against a bed in the background. Both Manet and Daumier, convinced of the power of visual statements to incite change, created ambitious compositions of tremendous graphic power in a medium allowing immediate accessibility to large numbers of people.

The date 1871, which appears on the lithograph, prob-

ably refers to the date of the event and Manet's sketch, rather than to the date of the artist's work on the stone. The print was published in 1874 together with *The Urchin* (no. 62) in an edition of one hundred on a chine collé paper with prominent red and blue fibers that create a violet tint. The rarity of these two prints suggests that the edition may have actually been smaller than the size recorded by Lemercier in the Depot Legal. If the lithograph had been made and published in 1871, it probably would have been censored. Very probably, however, the lithograph was drawn later, closer to the publication date of 1874, because in 1872–1873 Manet made a number of lithographs possibly thinking of a larger edition of his lithographic works. When it came to a choice between the two works that relate to the bloody days of the commune, *Civil War* was chosen over *The Barricade* (no. 54) because its less specific subject only generally refers to the tragedy of the commune's fall, rather than to the reprisals afterward. Manet's choice of a title, printed in the lower margin in the second, published state, "Guerre Civile," identifies the scene as a universal comment on the tragedy of internal war between citizens. To the right are the legs of a civilian killed in the fighting, presumably an innocent victim. Daumier's lithograph had the same message (Reff 1982, p. 212).

No other lithograph by Manet better conveys his mas-tery of the medium in the service of an unconventional idea than does *Civil War*. In drawing on the stone with a crayon, Manet used the full breadth of the medium's graphic potential. Details are crisply defined with a sharpened crayon, while wide strokes, drawn with the side of the crayon, define broader areas. An especially effective example of this technique is the barricade behind the dead soldier. The shape of the paving stones is outlined with the sharp crayon, while the face of each stone is defined in broad strokes, alternating slightly in direction to suggest a modulating surface. A once-solid wall is now a shattered, unstable surface. Individual strokes retain their visual integrity because the viewer is aware of the actual application of the crayon on the stone. Finally, Manet used a familiar technique for his lithographs, scoring the stone with fine scratches to add accents or rubbing away wider areas of the crayon for bolder highlights. This technique allowed a final stage of refinement where Manet was able to revise work already on the stone to reflect better his conception. An example of this technique is the soldier's pack, delineated with scratches to separate the figure from the dark background of the barricade. This lithograph is close in style to *The Barricade* and is very different from the earlier, much more restrained, *Maximilian* or the freely drawn evocation *The Races*.

55 *Civil War*

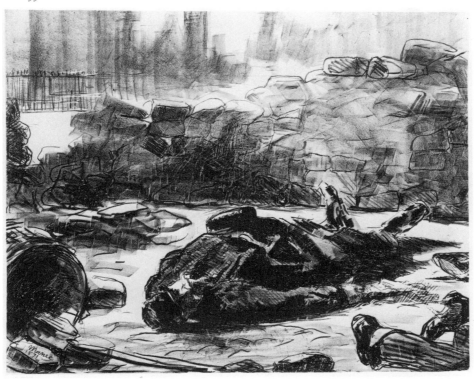

**56**
*The Races* (1865–1872)
Les courses

Crayon lithograph
On chine collé paper
Second state of three
Sheet: 470 x 597 mm (18½ x 23½ in)
Chine: 397 x 515 mm (15⅝ x 20¼ in)
Inscriptions: None
N.Y. 101, B. 76, I. 66, H. 41, G. 72, M.N. 85

*Alan and Marianne Schwartz*

Our appreciation of this extraordinary print has been overburdened by claims for its modernity. Yet it is a highly precocious statement of a bold, suggestive style only approached in the lithographs of the 1890s and perhaps not fully realized until the works of the German Expressionists. Not published until the posthumous edition of Manet's five unedited lithographs in 1884, it was no less unconventional then than it would have been if published in the 1870s. Even within Manet's oeuvre, the relationship between the lithograph and the relevant paintings and watercolor is extremely problematic, although a recent analysis by Moffett and Bareau, and before them Harris, offers plausible explanations for many of the more enigmatic aspects of these works (New York 1983, pp. 262–268; Harris 1966, pp. 78–82). Finally, it should not lessen our admiration for the work to see that the vigorous strokes to the right do not so much reflect a conscious expressionism but, as Bareau demonstrates, Manet's uncertainty about an unresolved aspect of his composition, an indecision seen in the other works as well (New York 1983, p. 267).

A range of dates from 1865, when Manet exhibited one of his paintings, *The Races at Longchamp,* to 1872, when he completed an entirely different composition of the same theme (R.W. vol. 1, 184), are the only certain parameters for dating *The Races*. Works related to the lithograph, which is in reverse to these compositions, include a destroyed painting known in two fragments (R.W. vol. 1, 94 and 95), a watercolor in the Fogg Art Museum at Harvard University (R.W. vol. 2, 548; see fig. 11), which probably represents the entire composition of the destroyed canvas, and a related painting of a slightly different composition in The Art Institute of Chicago (R.W.

vol. 1, 98). The lithograph is an intermediate step, closer to the watercolor and thus the destroyed painting and preceding the Chicago picture. It is not a replica of any of these, but rather an interpretation, in sequence, of a composition in progress. The lithograph *The Execution of Maximilian* (no. 49) served a similar role.

Bareau suggests that Manet's composition may have been based on a tracing of a photograph of the lost painting, although no such photograph or other evidence exists (New York 1983, p. 266). Generally, the print does follow the outlines and details of the watercolor (see fig. 11), except the area to the right where Manet covered the stone with imprecise lines, only suggestive of detail.

It is interesting to note that in the watercolor Manet added a separate sheet of paper at that point, easily visible, thus separating the problematic area from the rest of the composition. Bareau notes that in the lithograph Manet added another carriage in the upper right, where the horse and rider stand in the watercolor. Manet substituted an amorphous crowd, indicated with a few suggestive lines, replacing the three figures closest to the fence in the destroyed painting. In the final painting in Chicago he eliminated this area, cropping this side to a point just beyond the three fence posts connected by a horizontal board. This adjustment brings the horses closer to the foreground, "telescoping" the subject in a manner Moffett found consistent in Manet's reworking of canvases (New York 1983, p. 264). The energetic drawing on the right may imply movement and action consistent with the subject of running horses, but it also reflects Manet's indecision about this area of the composition. Bareau points out how Manet achieved some resolution in this vaguely suggested area with the curving line at the base of the fence that brings the track toward the center of the composition. This dynamic solution is not suggested in other works, and it enhances the action of the subject, with the horses seeming to "explode" from the background, galloping directly at the viewer (New York 1983, p. 267).

The Chicago picture is tentatively dated 1867, and while Manet's prints are not easily dated, the vigorous drawing in this print argues stylistically for a date as late as possible in the 1860s. The lithograph is more compatible with his works of 1870–1872 than the more restrained *Execution of Maximilian* of 1868. The openness and variety in strokes is not unlike the lithographs *The Barricade* (no.

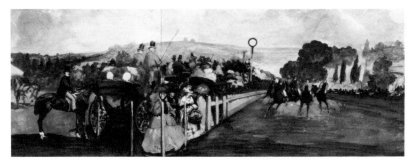

FIG. 11 *Races at Longchamp,*
Fogg Art Museum, Bequest-
Grenville L. Winthrop

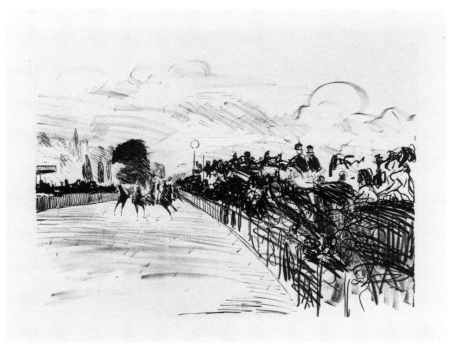

56 *The Races*

FIG. 12 *Races at Longchamp*
(detail), Indiana University Art
Museum

FIG. 13 *Races at Longchamp*
(detail), Indiana University Art
Museum

54) or *Civil War* (no. 55), both from 1871–1872. Perhaps after the Chicago picture Manet made the lithograph as a reprise to reconsider the composition once again before working on the variation of 1872. In the sky of *The Races* Manet used the crayon's side to make the same sweeping strokes. While his first major lithograph *The Balloon* (no. 22) was also boldly and unconventionally executed, *The Races* is closer to Manet's later lithographs in its more confident and controlled draftsmanship.

According to Clot no impressions of this print were made during Manet's lifetime, but a number of before-the-letter proofs, with some of the same variations seen in the other unpublished lithographs from the 1884 edition (no. 54, 59, and 60) raise questions about his statement (M. N. 82). Bareau and others suggest that before-the-letter proofs of fine quality, which exhibit changes from the edition impressions, provide evidence that life-time impressions may exist of *The Races*. The more likely

possibility, however, is that these changes are the work of a printer, and there is no persuasive evidence to indicate that the proofs were actually prepared for the artist. There are three distinct states for this print. The first, known in only four recorded impressions (Bibliothèque Nationale, Paris; National Gallery of Art, Washington, D.C.; Indiana University Art Museum; and private collection, see illustration, B. 76), shows the full composition before a small strip on the right side was trimmed. The second state, still without letters, is after the strip was removed and is represented by the exhibited impression. The third is with letters, including Lemercier's address. In a recent catalogue entry from Christie's (May 10–11, 1982, lot 233), the author attempted to demonstrate that there was actually no difference between the first and second states, as previously recorded by Bareau in her 1978 catalogue. The incorrect suggestion was made that in printing a frisket had been used and had merely shifted to the left, covering a strip to the right and uncovering more to the left. Two details from the Indiana University Art Museum first state proof show the full extent of the composition at both sides (see fig. 12 and 13). The Christie's assumption was based on the study of a photograph of the first state, which was hard to read because the design on the left side printed off the chine and is thus very light and difficult to see. Trimming the composition between first and second states was hardly an artistic change, but more likely the result of the printer's cleaning up the stone in preparation for the edition. In addition to the impressions noted above, there are masked impressions after the third state but without letters. The Art Institute of Chicago has an example of such a print where in the process of masking the letters a mistake was made. The paper for the mask flipped over so that the letters were printed as a counterproof, backward in a new position, slightly off center.

Other printing variations also occur. The impressions of the first state are printed on a luminous chine collé paper of a generally constant size (366 x 513 mm). The exception is the Bibliothèque Nationale proof, where the chine is wider (384 x 507 mm). Impressions of the second state, seen by this writer, are printed on a somewhat larger chine (approximately 402 x 515 mm). The standard edition is on a chine close in size to the Bibliothèque Nationale proof (387 x 511 mm). In addition, there are significant variations in printing effects, with the before-the-letter proofs being generally, although not always, better printed than the edition impressions. One major area of comparison is the area of very fine tone immediately above the spectators to the distant left. While it is still visible in the edition impressions, the first state impressions show a greater richness there. Also the landscape details behind the horses seem to show up better in the first and second state impressions. The Bibliothèque Nationale proof is the finest seen by this writer although the exhibited impression approaches it in some respects. The Bibliothèque Nationale proof is so richly inked that the lines have the suppleness of crayon lines directly applied to paper. The one area that is weaker in the first state impressions is the sky, which is much lighter than that of the exhibited second state. The tone of the sky enhances the stark black-and-white contrasts of the scene itself, although the sky is printed darker in the regular edition. In the edition impressions and in some before-the-letter proofs, the blacks begin to clog and print with a mottled effect. This is visible in the darkest areas and is not disturbing unless compared with the very finest before-the-letter proofs, such as the exhibited impression, where the blacks are rich and solid. These variations are best explained as printer's adjustments.

## 57
*Berthe Morisot* (1872)

Etching, drypoint, in bistre ink
On blue-green laid paper, unidentified watermark
Second state of three, from the 1894 Dumont edition
Sheet: 304 x 239 mm (11¹⁵⁄₁₆ x 9⅜ in)
Plate: 119 x 80 mm (4¹¹⁄₁₆ x 3⅛ in)
Inscriptions: None
B. 65, I. 76, H. 75, G. 59, M.N. 41

*The George A. Lucas Collection of The Maryland Institute, College of
Art, on indefinite loan to The Baltimore Museum of Art*
B.M.A. L.33.53.5142

57 *Berthe Morisot*

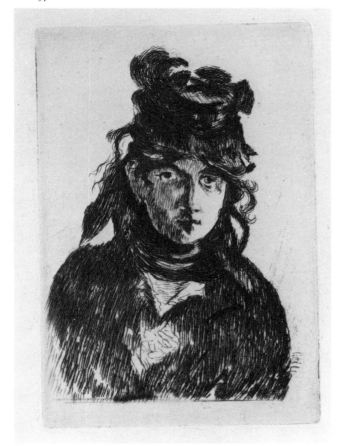

Manet made three prints after his 1872 painting of Berthe Morisot in a black mourning dress with violets (R.W. vol. 1, 179), two lithographs and this etching. Each print reflects a different aspect of the original canvas, as well as the varying emotional attitudes of the sitter, intense in the etching, more relaxed in the lithographs. Here Morisot appears anxious and disheveled as she leans toward the viewer, a pose that differs from the original. Manet created this effect by revising the left shoulder profile, bringing it down so the figure seems to twist to the right. The broad brushwork of the painting, when translated to etching, becomes a nervous line. The etching is in reverse orientation to the oil, unlike the lithographs. Manet probably drew directly on the plate or used a tracing from a photograph of the painting, reduced to the scale of the plate. The composition is slightly cropped at the bottom, eliminating the touch of light paint that defined the violets at the bottom edge of the painting.

For this portrait, Manet used an etching technique very similar to that of *Line in front of the Butcher Shop* (no. 53). Parallel strokes define the shape of the figure without the constraint of outlines. The rough, almost transparent, surface achieved with these dark etched lines is more noticeable in the first state before Manet etched the plate again to darken the dress. The painting is one of Manet's rare portraits where the face is lit from one side, and he was careful to carry this element to the prints as well. In the second state, exhibited here, the face is darker than in the first state, creating a more dramatic lighting effect than in the painting or lithographs. The modeling of the face is consequently less subtle, and Morisot seems gaunt, with tired eyes, perhaps showing her true feelings at a time of grief.

Nothing is known about Manet's reasons for making this etching, which was his last, except for his commissioned illustrations for *Le fleuve* from 1874 (no. 64a-h) and his etching *Jeanne* in 1882 (no. 75). It is the final work from the artist's second period of etching, which lasted from 1865 to 1872. The print was never published in his lifetime and is known in only a few lifetime proofs, including an impression of the first state in the Avery collection. It was published in all three posthumous editions and later in both the 1910 Waldmann German translation of Duret and the 1912 Flitch English translation. The exhibited impression printed on a blue-green paper with a brown ink is from the Dumont edition.

58
*Berthe Morisot*  (1872–1874)
(en silhouette)

Crayon lithograph with scraping
On grey chine collé, white wove paper
First state of two
Sheet: 330 x 245 mm (12¹⁵/₁₆ x 9⅝ in)
Chine: 235 x 163 mm (9¼ x 6⅜ in)
Image: 190 x 140 mm (7½ x 5½ in)
Inscriptions: None
B. 82, I. 74, H. 74, G. 78, M.N. 84

*The George A. Lucas Collection of The Maryland Institute, College of
Art, on indefinite loan to The Baltimore Museum of Art*
*B.M.A. L.33.53.5171*

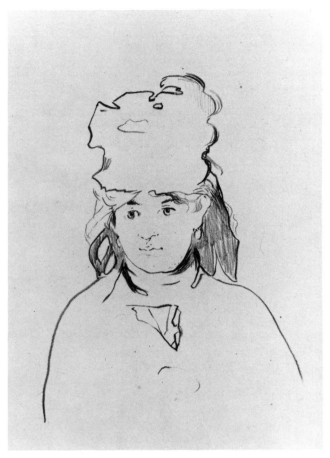

58 *Berthe Morisot* (en silhouette)

Of Manet's two versions of his lithographic portrait, *Berthe Morisot*, the one in outline is closest to the contours of the painting. Both lithographs have the same dimensions as the other work, and both follow the orientation of the original. Manet probably worked from a scaled photograph of the canvas, perhaps using a tracing. It is not possible to determine which lithograph came first, for Manet could easily have begun by remaining faithful to the contour of the image in his painting and, in the second lithograph, elaborated the tonal relationships, although the reverse is also possible. The exhibited version reflects the simplicity and directness of the painting and is a distillation of these formal qualities. The only exaggerated element in the portrait is Morisot's elaborate hat, with its distracting flourishes. By drawing the shape of the figure and then outlining those accents that appear white in the painting such as the open dress beneath the scarf, the blank paper becomes the equivalent of the flat black areas of the painting such as the dress. Manet drew this remarkably free interpretation directly on the stone with the crayon, making just a few fine scratches in the stone to add accents. In the silhouette version the image floats on the page, unrestricted by the border lines that frame the composition in the other lithograph. Like the painting, and unlike the etching, Morisot seems more relaxed here, and Manet achieved her somewhat preoccupied expression by carefully drawing her eyes, which in the second version are unfocused black dots without pupils. This version is not then an abstracted simplification of the original, but rather a carefully conceived interpretation, as detailed as the second version, but of different intent.

Neither of these lithographs was published in Manet's lifetime, and both appeared in the 1884 edition of five of his lithographs arranged by his widow. Bareau has determined that the edition was only fifty impressions, not the previously recorded one hundred (New York 1983, pp. 279–280). It is not known why these images were made, although Bareau has suggested that they may mark Morisot's marriage to Manet's brother Eugene in 1874. The exhibited impression is a rare before-the-letter proof of the first state, although there are some impressions where the letters are falsely masked.

This proof was printed on a grey chine collé of different dimensions than the chine collé of the impressions

with the letters (220 x 165 mm). Clot, a printer working for Lemercier, the firm that prepared the 1884 edition, maintained that none of these stones had ever been printed before (M.N. 82). While it seems unlikely that Manet would not have had any proofs pulled, there are no apparent aesthetic differences between the various before-the-letter proofs and those with letters. After the 1884 edition, the stones were effaced.

The lithograph has been heralded for its avant-garde character, prefiguring the printmaking styles of Lautrec and Bonnard in the 1890s, which also reflect the influence of Japanese prints. When considering Manet's influence, it must be remembered that although these lithographs were not seen until 1884, they are sufficiently early to have impressed the artists fervently interested in the artistic revival of the medium in the last decades of the century.

**59**
*Berthe Morisot*   (1872–1874)
(en noir)

Crayon lithograph with scraping
On grey chine collé, white wove paper
Second state of two (letters masked)*
Sheet: 309 x 227 mm (12³⁄₁₆ x 8⁷⁄₈ in)
Chine: 251 x 175 mm (9⁷⁄₈ x 6⁷⁄₈ in)
Image: 204 x 143 mm (8¹⁄₁₆ x 5⁵⁄₈ in)
Inscriptions: None
B. 81, I. 75, H. 73, G. 77, M.N. 83

*The George A. Lucas Collection of The Maryland Institute, College of
   Art, on indefinite loan to The Baltimore Museum of Art
   B.M.A. L.33.53.5170*

**60**
*Berthe Morisot*   (1872–1874)
(en noir)

Crayon lithograph with scraping
On chine collé, white wove paper
Second state of two*
Sheet: 267 x 190 mm (10½ x 7½ in)
Chine: 249 x 177 mm (9¹³⁄₁₆ x 6¹⁵⁄₁₆ in)
Image: 204 x 143 mm (8⅛ x 5⅝ in)
Inscriptions: In lower margin, c., "Imp. Lemercier & Cⁱᵉ, Paris"
B. 81, I. 75, H. 73, G. 77, M.N. 83

*The George A. Lucas Collection of The Maryland Institute, College of
   Art, on indefinite loan to The Baltimore Museum of Art
   B.M.A. L.33.53.5169*

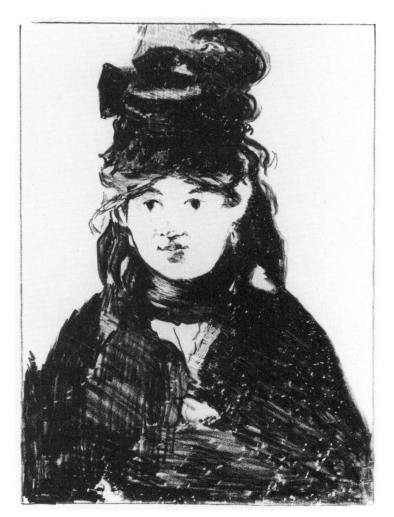

59 *Berthe Morisot* (en noir)

A second lithographic portrait, known as *Berthe Morisot* (en noir) after Manet's painting of her, interprets the tonal values of the oil. Although technically more complex, it is actually a freer translation of the original than the silhouette version of the first lithograph. Manet's vigorous drawing contrasts with the relaxed contours of the painting, which are accurately conveyed in the other lithograph. But unlike the other version, where Morisot's figure is a cropped vignette on a blank sheet, the exhibited lithograph has a border that delineates the limits of the composition. The design, following the painting, extends to those lines, including the lower section with the white area representing the violets Morisot holds in the oil.

The dimensions of the two versions are the same, and both were probably based on reversed photographs of the painting, possibly in the scale needed for work on the stone. In drawing this design on the stone Manet translated the relatively flat black area of the dress in the painting to an area of broadly conceived vertical and diagonal strokes, creating a more modulated surface. White spots throughout this passage occur where Manet's diagonal strokes end, further calling attention to the visual integrity of individual lines. Conversely, areas in the painting characterized by broader brushwork, particularly the white highlights, become outlined, flat areas of white paper, untouched by crayon. Additional visual accents are given to areas with fine scratches and burnishing. Enjoying the immediacy of this drawing medium,

Manet did not try to obscure the motion of his hand by filling in the space between lines or by removing lines that went beyond the basic outlines of the composition. The fluid quality of the line suggests that Manet drew with a soft, oily crayon, sometimes using the broad end or, for more precise drawing, a finer point.

The standard designation of states for this lithograph includes two stages, one before the letter and one with the address of Lemercier, the printer. In some impressions these letters have apparently been masked. Such an impression in the Victoria and Albert Museum is described by Griffiths as without letters, printed on a simili japon paper, and much poorer in quality than the 1884 edition of the lithograph—the first and only edition published in fifty impressions (Carey and Griffiths 1978, p. 37). Bareau was able to determine accurately the edition size as fifty impressions, not one hundred, through an examination of Depot Legal records. Additionally, she found a document relating to the Manet estate that in 1892 stated that the stones had been destroyed after an edition of 250 impressions (five lithographs from the 1884

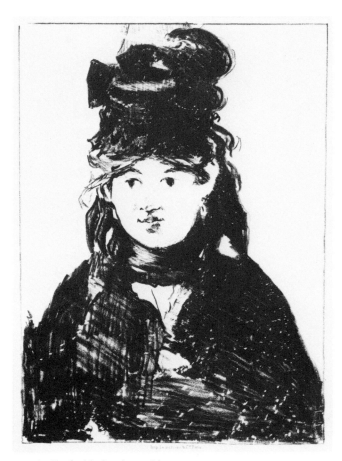

60 *Berthe Morisot* (en noir)

edition, fifty impressions each). In considering how to determine the existence of before-the-letter proofs that may have been printed during Manet's lifetime. Griffiths describes a proof in The Cleveland Museum of Art that shows a subtle application of shading to the right side of Morisot's face, an effect not visible in the published impressions or other impressions before letters. Consequently, this work should be the hallmark of an early, lifetime printing, according to Griffiths. A second proof with this characteristic is in The Art Institute of Chicago (see fig. 14).

Other explanations are possible, however, and these inconsistencies point up the inadequacies of cataloguing to date and of the basic understanding of the printing history for Manet's lithographs. Do these differences reflect different states, and should the standard listing of states be expanded to include changes that occur to the stone as printers worked on it? An identical case would be that of the lithograph *The Races* (no. 56), where the existence of before-the-letter proofs editioned after Manet's death is not at all unusual. It was a common practice for a limited number of impressions to be printed without letters in a kind of deluxe edition, and it is impossible to distinguish such impressions from "real" proofs made for the reference of the printer. Griffiths suggests that the Cleveland, and now Chicago, proofs

might be lifetime impressions and that shading was too subtle to be retained in the later printing, although with such a small edition it is unlikely. If he is correct, there would be before-the-letter proofs both from Manet's lifetime and from 1884, when the letters were eventually added to the stone for the regular edition. Perhaps these proofs merely show printing variations, and as Clot maintained, the stones had never been printed before the edition he printed for Lemercier in 1884 (M.N. 82).

Included in this exhibition are two impressions of the Morisot portraits: one with letters and one masked impression from the 1884 posthumous edition. The edition impression is exceptionally rich and contrasty, like other impressions of this state, but the masked impression from the Lucas collection shows none of the shading visible in the Cleveland or Chicago impressions. Careful examination indicates that the inscription has been masked so that letters on the stone would not print. In addition to the impression in the Victoria and Albert Museum described by Griffiths, another impression described as a masked printing was offered for sale at Sotheby's in New York, May 10–11, 1982, as lot 235. What then are the circumstances that could explain the characteristics of this proof, and what suggestions does this proof make about the printing of Manet's posthumously edited lithographs? More work on these objects will yield a definitive answer, but several possibilities exist.

The Lucas proof not only lacks the shading on the right side of Morisot's face that occurs in the painting, but it also lacks some of the shading visible in the edition impression. In the Lucas masked impression, the dark area above the chin is abbreviated, and no lines appear on the chin itself. The most important difference between the Lucas masked proofs and the other impressions can be found in the white areas, which are filled with a speckled tone composed of tiny dots of black ink. This is especially visible at the dress opening in the center below the scarf, where it can easily be seen that the scratch marks also removed this tone. In the Chicago and Cleve-

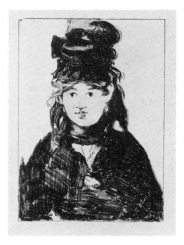

FIG. 14 *Berthe Morisot* (en noir),
The Art Institute of Chicago

land impressions only the break in Morisot's hair above her left shoulder retains traces of this shading. All the before-the-letter proofs seen by this writer are less contrasty, especially in an area such as that above the hat. Here the scratching is not as dramatically scored as in the edition impression. The Lucas proof like the Chicago proof is printed with a drier, less black ink, possibly a type used to proof stones before printing. Another proof comparable to the Lucas proof is illustrated on the cover of the Ingelheim catalogue.

Unlike the etching, which in the course of printing becomes lighter as the plate wears, the lithograph often prints darker as the stone fills in from repeated inking. The Lucas masked proof appears to illustrate this phenomenon, as it is much darker overall and lacks the clarity of the edition impression. Greys occupy areas that were previously white. A definitive identification of other proofs without letters must await a systematic first-hand study of the impressions themselves. The similarities between the Lucas masked impression and Chicago and Cleveland proofs without letters, however, suggests that they too are variant printings from the stone after the regular edition, where the letters have been removed or masked.

61

*Polichinelle* (1874)

Seven-color crayon lithograph with scraping
On white wove paper
Fourth state of four
Sheet: 556 x 362 mm (21⅞ x 14¼ in)
Image: 472 x 310 mm (18⁹⁄₁₆ x 12 ¼ in)
Inscriptions: Signed in stone, l.r., ''Manet''; in pen, l.r. of sheet, ''à Ed. Judeau Polichinelle/E. Manet''; c., ''Imp. Lemercier & Cⁱᵉ Paris''; below c., ''Féroce & rose avec feu dans sa prunelle,/ Effronté, saoul, divin, c'est lui Polichinelle!/Théodore de Banville''
B. 83, I. 90, H. 80, G. 79, M.N. 87

*The George A. Lucas Collection of The Maryland Institute, College of Art, on indefinite loan to The Baltimore Museum of Art B.M.A. L.33.53.18056*

Manet's first lithograph, and perhaps his first print, was his 1860 caricature of Emile Ollivier published in the journal *Diogenes*. The artist was sympathetic to lithography's history as a medium for the mass distribution of visual statements that could effect social change. Manet's last lithograph drawn directly on the stone was his color print *Polichinelle*, an image that is best understood in the context of political caricature. The Maréchal MacMahon, known less reverently as the ''Maréchal Bâton,'' was elected president of the republic in May 1873, two years after he had directed the reprisals against the Paris commune. There can be no question that Manet's well-documented political sympathies would have insured his disapproval of this general, who in the print is shown as Polichinelle inspecting his troops. Farwell has sought to minimize the connection to MacMahon because the print was modeled on Manet's friend, the painter Edmond André (Reff 1982, p. 124). In spite of this fact, we know that Manet intended a large distribution of the print in the journal *Le Temps* and that, according to a relative of his printer, the government destroyed much of the edition, prohibiting its distribution. A figure of the Commedia dell'arte, Polichinelle was a grotesque and deceitful character familiar to Manet and contemporary Paris through the writer Duranty's theatre performances in the Tuileries Gardens. He appears in several of Manet's works as early as 1862, in his frontipiece etchings (see no. 21) and later in the painting *Masked Ball at the Opera* from 1873–1874 (R.W. vol. 1, 216; Fried 1969, 37–40). Manet seems to have borrowed the pose from a painting of Polichinelle by Ernest Meissonier, exhibited in 1860 and known in an etching and wood-engraved reproduction from the *Gazette des Beaux-Arts*.

In addition to the lithograph, Manet painted two canvases of this subject, in slightly different poses (R.W. vol. 1, 212–213), and executed a watercolor (R.W. vol. 2, 563) that may have been the model for the lithograph. Although it has been given various dates, Bareau was able to date the edition definitively in June 1874 through records in the Depot Legal. The smaller edition of twenty-five impressions printed on japon paper must have directly preceded this larger edition. The actual size of the second edition cannot be confirmed, although Lemercier's nephew, Raçon, later told Tabarant that an edition of

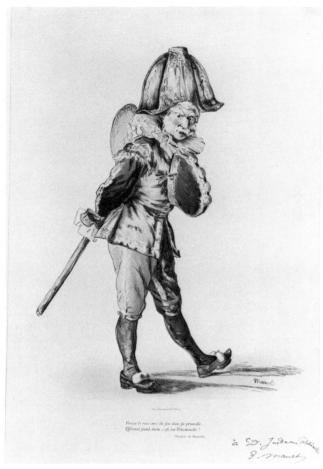

61 *Polichinelle*

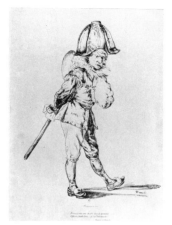

FIG. 15 *Polichinelle*, Bibliothèque Nationale, Paris

8,000 was planned for inclusion in *Les Temps* and that the police destroyed 1,500 impressions along with the stones (B. 83 and G. 79). While these statements need confirmation, a letter from Manet quoted in Moreau-Nélaton (reprinted in Guérin 1944, p. 19) indicates that Manet tried to find a buyer for the stones to bring out an edition but that by October he had still not secured a publisher. Lemercier, anxious for payment, may have effaced the stones. According to Bareau, Manet intended to exhibit the print in the Salon of 1874, but presumably because the color stones were not finished exhibited the watercolor or a watercolor version instead (B. 83).

Griffiths demonstrates that *Polichinelle* should be viewed in the context of chromolithography—a color lithograph of reproductive intent, where the color stones are prepared by the printer rather than the artist. We know Manet was looking for a printer to prepare stones for his edition, and his actual work on the stone probably extended only to the first state, a key stone, with the black lines delineating the figure (Carey and Griffiths 1978, p. 40). A limited edition of just this single stone, printed in a brown ink, was made at the time of the fourth state edition of 1874 (see fig. 15). Guérin has cited a proof of the first state that was painted with watercolor by the artist, undoubtedly as a model for the printers to prepare color stones. As cited in Guérin, Raçon described the

process for preparing these stones, done with Manet's supervision. A very similar approach was used later in the century for Cézanne's print *The Large Bathers*. The other possible model for the color stones could be the watercolor that the print so closely follows, but a careful examination of the actual object is needed before its relationship to the print, both in the same orientation, can be securely identified. It could possibly be a reprise after the print. In the rare impressions of the second state, such as that from the Bibliothèque Nationale in Paris, the beige color is achieved with a different stone than the one that appears for the final edition. Here, the beige stone is also a general tone stone, extending beyond the actual figure to the perimeters of the sheet. In the third state, where letters are also added, this stone is changed so that the beige stone, differently drawn, stays within the figure. This kind of variation is common to the procedures of a chromolithograph, which try to approximate the effects of an original—Manet's watercolored version of the first state. Because of the dark beige tone surrounding the figure in the second state, highlights were printed in white ink, and in the third state these highlights become the bare surface of the paper.

The fourth state, exhibited here, is printed on a white wove paper that often creates harsh contrasts because the colors are more intense. But a comparison between the exhibited impression and other impressions of the first state demonstrates that variations exist in this printing because the Lucas impression is not as garish as the other examples seen by this writer. While the paper may have darkened somewhat, thus muting contrasts, the colors seem closer to the third state edition of twenty-five printed on a japon paper that more effectively suggested the subtle washes of a watercolor. It is possible that the Lucas impression was a special proof from this edition since Manet selected it for a dedication to an Ed. Judeau. Besides the printing differences of color intensity between the third and fourth state, the stone is modified with a change in the letters. Both editioned states include a poem by Théodore de Banville on Polichinelle. Manet challenged several of his writer friends to compose a quatrain for the print, including Charles Cros and Mallarmé, but de Banville's was selected.

## 62
### The Urchin (Boy with Dog)  (1868–1874)
Le gamin

Crayon lithograph with scraping
On violet toned chine collé, white wove paper
Second state of two
Sheet: 582 x 456 mm (22⅞ x 18 in)
Chine: 287 x 227 mm (11⁵⁄₁₆ x 8¹⁵⁄₁₆ in)
Inscriptions: Signed in stone, u.l. corner, "Manet"; below image,
    c., "Le gamin"; l.l. "(Tiré à cent exemplaires)"; l.r., "Imp
    Lemercier & Cⁱᵉ Paris"
N.Y. 8, B. 75, I. 75, I. 45, H. 30, G. 71, M.N. 86

*The George A. Lucas Collection of The Maryland Institute, College of
    Art, on indefinite loan to The Baltimore Museum of Art B.M.A.
    L.33.53.13695*

62  *The Urchin (Boy with Dog)*

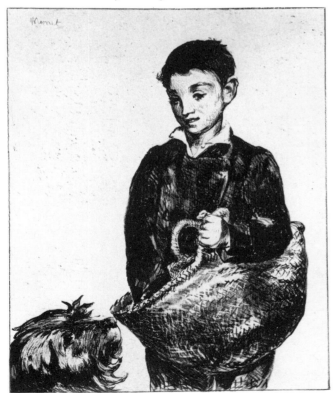

Only three of Manet's lithographs were published during his lifetime and all in 1874. The three include the single image of *Polichinelle* (no. 61) and two, published together—*The Urchin* and *Civil War* (no. 55)—excepting several lithographs produced for specific publishing projects, including the poster *The Cats' Rendezvous* (no. 50). The first three lithographs were printed in an edition of one hundred, although their rarity suggests a smaller edition, on a distinctive chine collé, a thin laid paper with prominent blue and red fibers adhered to a strong wove paper. The paper has a violet tone in impressions that have not been bleached or overexposed to light. *The Urchin* is based on Manet's 1861 painting, which was also the subject of one of Manet's first etchings (no. 4). Both lithograph and etching are in reverse orientation to the original, and the lithograph corresponds closely in size to a photograph the artist had made of the painting, suggesting that the outlines were drawn on the stone with the help of a tracing from the photograph. While the lithograph is an accurate translation of the painting as it looks today, the etching shows variations, particularly in the amount of space between the boy's legs. This variation had been taken as a sign of the etching's freer interpretation of the original, but in a lecture at the Manet symposium in New York in October 1983, Bareau demonstrated that new X-ray analysis of the painting confirms that the painting as it exists today was reworked and that its original appearance conforms with the etched composition.

Even though both lithographs were published together in 1874, the actual work on the stones could have taken place years earlier. *Civil War* was dated 1871–1873 but published a year later. Without documentation, stylistic comparisons are not definitive, so Bareau dates this print in a period from 1868 to 1874. Little is known about the 1874 edition, although Bareau suggests that Manet may have published these two lithographs in hope of improving his financial situation (New York 1983, pp. 60–61). Perhaps he envisioned a larger portfolio with a variety of images, for during the period between 1868 and 1874 he produced a number of lithographs that cannot be identified with specific publishing projects. The portfolio may have included political subjects of immediate interest, such as *Civil War* and *The Barricade*, together with *Berthe Morisot*, and this new interpretation of an earlier Manet work, an aspect of genre in the Parisian type, boy with dog.

The lithographs of the 1870s exhibit a variety of drawing styles, which vary depending on the nature of the particular composition. More detailed interpretations such as the exhibited impression could co-exist with the broadly drawn *Civil War* or *The Barricade*, not to mention the freely drawn lithograph *The Races* (no. 56). But the style of *The Urchin* corresponds closely to that of *Berthe Morisot* (en noir) (no. 59 and 60). The boy's coat was drawn with the same vigorous strokes, diagonal over lighter vertical. The detailed passages such as the collar were put on the stone with a sharper crayon, but still soft and greasy, to create a supple line. Fine scratches score the stone modeling the boy's face and adding accents in the dog's fur. On the straw basket a wider burnisher was used to highlight the surface texture.

**63**
*At the Café (Interior of the Café Guerbois?)* (1874)
Au café

Brush-and-ink transfer relief plate
On thin wove paper, center fold
Only state
Sheet: 276 x 348 mm (10⅞ x 13³⁄₁₆ in)
Image: 264 x 333 mm (10⅜ x 13⅛ in)
Inscriptions: Signed in stone, l.r., "Manet"
N.Y. 168, B. 85, I. 64, H. 66, G. 81., M.N. 88

*The George A. Lucas Collection of The Maryland Institute, College of
Art, on indefinite loan to The Baltimore Museum of Art
B.M.A. L.33.53.18058*

The earliest of Manet's prints catalogued as autographies are the two versions of *At the Café*, the first drawn with a brush (H. 67; see fig. 16), and the second, exhibited here, drawn with a pen. Both are extremely rare, although the brush version (Sterling and Francine Clark Art Institute, Williamstown, Massachusetts) is the rarist. The subject of this scene has been identified as the Café Guerbois based on an inscription by Guerard on an impression of the exhibited version in the Avery collection. Reff found documentation of the interior appearance of this café, confirming its similarity to Manet's design (Reff 1982, p. 86). Manet was known to frequent this café located near the Place de Clichy, and it was a favorite gathering place for many artists and writers in Manet's circle during the late 1860s and 1870s. This scene, related to a drawing dated 1869 now in the Fogg Art Museum (R.W. vol. 2, 502), is Manet's only description of the café. Bareau believes that the second, exhibited version, was conceived for an as yet unidentified periodical because the back of one of the rare impressions has an illustration by Bertall with a text titled "Le Troubador carnavalesque" and the date, "Paris, February 21, 1874" (New York 1983, p. 413). Furthermore, the Lucas impression is folded in the center, just like a related autographie, *In the Upper Gallery* (no. 73), which was included in the *Revue de la Semaine*. The impression described by Bareau also contained the imprint "Lefman sc" for the Bertall illustration on the verso. Lefman was undoubtedly the printer for the both the Bertall illustration and *At the Café* since he is known to have printed other Manet autographies such as the illustrations for *The Raven* (no. 65–71) and *In the Upper Gallery* (no. 73).

*At the Café* has traditionally been viewed as Manet's first use of a new printmaking technique—transfer lithography—directly following his crayon lithographs, the last of which, *Polichinelle* (no. 61) dates from 1874. *At the Café* together with *The Raven* illustrations, *In the Upper Gallery*, and a unique print, *La Belle Polonaise* (private collection; H. 87) have been termed autographies. Cataloguers have incorrectly limited the usage of this category to lithography, although it also includes other processes such as gillotage that use direct transfer, as does transfer lithography, but are instead printed in relief rather than planographically. Manet's interest in autographic prints of his drawings was in fact long-standing. During the time when his earliest etchings were being published by Ca-

dart, he was also contributing drawings for direct transfer as gillotage prints to Louis Rousseau's publication *L'Autographe au Salon* (Druick and Zegers 1984, p. xxiv). Gillotage was invented by Firmin Gillot in the early 1850s, and the techniques for such transfer relief prints developed rapidly during the period of Manet's printmaking (Druick and Zegers 1984, p. xxi; Josef Maria Eder, *History of Photography*, New York: Dover Press, 1978). Manet's printer Lefman was known for his gillotage prints and was perfecting techniques for photographic transfer to zinc plates for relief printing. Even the techniques for transfer lithography, a technique described by lithography's inventor, Senefelder, were greatly improved by procedures developed for gillotage. In 1873 artistic interest in transfer processes for multiple drawings was heightened by the publication of Corot's autographies, an album of landscapes (Druick and Zegers 1984, p. xxxiv). Manet like many artists was intrigued with the possibilities of creating multiple drawings, a concept that was also integral to the contemporary view of etching as expressed by numerous critics, including Baudelaire.

The confluence of techniques for transfer prints, lithographic and relief, is what makes the technical identification of Manet's autographies so difficult, although the evidence suggests they are in fact gillotage prints rather than lithographs. Both *At the Café* and *In the Upper Gallery* were intended for publication in periodicals, and one of the chief advantages of the gillotage process was that it allowed simultaneous printing of text and illustration. Certainly the strongest indication that Manet used this process is the connection of these prints to Lefman, for his name is printed below *In the Upper Gallery*, is linked through documentation to *The Raven* illustrations (B. 105), and is related to *At the Café* through Bareau's discovery of the proof with the Bertall illustration. For his crayon lithographs Manet had consistently used Lemercier, perhaps the best lithographic printer of the day, who was equally skilled in transfer lithography as shown by Corot's autographies. Lefman was a specialist with gillotage, and if Manet had prepared drawings for transfer as lithographs he would not have used a printer with Lefman's capabilities.

The most problematic area of Manet's drawings are the relatively few number of pen-and-ink examples, as both their dating and purpose are unclear. Bareau points out that the Fogg drawing is most likely not a sketch of the café from life, as Reff suggested (Reff 1982, p. 86). For such sketches Manet usually used a pencil (R.W. vol. 2, 500–501; New York 1983, p. 413). Because of their careful finish and precision, such ink drawings were more likely prepared for reproduction. A documented use of such a pen-and-ink drawing is another work from the Fogg, a drawing traced on the verso of a photograph of Manet's painting *Jeanne: Spring* (R.W. vol. 1, 372). Drawings used for direct transfer to a gillotage plate would not have survived, which explains why original drawings for direct transfer to gillotage plates have not been recorded, including those for Manet's autographies. Where drawings used for reproductions do exist, a photographic transfer was made, such as *Henri Vigneau* (R.W. vol. 2, 472), a pen-and-ink drawing that is part of the Cone collection at

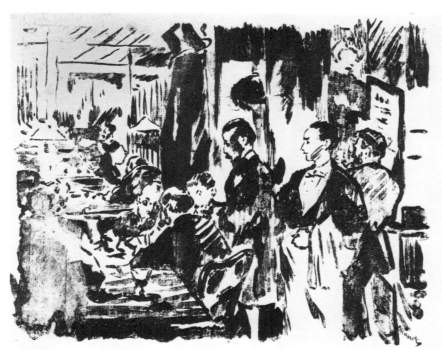

63  *At the Café (Interior of the Café Guerbois?)*

FIG. 16   *At the Café*, Sterling and
Francine Clark Art Institute,
Williamstown, Massachusetts

The Baltimore Museum of Art and is also known in a
gillotage reproduction. Moreau-Nélaton was careful to
distinguish between prints made through ''procédés pho-
tographiques,'' including a well-known portrait of Cour-
bet, from Manet's autographies such as *At the Café*,
achieved through direct transfer, although Moreau-Néla-
ton thought the transfer was made to stone for litho-
graphic printing. The Fogg *Au Café* drawing, prepared for
a gillotage transfer, was abandoned in favor of a re-
worked composition adding the billiard room behind and
extending the design to the right. Manet first prepared a
version of the new design in brush and ink, but from the
few proofs that survive, it is clear that this approach was
not suitable for successful transfer. After the unsuccessful

printing of the brush attempt, he prepared a second
version, the exhibited one, in a more standard pen line
that was transferred directly, probably to a zinc plate that
was then etched with chemicals to create a relief plate.

Examination with strong magnification and raking light
cannot confirm whether the transfer was made to zinc
plate or stone, or printed in relief or planographically.
While some examples of gillotage printing clearly show
indentations from relief printing, no such evidence is
visible for the autographies included in this exhibition.
But using a careful soft printing and fine papers such as
chine, or light wove paper like that used for the exhibited
impression, it was possible to print a gillotage without
embossing, a fact determined by Druick and Zegers in a
careful examination of a gillotage periodical, *La Vie mo-
derne* (Druick and Zegers 1984, p. xliv, note 60; personal con-
versation with Druick, 2 February 1985). Visual confirma-
tion of the gillotage process might also come from the
apparent flatness and surface regularity of this print. The
edges of the composition are clean and squared; the pen
strokes are so self-contained and rounded at the ends
that they depart from lines drawn directly with a pen
point, which cause occasional irregularities and a more
pointed end to the stroke—qualities that might have re-
mained in a lithographic transfer. On the back of the
seated figure in the center, a number of lines printed
only partially, perhaps corresponding to what was light
underdrawing in Manet's original drawing that would be
difficult to retain with the current relief print technology.

## 64
### *Eight Illustrations for Le Fleuve (The River) by Charles Cros* 1874

Cover on simili japon paper, prints and text on laid paper
Second state of two, from the 1874 Librairie de l'eau-forte edition
Sheet (text and prints): 278 x 476 mm (10¹⁵⁄₁₆ x 18¾ in)
Cover: 276 x 437 mm (10⅞ x 17³⁄₁₆ in)
Inscriptions: Signed in pen, facing title page, c., "51/Charles
　　Cros E. Manet"; printed above in black, "Tiré à cent
　　exemplaires, numérotés et signés par les auteurs"; back page,
　　printed in black, "Meaux.—Imp. A. Cochet"; title page,
　　"Charles Cros/LE FLEUVE/ EAUX-FORTES D'EDOUARD
　　MANET/PARIS/LIBRAIRIE DE L'EAU-FORTE/61, rue
　　Lafayette, 61"; front cover, "CHARLES CROS/LE FLEUVE/
　　EAUX-FORTES D'EDOUARD MANET/PRIX 25 FRANCS/
　　PARIS (in red) Librairie de L'Eau-Forte/61, rue Lafayette 61/
　　1874"; back cover, "Imprimé/par COCHET, à Meaux et par
　　DELÂTRE, à Paris en Décembre 1874"
B.69, I. 81–89, H. 79a-h, G. 63, M.N. 23–30

*The George A. Lucas Collection of The Maryland Institute, College of
Art, on indefinite loan to The Baltimore Museum of Art
B.M.A. L.33.53.5180*

　a. *Dragonfly* (Libellule) title page†
　　　Etching, drypoint (?)
　　　Image: 48 x 57 mm (1⅞ x 2¼ in)
　　　Plate: 54 x 62 mm (2³⁄₁₆ x 2⁷⁄₁₆ in)
　b. *The Mountain* (La montagne) p. 5†
　　　Etching, bitten tone
　　　Image: 75 x 96 mm (2¹⁵⁄₁₆ x 3¾ in)
　　　Plate: 77 x 99 mm (3¹⁄₁₆ x 3⅞ in)
　c. *The River in the Plain* (La rive en plaine) p. 9†
　　　Etching, bitten tone
　　　Image: 82 x 101 mm (3¹⁵⁄₁₆ x 3¹⁵⁄₁₆ in)
　　　Plate: 86 x 104 mm (3⅜ x 4⅛ in)
　d. *The High Valley* (La haute vallée) p. 7
　　　Etching, bitten tone
　　　Image: 84 x 105 mm (3¹⁵⁄₁₆ x 4⅛ in)
　　　Plate: 94 x 116 mm (3¾ x 4⁹⁄₁₆ in)
　e. *The Parapet of the Bridge* (Le parapet du pont) p. 11
　　　Etching, bitten tone
　　　Image: 69 x 122 mm (2¾ x 4¹³⁄₁₆ in)
　　　Plate: 74 x 126 mm (2¹⁵⁄₁₆ x 4¹⁵⁄₁₆ in)
　　　Signed in plate, l.l., "ME"
　f. *The Arch of the Bridge* (L'arche du pont) p. 13
　　　Etching
　　　Image: 109 x 152 mm (4⁵⁄₁₆ x 6 in)
　　　Plate: 115 x 157 mm (4⁹⁄₁₆ x 6³⁄₁₆ in)
　g. *The Sea* (La mer) p. 15†
　　　Etching
　　　Image: 80 x 134 mm (3¹⁄₁₆ x 5¼ in)
　　　Plate: 84 x 140 mm (3⅜ x 5½ in)
　h. *Swallows* (Hirondelle) tailpiece†
　　　Etching, drypoint (?)
　　　Image: 36 x 53 mm (1⁷⁄₁₆ x 2¹⁄₁₆ in)
　　　Plate: 42 x 58 mm (1⅝ x 2¼ in)

†Exhibited plate

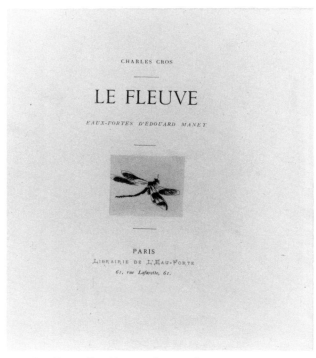

64a *Dragonfly,* title page from *Le fleuve*

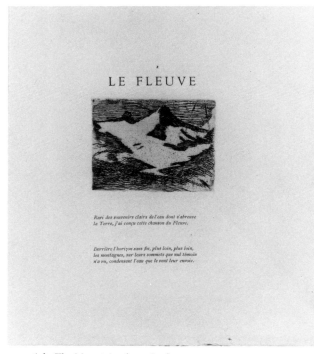

64b *The Mountain,* from *Le fleuve*

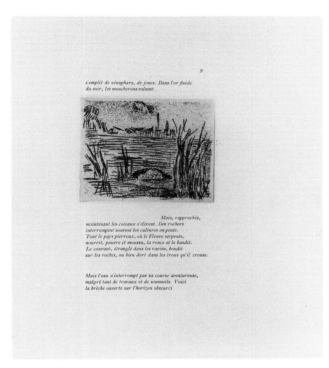

64c *The River in the Plain*, from *Le fleuve*

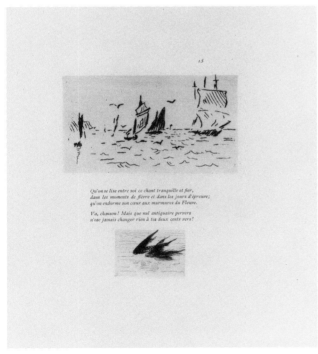

64g and h *The Sea* and *Swallows*, from *Le fleuve*

Charles Cros's poem *Le fleuve* traces the flow of a great river from its source in the mountains, through the plain, under city bridges, and finally to the sea. In 1873 Cros developed a concept for publishing the poem that would include eight illustrations by Manet. Cros wanted a pamphlet-size book with finely printed etchings, an idea at least suggested by earlier publications such as *Sonnets et eaux-fortes* produced by Burty in 1869, which included Manet's etching *Exotic Flower* (no. 46). Publications such as Burty's linked contemporary writing with a general critical enthusiasm for etching, the medium identified with modern, unconstrained artistic expression. Richard Lesclide, who later published Manet's illustrations for *The Raven*, published *Le fleuve* through his Librairie de l'eau forte. He published etchings by a new generation of printmakers not linked to Cadart's Société. His commentary in the illustrated periodical *Paris a l'eau-forte*, together with the etchings he published by artists such as Buhot and Guerard, confirmed his interest in the more inventive aspects of etching, especially tonal processes (Druick and Zegers 1984, pp. xxi–xxii). The etching published in *Paris a l'eau-forte* shared with Manet's etchings in *Le fleuve* the quality of rapidly conceived drawings. The pamphlet was published in 1874 in an edition of one hundred with text and illustrations on a Holland laid paper and the outside cover, slightly larger than the inside sheets, on simili japon. Manet produced eight etchings including six vignettes, title page illustration, and tailpiece. Exhibited here are pages from the pamphlet, showing text and five illustrations, among them the illustrated title page and tailpiece.

These plates represent Manet's first etchings since 1870–1871 when he made *Line in front of the Butcher Shop* (no. 53). After completing these prints in 1873, he produced only a few additional etchings, such as an unsuccessful attempt in 1874 at a portrait of Théodore de Banville for his book of "Ballades" (H. 81–82). None of Manet's last etchings rival the originality of these plates for *Le fleuve*. Like *Sonnets et eaux-fortes*, Manet's illustrations were more enhancements than illustrations to the text, for Cros's poem was not a narrative, but rather a symbolic description. Each of the six scenes was imaginatively devised to show a stage of the river in its progress to the sea—as seen here: the mountain, the plain, and the sea. There are no equivalents in Manet's etched oeuvre to these rapid sketches, drawn with immediacy and openness, surrounded by white paper.

Manet made a number of trial proofs and variant plates for this project, and most either are in the collection of the Bibliothèque Nationale or are part of the recent acquisition of prints from the Guerard collection by The Art Institute of Chicago (see Wilson 1978). Technically, the etching style of these plates is straightforward, with strongly etched lines, some bitten tone, and possibly touches of drypoint, especially for the title page and tailpiece illustrations. The drypoint is singularly difficult to identify, for what appear to be richly burred lines could also be fine etched lines inked and wiped with retroussage to look like drypoint. The plates were printed by Delâtre, who was known for such effects. Here, how-

ever, the plates generally are printed very cleanly, a style Lesclide seemed to prefer for the more sketchlike etchings he published. The plates were probably steel faced for this edition of one hundred and then canceled. The steel facing would have retained some drypoint burr, which could then have been exploited by Delâtre's printing. Several plates, for example, *The River in the Plain* and *The Mountain*, show a bitten tone that is too coarsely textured for aquatint and more like a salt ground.

The drawing in Manet's illustrations, while spontaneous, is also quietly restrained, which continues throughout this carefully designed pamphlet. The illustrations for title page and tailpiece are perhaps most indicative of the conception of these plates, for with just a few lines Manet described dragonfly and swallows simply and realistically. This striking economy must relate to pages from Hokusai's *Manga* (Ives 1974, 29–30). The total integration of illustrations and text made the pamphlet a model for later illustrated books. The perfect harmony of this collaboration has encouraged many to consider *Le fleuve* as the beginning of modern book illustration (Ray 1982, pp. 366–367; B. 72).

65
*Raven's Head in Profile for Poster (Slipcase and Cover)*  1875
Illustration for "Le corbeau." Translation by Stéphane Mallarmé of Edgar Allan Poe's "The Raven"

Brush-and-ink transfer relief plate
On parchment paper, cut from slipcover
Only state
Sheet: 319 x 270 mm (12½ x 10⅝ in)
Inscriptions: None
N.Y. 151, B. 89, I. 95, H. 83a, G. 85, M.N. 95

*The George A. Lucas Collection of The Maryland Institute, College of Art, on indefinite loan to The Baltimore Museum of Art*
*B.M.A. L.33.53.5172*

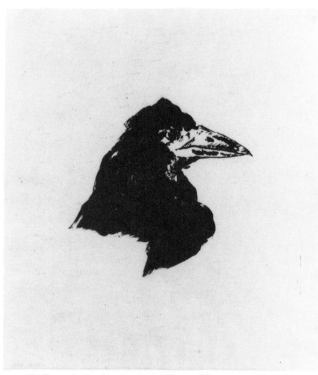

65  *Raven's Head in Profile for Poster (Slipcase and Cover)*, from *The Raven*

**66**

*Once upon a Midnight Dreary (Under the Lamp)*   1875
Illustration for "Le corbeau." Translation by Stéphane Mallarmé
  of Edgar Allan Poe's "The Raven"

Brush-and-ink transfer relief plate
On chine paper
Only state
Sheet (irregular): 300 x 438 mm (11¾ x 17¼ in)
Inscriptions: Signed in stone, l.l., "E.M."
N.Y. 151, B. 89, I. 97, H. 83b, G. 86a, M.N. 91

*The George A. Lucas Collection of The Maryland Institute, College of
  Art, on indefinite loan to The Baltimore Museum of Art
  B.M.A. L.33.53.18049*

**67**

*Open Here I Flung the Shutter (The Window)*   1875
Illustration for "Le corbeau." Translation By Stéphane Mallarmé
  of Edgar Allan Poe's "The Raven"

Brush-and-ink transfer relief plate
On chine paper
Third state of three
Sheet: 421 x 315 mm (16⅝ x 12⅜ in)
Image: 395 x 315 mm (15½ x 12⅜ in)
Inscriptions: Signed in stone, l.l., "E.M.."
N.Y. 151, B. 89, I. 98, H. 83c, G. 86c, M.N. 93

*The George A. Lucas Collection of The Maryland Institute, College of
  Art, on indefinite loan to The Baltimore Museum of Art
  B.M.A. L.33.53.18047*

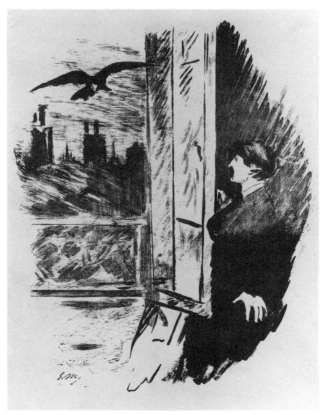

67 *Open Here I Flung the Shutter (The Window),*
from *The Raven*

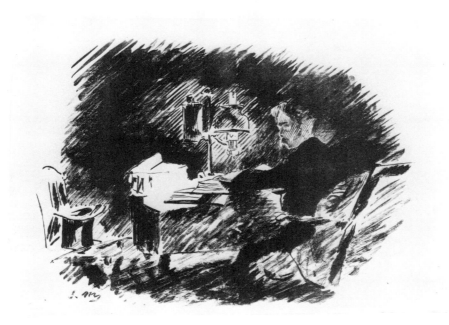

66 *Once Upon a Midnight Dreary (Under the Lamp),*
from *The Raven*

68
*Perched upon a Bust of Pallas (Raven on the Bust)*  1875
Illustration for "Le corbeau." Translation by Stéphane Mallarmé
  of Edgar Allan Poe's "The Raven"

Brush-and-ink transfer relief plate
On chine paper
Second state of two
Sheet (irregular): 483 x 325 mm (19 x 12¹³⁄₁₆ in)
Inscriptions: Signed in stone, l.r., "E.M."
N.Y. 151, B. 89, I. 99, H. 83d, G. 86b, M.N. 92

*The George A. Lucas Collection of The Maryland Institute, College of
  Art, on indefinite loan to The Baltimore Museum of Art
  B.M.A. L.33.53.18050*

69
*Perched upon a Bust of Pallas (Raven on the Bust)*  1875
Illustration for "Le corbeau." Translation by Stéphane Mallarmé
  of Edgar Allan Poe's "The Raven"

Brush-and-ink transfer relief plate
On heavy laid paper
Second state of two
Sheet: 545 x 356 mm (21½ x 14¹⁄₁₆ in)
Image: 483 x 317 mm (19 x 12½ in)
Inscriptions: Signed in stone, l.r., "E.M."
N.Y. 151, B. 89, I. 99, H. 83d, G. 86b, M.N. 92

*The George A. Lucas Collection of The Maryland Institute, College of
  Art, on indefinite loan to The Baltimore Museum of Art
  B.M.A. L.33.53.18055*

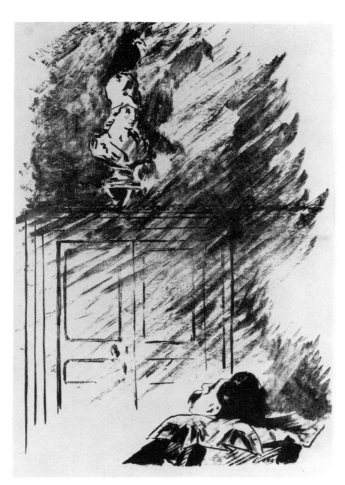

68 *Perched Upon a Bust of Pallas (Raven on the Bust)*,
from *The Raven*

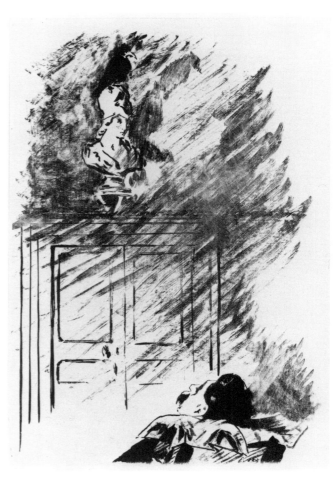

69 *Perched Upon a Bust of Pallas (Raven on the Bust)*,
from *The Raven*

**70**

*That Shadow That Lies Floating on the Floor (The Chair)*   1875

Illustration for "Le corbeau." Translation by Stéphane Mallarmé of Edgar Allan Poe's "The Raven"

Brush-and-ink transfer relief plate
On chine paper
Only state
Sheet: 354 x 294 mm (13¹⁵⁄₁₆ x 11⁹⁄₁₆ in)
Inscriptions: Signed in stone, l.l., "E.M."
N.Y. 151, B. 89, I. 100, H. 83e, G. 86d, M.N. 94

*The George A. Lucas Collection of The Maryland Institute, College of Art, on indefinite loan to The Baltimore Museum of Art*
   *B.M.A. L.33.53.18048*

**71**

*Raven in Flight, ex Libris*   1875
Illustration for "Le corbeau." Translation by Stéphane Mallarmé of Edgar Allan Poe's "The Raven"

Brush-and-ink transfer relief plate
On parchment paper
Only state
Sheet (irregular): 242 x 278 mm (9⁹⁄₁₆ x 10¹⁵⁄₁₆ in)
Image (including title): 135 x 241 mm (5⁵⁄₁₆ x 9½ in)
Inscriptions: In stone, upper c., "ex libris"; in pen, lower c., "Au New York Herald/Exemplaire Offert/par M.M.S. Mallarmé/E. Manet"
N.Y. 151, B. 89, I. 96, H. 83f, G. 86, M.N. 90

*The George A. Lucas Collection of The Maryland Institute, College of Art, on indefinite loan to The Baltimore Museum of Art*
   *B.M.A. L.33.53.16172*

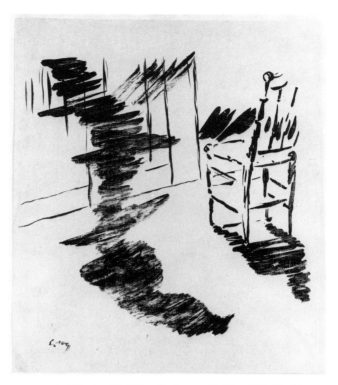

70 *That Shadow That Lies Floating on the Floor (The Chair)*, from *The Raven*

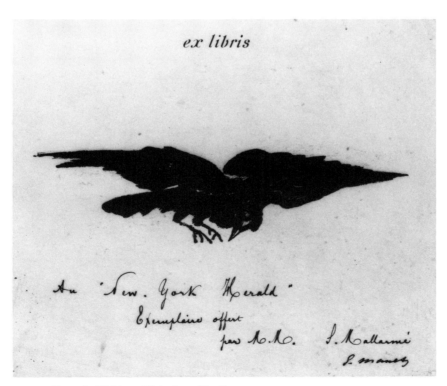

71 *Raven in Flight, ex Libris*, from *The Raven*

With Mallarmé, and before him Baudelaire, Manet shared a fascination for the writings of Edgar Allan Poe. One of the artist's first prints was an etched portrait of Poe based on a daguerrotype and perhaps intended for an edition of Baudelaire's articles on the writer (H. 2; see fig. 18). Mallarmé began his prose translations of Poe as early as 1862, but it was not until 1872 that they were first published. Shortly after, he met Manet and the two became lifelong friends. The collaborative project for an illustrated edition of Mallarmé's translation of *The Raven* was probably conceived in late 1874 or early 1875. A rare proof from the British Museum dated January 1875 represents Manet's earliest rendition of the "raven's bust" used in a modified version for the slipcover, poster, and cover of the series. Manet and Mallarmé planned several other projects although only one was ever realized after *The Raven*, *L'après-midi d'un faune* (no. 72).

Mallarmé and Manet applied exacting standards to their collaborations, and the presentation of these works is evidence of a refined taste in book design. *The Raven* was published by Richard Lesclide, appearing in 1875 in an edition of 240 copies on Holland laid paper, chine, or both, together with ex libris, illustrated cover, and slipcover on parchment. Poe's poem was printed in English on one side with Mallarmé's translation on the other, and the illustrations were interleaved between on separate sheets. The impressions exhibited here come from the edition on chine, which more effectively conveys the subtle effects of Manet's almost transparent washes of ink. The third illustration *Raven on the Bust* is exhibited in impressions from both the chine edition and the Holland laid paper edition, which prints much darker. Holland paper is generally not used for lithography because of its texture, but since it more closely approximates drawing paper, some scholars argue that its use may reflect an attitude that viewed lithographs as multiple drawings. These prints were in fact called "dessins" on the illustrated poster (Druick and Zegers 1984, p. xxxiii, note 26). Through his publication *Paris a l'eau-forte*, Lesclide created both a source for publishing etchings and a forum for discussing issues that related to etching (Druick and Zegers 1984, pp. xxxi–xxxii). For a second generation of more experimental etchers he filled a role similar to Cadart's in the 1860s. Publishing *Le fleuve* undoubtedly encouraged him to take on *The Raven*, a technical departure from his more frequent publications of etchings. Lesclide patiently agreed to the poet's and painter's suggestions for presentation (New York 1983, p. 384) and enlisted Lefman, who had printed Manet's *At the Café* (no. 63), a plate intended for a periodical. Lefman was involved in the most advanced technologies for the reproduction of drawings on zinc plates. *The Raven* was far from a commercial success, whether because of Mallarmé's then-slight reputation or Manet's still-controversial art. Although it was advertised as an edition of 240, a letter to Mallarmé indicates that the edition was actually printed on demand so surely many fewer copies were printed (B. 105).

Unlike his other two book projects, *L'après-midi d'un faune* and *Le fleuve* (no. 64a–h), which evoke rather than

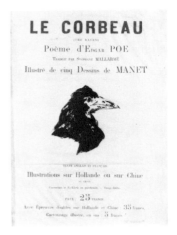

FIG. 17 Poster advertisement for *Le Corbeau (The Raven)*, The Detroit Institute of Arts

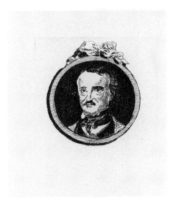

FIG. 18 *Edgar Allan Poe*, The George A. Lucas Collection, The Maryland Institute, College of Art, on indefinite loan to The Baltimore Museum of Art

illustrate the narrative, Manet searched through *The Raven* for episodes that "could successfully be rendered in concrete visual terms" (Harris 1967, p. 231). These illustrations convey the spontaneity that was a part of Manet's idea to use imaginative designs corresponding accurately to most details in the text. As Harris points out, these illustrations lack Manet's normal references to older art or, indeed, quotations from his own art (Harris 1967, p. 230). This immediacy of conception enforces the stylistic character of the illustrations as rapidly conceived sketches. In the first illustration, *Once upon a Midnight Dreary*, Bareau suggests that Manet humorously included his cane and hat on the chair, as if the artist were there to observe the musings of the poet, who is most likely Mallarmé (New York 1983, pp. 384–385). All the details of the first stanza are actually represented in the first plate.

"Once upon a midnight dreary, while I pondered,
   weak and weary,
Over many a quaint and curious volume of forgotten
   lore—
While I nodded, nearly napping, suddenly there came
   a tapping,
As of some one gently rapping—rapping at my cham-
   ber door.
" 'Tis some visitor," I muttered, "tapping at my cham-
   ber door—Only this and nothing more."

The second illustration *Open Here I Flung the Shutter* is
equally evocative of the mood of the poem, although
Manet departed slightly from the text in having the raven
fly through the window, whose shutter opens inward,
not outward as in the poem. Evidently Manet had diffi-
culty with this plate as an abandoned early version exists
(Bibliothèque Nationale, Paris), as well as an early state
of the final illustration, before he reworked the window
scene. He modified the background to describe better the
buildings and scraped away some of the clouds in the
sky to give more impact to bird's silhouette. He also
extended the composition more to the left. In general the
mood closely approximates the darkness of a "bleak De-
cember."

Open here I flung the shutter, when, with many a flirt
   and flutter,
In there stepped a stately Raven of the saintly days of
   yore,
Not the least obeisance made he; not an instant
   stopped or stayed he;
But, with mien of lord and lady, perched above my
   chamber door—
Perched upon a bust of Pallas just above my chamber
   door—
      Perched and sat and nothing more.

In the third plate *Perched upon a Bust of Pallas* where
"Quoth the Raven, 'Nevermore'," Manet heightened the
confrontation between poet and raven as the writer
broods on the meaning of the raven's word and on mem-
ories of his lost Lenore.

But the Raven still beguiling all my sad soul into smil-
   ing,
Straight I wheeled a cushioned seat in front of bird and
   bust and door;
Then, upon the velvet sinking, I betook myself to link-
   ing
Fancy unto fancy, thinking about what this ominous
   bird of yore—
What this grim, ungainly, ghastly, gaunt and ominous
   bird of yore
      Meant in croaking "Nevermore."

Thus I sat engaged in guessing, but no syllable ex-
   pressing
To the fowl whose firey eyes now burned into my
   bosom's core;
This and more I sat divining, with my head at ease
   reclining
On the cushion's velvet lining that the lamp-light
   gloated o'er,

But whose velvet violet lining with the lamp-light
   gloating o'er,
      She shall press, ah, nevermore!

The last illustration *That Shadow That Lies Floating on the
Floor"* is perhaps the most remarkable for its sheer inge-
nuity and suggestiveness. As a visual statement of the
last stanza, it is the most intangible. Manet drew the
raven's shadow on the floor and over the wall, leaving
the chair empty, a disconsolate soul in a void of loneli-
ness.

And the Raven, never flitting, still is sitting—still is
   sitting
On the pallid bust of Pallas just above my chamber
   door;
And his eyes have all the seeming of a Demon's that is
   dreaming,
And the lamp-light o'er him streaming throws his
   shadow on the floor
      Shall be lifted—nevermore!

The technical procedure used for these illustrations,
usually identified as transfer lithography, is more likely
gillotage, a position that was recently advanced by Druick
and Zegers in an essay reflecting their careful scrutiny of
Degas's printmaking techniques for which Manet was
often an important model (Druick and Zegers 1984,
p. xxxiii). The identification of Manet's autographies as
gillotage prints is discussed in detail in catalogue entry
no. 63. Like the café print and *In the Upper Gallery* (no.
73), Manet's drawings for *The Raven* were transferred
directly to a zinc plate and, after chemical etching,
printed as reliefs. Lefman's involvement with *The Raven*
illustrations is documented in correspondence between
Manet and Mallarmé in a discussion about production
details relating to the publication (B. 105).
*The Raven* illustrations are identified as "dessins" on
the illustrated poster, rather than lithographs, which is
consistent with the designation of *In the Upper Gallery* as a
"dessin inédit." Druick and Zegers point out that this
term, frequently found on gillotage prints reproducing
drawings, identifies their role as multiple drawings
(Druick and Zegers 1984, p. xxiii–xxiv, note 26). This
phenomenon interested Manet throughout his career as
seen in the numerous gillotage reproductions of his pen-
and-ink drawings, his experiment with Bracquemond us-
ing the pen process (no. 31), and even his interest in
preparing blocks for the wood engraver, such as his illus-
trations for *L'après-midi d'un faune* (no. 72). Manet clearly
did not see such procedures or new technologies as a
threat to original printmaking, for as his interest in direct
printmaking such as etching and crayon lithography
waned, he saw these transfer processes as more effective
media for his current artistic ideas.
Lefman specialized in the use of photographic transfer
to zinc plates for gillotage prints, and Manet himself had
a long history of interest in photography, specifically as a
working method for the preparation of his etchings. But
*The Raven* illustrations more likely used a direct nonpho-
tographic transfer common for gillotage prints. Like
Manet's other autographies, there is no indication of in-
dentation from the relief process, although this appear-

ance can be eliminated with the use of fine papers such as chine and a careful, soft run through the press. Harris and others note that there are preliminary stages for plates two and three in the series documented by rare proofs. This fact has been taken by Bareau to indicate that Manet worked on the plates himself, in the context of transfer lithography, but such work could have easily occurred for gillotage prints, which also begin as a direct transfer (New York 1983, p. 384). For plate two, the window scene is totally reworked and in the third state the margins are cleaned up. Manet was clearly involved in the reworking of the window scene, but the adjustment of margins, and in plate three the filling in of a white spot on the raven, probably resulted from a printer's efforts.

Unlike the first version of *At the Café* the process used for *The Raven* captures the subtleties of the brush-and-ink original drawing, especially for the wash effects, marked by their freshness and transparency. But, in darker areas, as is seen in *At the Café*, the lines seem too abrupt and too precisely contoured to represent actual brushstrokes, which often show traces of fine lines where the bristle has splayed. Such details would very likely have transferred if a lithographic process had been used, although there are relatively few examples of prints using a brush-and-wash drawing technique that can be identified as transfer lithographs.

The possibility that these masterpieces of printmaking may have been achieved with a gillotage process should not exclude their identification as important examples of original printmaking. Even if a photographic transfer of Manet's drawing to the zinc plate was indicated, and it is not, this procedure would have been used with Manet's full knowledge as he was preparing the original drawing. In a search for originality, artistic intention is more important than process, and Manet's illustrations for *The Raven* clearly take full artistic advantage of the gillotage process. It is precisely this characteristic of Manet's printmaking that made his work such a valuable source for an innovator like Degas.

72
*Illustrations for "L'après-midi d'un faune" by Stéphane Mallarmé* (1875–1876)
*Unknown Artist, after Edouard Manet*

Wood engravings
On tan laid paper, crowned shield with fleur de lis watermark
Second state of two
Sheet (irregular): 362 x 250 mm (14¼ x 10 in)
Inscriptions: None
B. 90, I. 101–104, H. 84, G. 93, M.N. 101–104

*The George A. Lucas Collection of The Maryland Institute, College of Art, on indefinite loan to The Baltimore Museum of Art*
B.M.A. L.33.53.5174

a. *Nymphs*
   Les nymphes
b. *Bunch of Grapes*
   Grape de raisin
c. *Faun*
   Le faune
d. *Leaves in the Grass*
   Feuilles dans l'herbe

The wood-engraved illustrations after Manet's designs for Mallarmé's poem *L'après-midi d'un faune* represent the second close collaboration between the artist and writer. Other projects were planned but never realized. Exhibited here is a rare sheet showing all four illustrations from the book. Originally this was thought to be a proof of the blocks before they were separated to print the book. But Bareau demonstrates that, in fact, this sheet came after the book because a crack has developed through the knee of the faun, which is not visible in illustrations found in the book. There is no indication that this page was printed from separate blocks, but it would be possible to print them without such marks. This sheet was evidently printed for distribution to certain friends, as a copy described by Bareau was given by Mallarmé to Mery Laurent, where he inscribed passages from the poem, evoked by each illustration (Wilson 1978, p. 90). Generally the illustrations on this sheet do not print as sharply as those in the book, especially the volumes printed on japon paper.

The presentation of the volume reflected Mallarmé's exquisite taste and the exacting standards of both poet and painter. The book appealed to the collecting standards of the amateur. It was printed in an edition of 195 copies, 175 on Holland laid paper and 20 on japon. An unbound copy in the Bibliothèque Nationale shows the extent of concern for the volume's presentation—a cover on a stiff japon with gold lettering, tied with strings of black and rose silk. The four illustrations included ex libris and tailpiece. A major influence for the conception of Manet's illustrations were the woodcuts from Hokusai's *Manga*, an influence visible in other projects as well (see no. 51, 52, and 64). The tailpiece *Leaves in the Grass* is actually derived from a plate in the *Manga* (Baas and Field 1984, p. 37, fig. 4a). For the japon copies of the book Manet tinted the plate *Faun* with a rose wash that approaches the subtle understated coloring of the *Manga* plates.

72 *Illustrations for "L'après-midi d'un faune,"* unknown artist, after Edouard Manet

A number of wood engravings have been catalogued among Manet's prints as original graphics although Manet did not cut the blocks (see H. 84). Bareau only included *L'après-midi d'un faune* because of documentation surrounding Manet's interest in this book illustration and the meticulous care he took in preparing the volume with Mallarmé. In addition to these illustrations, the other frequently mentioned wood engravings include three variant portraits of Nina de Callias (H. 76–78) engraved by Prunaire and an engraving of *Olympia* by Moller that may have been the one described by Manet in a letter to Zola in 1867 (see no. 39). Should these be considered original prints? For the first portrait of Nina de Callias, Manet drew a design on a block, now in the Cabinet des Dessins in the Louvre. To save this drawing, Prunaire had the image transferred photomechanically to another block, which he then engraved. A similar procedure may have been used for the illustration the *Nymphs*, for a photograph in the Bibliothèque Nationale Lochard album preserves the only record of Manet's drawing on the block. Because the drawing is in the same orientation as the illustration, it was probably photomechanically transferred to another block and reversed in the process, since the lines on the drawn block correspond exactly to those in the wood engraving, including the passages that Manet modified by adding white gouache. In a letter to Zola

at the time of the Avenue de l'Alma exhibition in 1867, Manet wrote about the difficulty of finding an engraver for *Olympia* "skilled enough to make a good job of it" (New York 1983, p. 188). And later in a letter to Mallarmé complaining of difficulties in the production of *L'après-midi*, Manet related his frustration at Bracquemond's suggestion of an engraver whom Manet considered "industriel." Like his transfer relief prints, Manet's concern for the outcome of these illustrations evidences his originality and creativity, regardless of the particular technique used to achieve the result.

The engraver of these illustrations is not known. Apparently, it was not Prunaire since Manet knew him and had used him for other projects but did not mention his name in the context of these prints. Furthermore, as Baas points out, "the result conveys far better than the portraits of Nina de Callias, the expressive, calligraphic stroke of Manet's drawing." Indeed, Manet devised a drawing that would at once require less of the engravers, but also more, for they could not resort to their standard techniques such as "teinte" to add tone with parallel lines, in this case seen only in *Leaves in the Grass*. Manet's drawing demanded a simple, pure rendition, which in effect explored the artistic potential of the medium of wood engraving (Baas and Field 1984, p. 39).

It was perhaps Manet's difficulty in finding an engraver for this assignment together with other production problems that caused a delay in the appearance of the book until spring 1876, when it was published in Paris by Alphonse Derenne. As Harris points out, the poem by Mallarmé, his most famous and printed for the first time in this edition, "deals not with real events, but with secondary illusions about events" (Harris 1967, p. 233). Plates could not illustrate the text as if it had a narrative, so instead Manet invented the two scenes, identified as a frontispiece (the faun) and a tailpiece (the nymphs), which enhance the text, representing the characters of the poem. An exquisite grace and simplicity harmonize plates and text.

73
*In the Upper Gallery* (1877)
*Au paradis*

Brush-and-ink transfer relief plate
On trimmed chine paper
Only state
Sheet (irregular): 251 x 348 mm (9¹³⁄₁₆ x 13¹¹⁄₁₆ in)
Image (border lines): 242 x 340 mm (9½ x 13⁵⁄₁₆ in)
Inscriptions: Signed in stone, l.r., "E.M."
B. 86, I. 105, H. 86, G. 82, M.N. 89

*The George A. Lucas Collection of The Maryland Institute, College of
Art, on indefinite loan to The Baltimore Museum of Art*
  *B.M.A. L.33.53.13697*

Like his other autographie, *At the Café* (no. 63), *In the Upper Gallery* is undoubtedly based on sketches from life. Manet shows a group of young spectators with an older woman behind, obviously enjoying an entertainment in the upper reaches of a variety theatre. Manet executed his original drawing in a brush-and-ink technique similar to *The Raven* illustrations, and like those plates, Lefman's transfer process effectively captured the subtlety of the brushstrokes Manet applied with such freshness and immediacy. This print was prepared for publication in the *Revue de la Semaine,* where it was included as a separate folded sheet, on chine paper (a slight vertical fold is visible in most impressions) to accompany an article on Manet by Jules de Marthold in the 29 April 1877 issue. The exhibited impression from the Lucas collection, like most recorded copies of this print, has been trimmed to eliminate the letters that appear beyond the printed border line (see illustration, I. 105). While Guérin has described a proof before letters, Bareau believes that, like the Lucas impression, the so-called first states are just trimmed since no other differences are visible (B. 86). The printed letters identify this print as a "dessin inédit" in a manner similar to *The Raven* illustrations, and other gillotage prints after Manet drawings. Lefman, the printer of Manet's other autographies, is clearly identified as the printer of *In the Upper Gallery.*

Because of its inclusion, presumably in a large edition, in an identified periodical, and because Lefman was designated as the printer, this object can be most securely identified as a gillotage print, rather than a transfer lithograph. In a recent sales catalogue from the Hom Gallery in Washington, D.C., the catalogue author correctly observed a number of changes between impressions of this print that were mistakenly taken as a positive indication of the two states suggested by Guérin and a proof of Manet's involvement with the plate after transfer. The changes basically involve the darkening of certain areas such as the face of the boy to the right, which is almost obscured in some impressions, the shading of the woman's face, and the relative length of the balcony railing on the left, which is shorter in the impressions that also show the darkening. The impression illustrated in the Hom catalogue corresponds closely to the Lucas impression, and it in fact shows the same vertical fold and trimming of letters, indicating it too probably comes from the *Revue* (see illustrations, Guérin 1944 and Wilson 1977). But a careful comparison between the Lucas impression and a variant impression from the Rosenwald collection at the National Gallery of Art in Washington D.C., demonstrates convincingly that the variations do not indicate a change in state or that Manet worked on the plate after transfer.

Transferring the design from the original plate to other

73 *In the Upper Gallery*

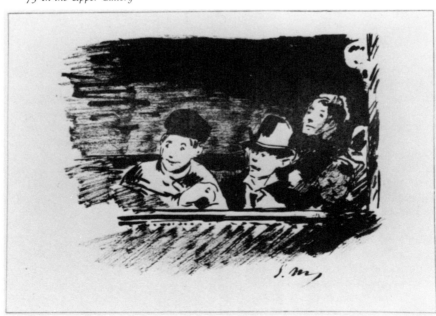

plates to create multiple printing surfaces was common, especially for such large editions. Variant versions such as the National Gallery impression were probably printed from a different surface, a second plate, where the more transparent brushstrokes appear to have filled in, printing much darker. In these impressions the railing is not longer, instead, more can be seen of the brushstrokes below. Judging by the first version of *At the Café*, Manet's brush drawings presented greater problems for Lefman's transfer process than the more common pen style. While the small edition of *The Raven* turned out well, multiple plates were required for *In the Upper Gallery*. The first can be represented by the exhibited impression, which printed without difficulty, but in the transfer to another plate the subtleties of Manet's brush drawing became muddled. Changes such as the darkening of the boy's face are the result of the printing process, not artistic modification.

74
*The Smoker*   (1879–1882)
Le fumeur

Drypoint
On laid paper, shield with M crowned with crescent watermark (Hallines)
Only state
Sheet: 370 x 257 mm (14½ x 10⅛ in)
Plate: 235 x 152 mm (9¼ x 5¹⁵⁄₁₆ in)
Inscriptions: None
B. 54, I. 49, H. 49, G. 48, M.N. 34

*The George A. Lucas Collection of The Maryland Institute, College of Art, on indefinite loan to The Baltimore Museum of Art*
*B.M.A. L.33.53.5158*

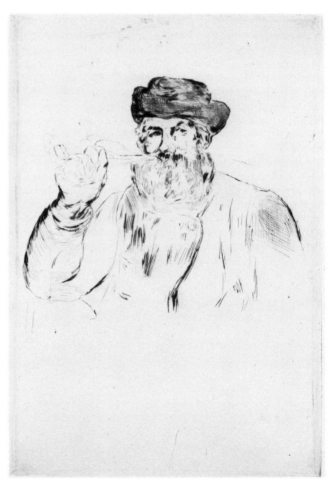

74  *The Smoker*

Although the drypoint *The Smoker* is one of Manet's last prints, until Bareau's 1978 catalogue it was considered to be an initial sketch for the etching of 1866 (no. 40) and therefore closer to the painting of the same year. Bareau's discovery of the mark of the copper plate manufacturer on the back of the plate proves that the print must date after 1879. The inscription ''E. BRIDAULT/

SUCCr. DE H. GODARD/27 RUE DE LA HUCHETTE/ PARIS" could only have appeared on a plate after this date, when Bridault took over the firm from Godard. This discovery points out the difficulty of associating and dating Manet's prints on the basis of subject or style, since retrospective treatments of early themes are very common and since his style shows great variety depending on the particular goals of the piece.

Nothing is known about the circumstances surrounding the only pure drypoint in Manet's printmaking oeuvre and why he chose, near the end of his life, to return to this subject of 1866. Unlike the earlier etching, this drypoint is in reverse to the painting, and while cropped similarly at the bottom, it shows the full composition at the sides. Otherwise it is almost the same size. Like the first state of the etching, the plate extends well below the image, allowing space for the entire composition as it appears in the painting, but here also the image is cropped. Only because the plate is not trimmed and the drypoint lines fade out near the bottom of the image does it resemble a sketchlike vignette. Manet probably drew directly from the model onto the plate, either working from the etching or the painting, in a rapid abbreviated style appropriate for the drypoint technique.

This plate was eventually steel faced to allow a large edition but when is unknown—for the large Strölin edition only or earlier for the Dumont edition, the first from the plate. Although the exhibited impression from the Lucas collection is designated by that collector as a modern impression from Dumont, its atypical paper and the strong quality of the drypoint lines, somewhat exaggerated by inking, suggest that it might be one of the Guerard proofs from Manet's lifetime. Close comparison reveals little difference between this impression and one now in The Art Institute of Chicago, former Guerard collection, that was catalogued by Bareau as one of the rare lifetime proofs of the plate. The impression from the Bibliothèque Nationale, illustrated in Guérin and Moreau-Nélaton, has an even stronger, richer drypoint burr. The steel facing allowed Strölin to print his large edition, but retroussage used to make up for the loss of drypoint burr can never equal the feathery accents of fresh drypoint lines.

## 75
### Jeanne: Spring   (1882)
Jeanne: Le printemps

Etching, bitten tone, roulette
On laid paper, partial Van Gelder watermark
First state of four
Sheet: deckle edge bottom 286 x 215 mm (11¼ x 8½ in)
Plate: 248 x 183 mm (9¾ x 7³⁄₁₆ in)
Image: 156 x 108 mm (6⅛ x 4¼ in)
Inscriptions: Signed in plate, l.l. margin, "Manet"; in pen, l.l. below plate mark, "Jeanne, 1ᵉʳ Etat avant l'aquatinte dernière pl. de Manet. mordue & aquatinte par Guerard." (Inscribed by Henri Guerard)
N.Y. 214, B. 72, I. 107, H. 88, G. 66, M.N. 47

*Samuel P. Avery Collection, The New York Public Library Astor, Lenox, and Tilden Foundations MN47*

After 1872 Manet made very few etchings, including his unsuccessful attempt at a portrait, *Théodore de Banville* in 1874 (H. 81–82), the etching of his ill wife, *The Convalescent* from 1878–1881 (H. 85), and the series of illustrations for Cros's *Le fleuve* in 1874 (no. 64). None of these etchings are derived from painted compositions, but in 1882, after the Salon, the popularity of two Manet paintings exhibited there, *A Bar at the Folies Bergère* (R.W. vol. 1, 388) and *Jeanne: Spring* created a demand for reproductions. The critic Gustave Goetschy had asked Manet for a drawing of the *Bar* for reproduction to accompany a review he was writing on the Salon, because in April 1882, Manet wrote him "it is impossible to do a drawing of the Bar with a process that excludes halftones—I will do the other picture, *Jeanne* for you" (New York 1983, p. 487). Manet was apparently commissioned by his friend Antonin Proust to produce a series of paintings showing the seasons, but only two were completed, the other being *Autumn* (R.W. vol. 1, 393). For this symbol of spring he created the portrait of the actress Jeanne Demarsy.

Evidently the drawing for Goetschy was not complete in time for the review, but Manet did produce a drawing (without halftones) to be reproduced for Proust's account of the Salon in the June 1882 issue of *Gazette des Beaux-Arts*. The tracing of that drawing executed on the back of a photograph (Fogg Art Museum; R.W. vol. 2, 439) provides the only documentation of Manet's supposed use of photography in the production of prints and drawings based on paintings, a method Alain de Leiris first discussed in his 1957 Harvard dissertation and later in his catalogue of Manet's drawings ( Leiris 1969, pp. 10–14). Carl Chiarenza outlined the specific procedure Manet used for the Fogg drawing in an article that demonstrates, contrary to Leiris, that both drawing and etching were based on photographs of the original oil (Chiarenza 1969, pp. 39–45). For the Fogg drawing, Manet had an albumen print photograph made in reverse orientation to the original, simply by reversing the negative. The drawing traces the outlines of the reversed photograph onto the back of the sheet, retaining the orientation of the original. The *Gazette des Beaux-Arts* reproduction was then made from this drawing through a

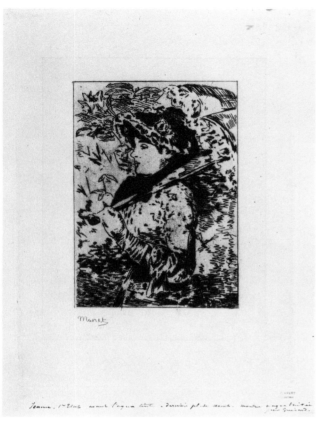

75 *Jeanne: Spring*

photomechanical process. The Fogg drawing could have been done very rapidly since the technology was not complicated and since, according to Tabarant, Manet often made photographs of his own works (Reff 1982, p. 58). For his work on the copper plate Manet then used as a model a second photograph, reversed and reduced approximately 50 percent. Because the contours of the etching are much closer to the photograph than to the Fogg drawing, Chiarenza confirmed that Manet did not have to make a tracing before working on the copper plate. With the use of reversed negatives, both drawing and painting could accurately reproduce the composition of the original in the same orientation.

Manet had most of his paintings photographed, first by Godet and later by Lochard. Albums of these photographs can be found in the Bibliothèque Nationale and The Pierpont Morgan Library. Many of Manet's prints correspond in size to these photographs, and numerous drawings appear to be traced from photographs, although the Fogg drawing is the only recorded drawing actually on the reverse of a photograph. In the second period of Manet's etching beginning in 1865, those prints that reproduce painted compositions are even closer to the original and are more often in the same orientation, unlike the majority of his early etchings (see no. 32 and 33). They were probably made with the same process of reversed and scaled-down photographs, a process Manet used for the last time with the etching *Jeanne*.

Even though the reproduction of the Fogg drawing appeared as the illustration for Proust's review, Manet probably intended the etching to illustrate that article. Yet in May he wrote to Guerard, who was helping him with the plate, telling him to cancel it: "Thanks, my dear Guerard—evidently etching is no longer my affair—put a good burin stroke through the plate and best wishes" (New York 1983, p. 488). The popularity of *Jeanne* and the *Bar* would have insured some success for an etched reproduction, but Manet felt *Jeanne* was not successful and the *Bar* was, as he told Goetschy, ill suited for reproduction as a drawing and undoubtedly as an etching as well.

Guerard did not follow Manet's instructions to cancel the plate, and instead printed a few proofs. An inscription on the exhibited impression of the first state indicates that Guerard etched the plate in the acid and added the aquatint, perhaps in hope of retrieving this plate with obvious technical inadequacies. The plate was never published in Manet's lifetime but was included in the 1890, 1894, and 1905 editions. In 1902 the image appeared in the *Gazette des Beaux-Arts* but because the plate size is larger than that of the posthumous editions it is likely that the *Gazette* image is an electroplate reproduction. The exhibited proof of the first state shows a light aquatint that was subsequently strengthened in later states, together with a bitten tone, possibly an irregular roulette or some other process such as a salt ground.

The nature of the various reproductions made after Manet's painting of Jeanne tell a great deal about the changes that occurred in printing during this time. The cover of Ernest Hoschedé's *Impressions de mon voyage au Salon de 1882* was printed with a three-color photomechanical reproduction of Manet's painting, quite possibly the

first of its kind, a process developed by Cros. His invention and its early use in reproducing Manet's painting is discussed by Adriane Isler de Jonghe in a recent article (see Bibliography). Manet was fully aware of these developments and was very cooperative. It is logical that as Manet's interest in the more original and creative aspects of printmaking declined after the mid-1870s, he had a thorough knowledge of new printing technologies that used the photograph and saw advances such as Cros's invention as having far more potential for faithful reproduction than an etching. The Société etchers of the 1860s had feared photography because it eliminated the possibility of artistic interpretation in the reproduction of other works of art, the main staple for these artists. But it was precisely photography that eventually liberated the etcher so that he could pursue the concerns of a peintre-graveur. The etching *Jeanne* was an anachronism for printmaking in general but also in Manet's oeuvre, for he was quite obviously more interested in Cros's experiments than his halfhearted attempt at an etched reproduction.

76

*Edouard Manet*   (1867)
by Felix Bracquemond

Etching
On laid paper
Only state
Sheet (irregular): 305 x 240 mm (12 x 9½ in)
Plate: 158 x 120 mm (6¼ x 4¹¹⁄₁₆ in)
Image: 143 x 105 mm (5⅛ x 4⅛ in)
Inscriptions: In pencil, lower margin, ''Bon à tirer pour 600 E. Manet''
Beraldi 75, I. p. 140

*The George A. Lucas Collection of The Maryland Institute, College of Art, on indefinite loan to The Baltimore Museum of Art*
*B.M.A. L.33.53.4596*

76 *Edouard Manet* by Felix Bracquemond

As a printmaker, Manet's most important colleague was the master etcher Bracquemond, who like Manet was a founding member in the Société des Aquafortistes. In the course of his long life, Bracquemond offered technical advice to numerous artists such as Manet and later Degas, who as peintre-graveurs sought the technical knowledge they needed to evolve their own printmaking styles. Bracquemond was clearly a generous and stimulating adviser who worked closely with Manet in the production of his etchings until about 1866–1867 when Manet appears to have used the technical advice of Guerard. Bracquemond not only helped Manet with technical de-

ch as the application of an aquatint ground for
 (no. 39), but he probably printed the proof
ons of many of Manet's early plates, especially
chine. Manet's portrait of Bracquemond (no. 31)
lt of an artistic collaboration between the two—
the first and only time using Bracquemond's
ss.

Zola proposed the idea of a small pamphlet
g an earlier review he had written of Manet's
at would be distributed during Manet's inde-
nt exhibition off the Avenue de l'Alma. Manet in
ing to this project asked Bracquemond to etch a
rait of him, which would be included in the pam-
let as a frontispiece. The pamphlet also included *Olym-
*, the etching for which Manet required Bracquemond's
ssistance as well. The exhibited impression of this
tched portrait frontispiece is the bon à tirer impression
signed by Manet and designated for an edition of ''600.''
The Bracquemond portrait, typically dry in conception, is
based on a photograph of Manet made by Camentron
(Bouillon 1975 p. 40, fig. 7–8). In spite of Manet's bon à
tirer, impressions actually printed for the Zola publication
are inked much more heavily and approach the graphic
impact of a photograph.